Making Dying Illegal

Architecture Against Death:
Original to the 21st Century

Making Dying Illegal

Architecture Against Death:
Original to the 21st Century

Arakawa and Madeline Gins

Introduction by Jean-Jacques Lecercle

ROOF BOOKS
NEW YORK

ISBN 13: 978-1-931824-22-4
ISBN 10: 1-931824-22-3
Library of Congress Catalog Card Number: 2006936056

Roof Books are distributed by
Small Press Distribution
1341 Seventh Avenue
Berkeley, CA. 94710-1403
Phone orders: 800-869-7553
www.spdbooks.org

This book was made possible, in part,
with public funds from the New York State Council on the Arts,
a state agency.

Roof Books
are published by
Segue Foundation
300 Bowery
New York, NY 10012
seguefoundation.com

Making Dying Illegal

Contents

List of Illustrations

An A to Z Guide to *Making Dying Illegal*

Jean-Jacques Lecercle

1. Event

Suppose human destiny *was* reversed, that dying was not only made illegal (which it used to be in Great Britain in the case of suicide) but became avoidable: that would surely count as the greatest event in human history. Provided we are clear in our minds about what an event, a real event, not merely the common and garden variety that goes under the name of "historical events," consists of.

One of the theoretical languages where a concept of event is developed can be found in the works of Alain Badiou.[1]

And as usual, the concept takes its meaning from its associations with a cluster of related concepts. In Badiou, an *event* occurs in a determinate situation. It is inexpressible in the *language* of the situation, and it bores a hole in the situation, meaning that it changes the situation forever (once the event, which is unpredictable, has occurred, nothing can ever be the same). The radical novelty of the event produces effects of *truth* (it is Badiou's main thesis that there are not only bodies and words, but also truths), and it creates its *subjects*, always collective, in other words its militants, united by a bond of *fidelity* to the event. Lastly, according to Badiou there are four regions in which events can and do occur: politics, art, science, and love (love at first sight is an event in this sense).

On the face of it the reversible destiny project seeks to name such an event, and *Making Dying Illegal*, after *Architectural Body*, appears to be a manifesto, a call to arms to generate the event. There is, however, from the very start, a vast difference: the Badiou event cannot be anticipated, it cannot be named before it occurs, it cannot therefore be the object of a program or manifesto, as there is no language to phrase its radical novelty. It can only come as a divine surprise. Resurrection is such an event, but it cannot be the object of a statute. Whereas

Making Dying Illegal inscribes a vocation in the etymological sense: the event is announced, convoked, called into being by being formulated before it has occurred. So the question insists: what kind of event is this? In order to answer the question, I shall enter the text: its first and most striking characteristic is its fragmentation.

2. Fragment

What we have is barely a "text" in the ordinary meaning of the term. Not a coherent chain of argument, with systematic concepts, developments, illustrations, calling for interpretation on the part of the reader, seeking to persuade her that the position adopted by the text is right. Or rather, all those elements are indeed present (no one will reproach Arakawa and Gins for failing to try and convince their readers of the necessity and urgency of reversing destiny), but only in fragments, so that the text is a medley of apparently incoherent bits, a pastiche in the etymological sense of the term, still present in the Italian *pasticcio*, a hodgepodge. Here lies the most striking difference between *Making Dying Illegal* and *Architectural Body*: the former "text" is perhaps a manifesto, but certainly not a treatise—not a sequence of articulated chapters but a potpourri of aphorisms, seemingly without a plan, a series of additional footnotes to *Architectural Body*.

If we adopt this view of the text, we make it simply a useless appendix to the great work that preceded it. And we are unjust toward it. For not only do we miss the developments of Arakawa and Gins's research program (for instance the sketch of the new art-science of biotopology, which I take to be the core of the work), but we miss what they have set out to do: construct a textual event that reflects in advance the real event of the reversing of destiny. It is essential, therefore, to account for the fact that the text is deliberately made up of fragments.

A first account could go like this. *Making Dying Illegal* belongs to the tradition, from the Romantics to the postmodern era, of the literary fragment. And indeed Arakawa and Gins are fond of aphorisms, witness the introduction to their correspondence with Leslie Fukuzawa-Emerson:

> To be more sure of the body and thereby less sure of it
> To be more sure of the *organism that persons* and thereby
> less sure of it . . .

But such an account is unsatisfactory, as it turns *Making Dying Illegal* into merely an aesthetic object, which in a sense it is, although it can in no way be

reduced to a postmodern game or a Romantic pose. It ignores essential aspects of the text, for instance the fact that, as its title clearly indicates, it also aims to be a *political* text.

So I suggest a second account. *Making Dying Illegal* inscribes a project that is both revolutionary and impossible: it attempts to invent a language for what cannot be formulated in a language, for what is unsayable as long as it has not occurred, an event as Badiou thinks it. Hence the fragmentation and tentativeness of a language that ought to be entirely, radically new, and yet cannot do without the words of the tribe, the always already formulated, the language of the old situation. Such an event can only be expressed under erasure, through paradox.

But perhaps this is asking too much of the text, putting too much theoretical weight on it. Perhaps this is asking for the impossible, as we say in French (but that is precisely what a *revolutionary* demand consists in). Interpreted in this way, *Making Dying Illegal* can be at best a glorious failure, at worst nothing. And it is emphatically *not* nothing. So here is a third account for the fragmentariness of the text. What counts is not the event that has already occurred, as in Badiou, but the event we are struggling toward, as in Marx—the event that we are calling into being, an event that may be anticipated in the languages of science, philosophy, poetry, in other words, in the languages of utopia. The important point is that a text struggling toward such an event, a utopian text in a strongly positive sense, must attempt to abandon the *status quo*, welcome the radically new. In the terms of the British Marxist John Holloway (about whom more later), such a text must move from result to process, recover the flow of doing in the reification of the done.[2]

I take it that this is exactly what *Making Dying Illegal* is doing. The tentativeness that is at the core of the construction of an architectural body has contaminated the text: this is what the fragmentation of the text tentatively inscribes.

3. Genre

We now understand the motley aspect of the text, a nightmare for librarians: neither fish nor fowl, art nor science, poetry nor philosophy, how can it be classified? But then, classification is the very embodiment of what Badiou calls the language of the situation.

Architectural Body was already characterized by the multiplicity of the genres present in the text, from case histories to poetry to philosophical argument to architectural manifesto. And this multiplicity was inscribed in the variety of the intertext, from Francis Ponge to *Gulliver's Travels*. The same holds for *Making Dying Illegal*: we need only take a glance at section 9 (the title of which is not par-

ticularly perspicuous). In that section the reader soon recognizes word for word quotations from *Frankenstein* and *The Sorrows of Werther*. And the reader (this reader) knows that the passages that immediately follow must also be quotations, although he fails to recognize them: so he is relieved when, at the end of the section, he comes across a list of sources, as in the most serious of academic textbooks. So the fragments from the celebrated texts were, if not parodies, at least travesties or instances of rewriting, and the section is truly a pastiche in both the literary and the etymological sense. And at first sight, this is a typically postmodern game (at this point, shades of Kathy Acker and Donald Barthelme flit by).

Except that this is not a game, not even a literary game, for the text is deadly serious (if you pardon me this facile joke): the multiplicity of genres involved is part of an overall strategy of textual tentativeness, a deliberate rejection of the commonsense freezing of the text within a regular genre. And indeed this patchwork text involves not only a variety of literary genres but a multiplicity of *discursive* genres in the sense of Bakhtin, or language-games, in the sense of Wittgenstein. We move from literary pastiche to plain science (with the elements of biotopology), taking in the least-expected forms of discourse: a personal correspondence, an exchange of e-mail messages, and an afterword written by a philosopher of language. This strategy is a strategy of *eventing* the text (I shall return to that coinage): not only are the narrative structure and the argumentative coherence of the text dissolved, but the identity of the authors (already a Janus-like author, like Deleuze and Guattari and a fine example of *écriture à quatre mains*) gives place to a plurality of not so concordant voices.

And here we must note that the range of discursive genres involved covers the four fields in which an event according to Badiou may occur: politics (the title makes a strong gesture towards this), science and art (or, paradoxically, what they call art-science), and love. If you think I am imagining the authors' interest in the last field, just take a look at the back cover: the baby that has pride of place there is not an object of desire, but an object of love and hope (and I love his or her red toes). It is now clear that this motley text is not the joint production of two *fous littéraires* but a courageous attempt at naming an event.

4. Identity

In the work of Arakawa and Gins "identity" is not a positive word. There is a sense in which, and I admire them for this, they are *against identity*. Witness the following passages:

To form a person and to form an identity are not the self-same process. All supposed identities are half-told stories, dogmatic and highly unreliable patchwork narratives. It is incredibly important that what each *organism that persons* claims as its identity be nothing more than this: *organism that persons*. To try to have an identity over and beyond this would too drastically limit one's possibilities, inasmuch as it would promote separatism, isolating this ethnicity, this family from that.

Or again:

> *Should I agree to quit having an identity, then the* organism that persons *that I had been or some rearrangement thereof would continue on in perpetuity (so what if this takes a wholly different shape in some distant cove I have never visited).*

It is clear from this that identity claims are undesirable, *insofar as they work against the possibility of reversing our destiny.* There is a constitutive link between identity and fate: my identity will be fully constituted when the Parcae cut off the thread of my existence, when the narrative of my life no longer has gaps, and can be told as a coherent whole, but of course in the past tense. In this Arakawa and Gins join forces with John Holloway, for whom identity is the climax of the fetishism against which the revolutionary militant must struggle. For Holloway's Marxist stance revisits the concept of fetishism in Marx, and the concepts of alienation and reification in the early Lukacs. And he introduces the concept of defetishization: his utopian position contrasts the flow of doing, of processes and practices (Arakawa and Gins would no doubt say "procedures"), and the fetishism of the done, of objects and results, of which identity is the cardinal example. The question, of course, is: if we do away with identity, what do we replace it with? And the answer is, not with a concept of a subject, but with radically new concepts, the organism that persons and the architectural body. In this Arakawa and Gins are more radical than Holloway, where the struggle for defetishization produces subject positions (as in Badiou the event produces non-individual subjects). But the movement is similar; Arakawa and Gins also move from the done to the doing, from the result to the process, or procedure. So we have an architectural body, constructed through tentativeness and procedures (see the Directions for Use for the *Reversible Destiny* Lofts—Mitaka, in Appendix D), not an achievement, a result, an identity-bearing subject. And we have an organ-

ism that persons, Arakawa and Gins's version of the *Dasein*, with its linguistic inventiveness inscribed in the conversion of a noun (typically naming objects and results) into a verb (typically naming processes). We might compare this with a similar move in Deleuze and Guattari, where the concepts of haeccity and collective assemblage of enunciation do the philosophical work an exhausted subject is no longer able to do.

This rejection of identity is coherent with the calling for an event. In Badiou, the event creates its own subject (the political militants, the couple in love)—the subject is always collective, never individual. Thus, the subject of the Frankenstein event is made up of the monster and its creator, an indissoluble couple, whom only the death of the master and the consequent suicide of the slave can dissolve. In Arakawa and Gins, the calling for the event, an evocation that is also an etymological vocation, involves a dissolution of the old subject, the individual as center of consciousness, who knows he or she is destined to die, and the creation of a new subject, an organism that persons, the militant of the reversible destiny project, who is inseparable from his or her environment: the architectural body is never entirely alone. And of course such a subject is so new that the classic concept of subject must be not only renamed but thoroughly transformed. One of the sites of such transformation is language: the organism that persons is no longer the individual speaker of methodological individualism, but a cluster of positions embodied in language through pronouns: "In the heat and cool of actuality, the architectural body 'biotopologizes' along. Each and every movement of the organism that persons or of any of the referents of its ever-available suite of pronouns and would-be pronouns starts up an atmospheric trajectory." It would appear that the organism that persons is not merely a possessor of language as an instrument of communication, but, in a sense, *is*, or *is also*, language.

5. Language

The question of language is at the center of Arakawa and Gins's event-evocation project. In Badiou, one of the most striking characteristics of the event is that it cannot be formulated in the established language of the situation (this is why it can be said to "puncture" the old situation, to make a hole of unsayability in it), so that the question raised by the welcoming of the event is that of the creation of a new language, a language capable of expressing the radically new. There is a *poetic* force in the Badiou event that compels its militant to be also a poet. In Arakawa and Gins, we find the same central function ascribed to language and the same poeticity of the event and of the text that calls for it. And we find the same

attempt to produce a new language and to think language anew. This is why *Making Dying Illegal*, like *Architectural Body*, is both a philosophical and a poetic text.

That the question of language pervades the Arakawa and Gins project is clear. In its simplest form, this intricate relation between architectural body and language takes the form of an analogy (see the section entitled "The Tactically Posed Surround as a Sentence (Phrase, Paragraph, Text)"). It is clear that language is a red thread in Arakawa and Gins's philosophy, as was already apparent in *The Meaning of Meaning*, and the analogy is strict and systematic: the word is the predecessor of the architectural procedure, tactically posed surrounds are phrases and sentences, their sequences propositions, complete with logical connectives, or "three-dimensional THEREFOREs, BUTs, Ors, ANDs and built-up WHATEVERS."

But this intricate relation between the reversible destiny project and language goes further. Reinventing language means actually doing violence to it in order to renew it; it means not only inventing a new language (for this might be simply a new architectural or philosophical jargon) but *eventing* language. In Arakawa and Gins this eventing takes two main forms: the coining of new words, and the style of the text.

There is a link between the coinage of new words and the creation of new concepts. Philosophers of all descriptions have widely used that fundamental characteristic of language: that the lexicon is virtually infinite, even if subjected to the constraints of human memory. But Arakawa and Gins go further than the customary elaboration of a series of terms of art: their linguistic and conceptual creation is a deliberate attempt to force language out of its ruts, to event it. The best illustration of this position, which was already apparent in *Architectural Body*, occurs in *Making Dying Illegal*, with the creation of two new demonstrative pronouns, *thas* and *thit*. For it is clear that the usual deictics, *this* and *that*, are insufficient for the conceptual work Arakawa and Gins need for the evocation of the event: true to the paradoxical nature of that event, they need deictics that mean not only this and that, but also neither this nor that (the meaning they ascribe to *thit*) and neither that nor this (*thas*). A linguist might object that one new pronoun would be sufficient to do the work of both, a work that is needed in formal logic, and perhaps also in the logic of language, but the eventing of language to which Arakawa and Gins have recourse here, being a *spatial* organization of language, combines paradox and symmetry. The result of such eventing is that they force language, the English language, to express what it fails or refuses to express. We might compare

15

this attitude to that of Roland Barthes, when he claimed that language is fascistic, by which he means that the "mechanism of meaning" (the over-assertion, intimidation, arrogance, of syntax, connotation, and narrative) imposes the constraints of *doxa* on a helpless speaker, who is spoken by language at the very moment when she is convinced she speaks it out of her own free will.[3] And the site of the violence done to language in order to force it out of *doxa* is style.

The style of Arakawa and Gins is indeed their own: you can recognize a text written by them as you can recognize a Cézanne. Their style is abstract ("Within the declaring of a thing or an event to be a thit or thas lies the pronouncement of its status as an example of the 'neither and the both,'"), a potential nightmare for a translator (but we remember the spirited defense Adorno conducts of the difficulty of Hegel's style:[4] the difficulty of the text is the unmistakable mark and the direct consequence of the eventing of language). Their style is sometimes finicky (as in their discussion of the contrast between "indirectness" and "indirection"), and more often repetitive, to the point that one has the impression of reading a piece by Beckett :

> To be more sure of the body and thereby less sure of it
> To be more sure of the *organism that persons* and thereby less sure of it
> To be less sure of the body and thereby more sure of it
> To be less sure of the *organism that persons* and thereby more sure of it

Absence of punctuation, an elevated diction, the use of paradox, the typical Beckettian repetitiveness through exhaustion of logical possibilities: this is indeed a poetic style, but one whose poeticity embodies the violence of the event. "Clarity" here would only take us back to the language of the old situation, would involve a betrayal of the event, comparable to that of Victor Frankenstein when he abandons the "monster" he has just created, and who is in fact an organism attempting to person.

6. Materialism

We can understand the importance of the linguistic analogy, with its focus on deictics. By linking architecture and language, it places space at the center of the relation between language and its referents, and of the description of language itself. This is contrary to many research programs in linguistics, which insist on time location before (or instead of) location in space. And in Arakawa and Gins, space is of the essence. The organism that persons is nothing but a collection of

landing sites. On the face of it, this ought to be contradictory to the logic of the event, the main characteristic of which is surely that it *occurs*, that is, deploys in time. And indeed here lies the originality of Arakawa and Gins's eventing, where they part company with Badiou: their event deploys in *space*. The procedures that frame the event certainly take time, step after logical step, and they are determined by the historical conjuncture in which they occur, but that time is the logical time necessary for the exploration and organisation of space.

Such is the form of materialism characteristic of Gins and Arakawa: a materialism of space. Architectural procedures, organisms that person, landing sites dwell in a world of immanence. No transcendence is involved here, no origin or teleology, only diagrams and schemata, which reminds us strongly of the philosophy of immanence to be found in Gilles Deleuze, with its plane of consistency. So that the word "cleaving" in its paradoxical dual meaning expresses the essence of the event: it names a spatial operation, of attachment and detachment, engagement and disengagement. In the world of Arakawa and Gins, unlike Badiou's, there is no transcendence, and religion is not one of the fields where events occur (I am being unjust to Badiou, who lays claim to a form of materialism).

What does a materialism of space mean? In the Nanterre conference devoted to the work of Arakawa and Gins, I attempted to give an account of it in the shape of a correlation, under the general title of the passage to materialism in Arakawa and Gins.

1	2	3	4	5	6
Idealism	Time	Transcendence	Past/future	Teleology (origin/destiny)	Personal subject
Materialism	Space	Immanence	Open present	Construction/ procedures	Species/ Haeccity

Columns 1 to 3 have already been explained. Column 4 suggests a way of thinking time within a philosophy centered on space: in a sense this is the main subject of *Architectural Body*. And it is developed in column 5, which marks the utopian value of the Arakawa and Gins project (with a Marxian flavor: we construct our lives and our meanings by constructing our environment), and this utopia is materialist. Making sense is not a question of theory, in its etymological meaning of the contemplation of ideas, but of praxis, that is a series of procedures. The last column has already been hinted at: Deleuzean haeccity does the work an exhausted concept of the subject is no longer able to do, a work that in Arakawa

17

and Gins is effected by the concept of species: we act not as individual subjects but as members of the human species, the collectivity of potential organisms that person.

Both in *Architectural Body* and in *Making Dying Illegal* a formula embodies this passage to a materialism of space: "a tentative constructing towards a holding in place"—this is indeed the formula of spatial eventing: it falls, but it is not a dying fall on the word "place." It moves in space ("toward"), but paradoxically it is because it is attempting to "hold in place." The materialism of space has indeed the appearance of paradox.

7. Paradox

As we have seen, the systematic use of paradox is a notable characteristic of Arakawa and Gins's style, as it is of their cluster of concepts: thus, we hear about "approximate-rigorous abstractions," of biotopology as an "art-science," of "fuzzy exactitude." The notion of "approximativity" is obviously essential to their approach (and we immediately associate it with the "tentativeness" that is at the center of *Architectural Body*), and it duly receives a paradoxical definition, when they speak of "the grand 'approximativity' biotopology would set afloat, throwing everything greatly—if only by a little—out of kilter." And we remember that the central concept of "cleaving" is one of those primitive words with dual, paradoxical meaning that Freud celebrates. At the beginning, the paradox belongs to language: the vagaries of diachronic change have coalesced two ancient verbs with opposite meanings into a single one. But Arakawa and Gins take the concept further into paradox: they use it as an "approximative-rigorous term," and the use they make of it is itself deliberately paradoxical, as appears in the following definition: "Everything that happens due to massenergy shall be called cleaving, and cleaving shall always be thought of as happening on many scales of action at once."

The paradox lies, of course, in the "at once" of the operation of cleaving. The question that looms up at this point is, does this insistence on paradox lead biotopology into nonsense? This question is raised and immediately discarded by a disclaimer: "Despite appearances to the contrary, the science outlined in these pages is not that of nonsense."

I am not so sure. I understand of course the need to respond to the facile objections that the project beggars belief, biotopology is not a science, and the very notion of an "art-science" is a piece of nonsense. But I think the term can be inverted and given an entirely positive sense (this is what happens to it, although in a different form, in Deleuze's *Logique du Sens*,[5] where the indispensable con-

tribution of nonsense to the construction of sense is duly stressed). For it is clear that welcoming the event means going beyond *doxa*, and therefore into what does not make sense in the language of the situation, into nonsense. The event cannot, and yet must be named in the existing language, especially if the welcoming is not celebration after the event, as in Badiou, but a calling of the event, as in Arakawa and Gins. The old language, therefore, being inevitable and inadequate, the event called for can only be named through paradox and oxymoron. The very function of paradox is the formulation of this nonsense, in the new and exalted meaning of the term: what does not make sense in the old language, in the old situation, because it tentatively calls for new sense. And it is time to realize that here the terms "paradox" and "nonsense" are used, against the grain of tradition, in an entirely positive sense: "paradox" is what takes us outside doxa, and "*doxa*", or opinion, is, in the tradition of Greek philosophy, an antonym of "truth." Whereas "nonsense" points toward the layer of virtuality and undecidability from which meaning emerges, before it becomes frozen in common sense and doxa. In this text, as in Arakawa and Gins, paradox is the site of truth and nonsense the origin of meaning.

And here Arakawa and Gins are not far from the *literary* sense of the term, as in the phrase *Victorian nonsense literature*. Indeed, *Making Dying Illegal* often sounds like a modern version of *Alice in Wonderland*, and I feel I could construct a reading of that famous tale in the terms of the reversible destiny project: what are the adventures of Alice, if not the adventures of an organism that persons, a detailed description of the sequence of her landing sites, of the construction of her architectural body, a tentative constructing toward a holding in place? Wonderland is the site of a tentative exploration by a little girl who has lost her identity and seeks to become an organism that persons (remember the way she keeps changing size). As for Yoro park, it reminds me of the chessboard landscape in *Through the Looking-Glass*.

Paradox, as the name indicates, is the instrument of the breaking away from *doxa*. In this attempt, Arakawa and Gins find themselves in the company of Roland Barthes. What he does with culinary metaphors (*doxa* is described in terms of *le visqueux*, *le nappé*—a kind of chocolate topping, in terms of mayonnaise—*doxa* coagulates, or in terms of chewing gum—there is a kind of stickiness to *doxa* that makes it difficult to get rid of it), Arakawa and Gins do with paradoxical concepts and oxymorons. But we understand why the bioscleave cannot be a biosphere: the biosphere, like Barthes's *idéosphère*, the concept he elaborates in his seminar on *le neutre* in order to think *doxa*, surrounds us and compels us to accept

the language of the old situation, whereas bioscleave tries to think both the attachment to the old situation (in which we still live as long as dying is not made illegal) and the necessary separation from it. And here it appears that the struggle for the coming event, the struggle against *doxa,* is always also a political struggle.

8. Politics

It was inevitable from the start that the reversible destiny project should become political: not only is the struggle against *doxa* a political struggle, but politics is a central event-field. Reversible destiny involves reversing, but also revolutionizing the situation, and the second aspect is more important than the first.

Of which politics are we talking? Certainly not party politics, since Arakawa and Gins are not militant Marxists, even if they are materialists of space. Probably not, or not only, the cultural politics of hegemony, although there is a sense in which they are rather successful cultural "agitators" (as one used to say in the blessed days of the Third International). But certainly the politics of subversion of the situation, and in this sense Arakawa and Gins are closer to classical Marxism than Badiou: they have a program for the revolution, including a legislative program, which aims to guide us toward the event. Hence the fact that their politics is deliberately a politics of the impossible, as in the old 1968 slogan: *soyez raisonnables, demandez l'impossible*. A politics that is also a politics of nonsense, of making higher sense by rejecting common sense: their statute begins with article 17 and ends on article 1, that strongly reminds me of the King of Hearts' "Rule 42," the most important in the statute book, as he claims, to which Alice, speaking the voice of *doxa*, retorts that if it were the most important it should be Rule 1.

The main question in this respect is, is such a politics democratic, since this is the only form of politics we now admit? And there is at times an appearance of totalitarianism in their legal pronouncements, as in the formulation of article 11. Is this then simply the inversion of Trollope's dystopia, *The Fixed Period*,[6] where he imagines a society in which, by law, everyone is put down when they reach the age of sixty, a radical solution to the headache caused to our neo-liberal masters by the need to make superannuation payments to the aged—which incidentally raises the question of the risk of overpopulation on earth run by the reversible destiny project.

But there are good reasons for thinking that *Making Dying Illegal* is not a totalitarian project, but rather a form of democratic utopia. The project is firmly situated within the framework of a declaration of human rights, even if this takes the form of pastiche: the aim is nothing short of a new social contract. But even

more important to me is the proclamation of a democracy of architecture:

> It should not be viewed as preposterous, by you or by your neighbors of all sizes and densities, that you have overnight become an architect. Do not laugh at yourself for having as much as declared yourself to be an architect—unless.

This passage is "In support of Step Five" in the construction of an architectural procedure. And some neighbors are indeed denser than others. And this reminds me of Gramsci's attitude to philosophy, when he claimed that every man and woman, being a speaker, was a natural philosopher: philosophy is the most widely shared of talents, because it is based on the deployment of language, which we all possess. In Arakawa and Gins, the same may be said of architecture, the most widely shared competence, because it is based on our becoming organisms that person on the basis of the construction of architectural procedures. It would appear that politics, in Arakawa and Gins, is very much a question of procedures.

9. Procedures

The problem a materialism of space raises is the problem of time: what kind of time is involved, since an involvement with time is unavoidable? How can we avoid the ideality, and the idealism, of time? In Arakawa and Gins the answer lies in the concept of procedure. Time is no longer, or not importantly, the form of our intuition, the medium of our experience, the site for the deployment of our identity: it is the series of steps, to be methodically followed, that constitute a procedure —a form of time that is irreducibly linked to human practice, and which is therefore immanent.

But at least this concept of time-within-procedure seems to preserve one essential characteristic of the classic concept of time: the linearity of time, whereby the instant separates the past from the future, along a line that can be called the arrow of time. But a procedure is not an algorithm— being steeped in paradox, it cannot simply be a series of instructions for use: it is rather the site of a tentative exploration of space, of the construction at the same time of biocleave and organism that persons. So procedures are characterized by their tentativeness, at the very moment when, paradoxically, Arakawa and Gins number the necessary steps. And they are fully conscious of the paradox: for them, architectural procedures are not "designed" or "planned" but "invented" and "assembled." The first verb turns the construction of a procedure into a form of poetry, in the etymological sense of

21

poiesis; the second makes it a form of practice in the Marxist sense of the term. We now understand why we do not find algorithms, but diagrams and schemata, why the inevitable process of abstraction is "approximative rigorous," why "indirection" is an important concept in their work. With indirection, procedure is fading into process.

10. Process

If architecture according to Arakawa and Gins can be described along the language analogy, theirs is a verbal as opposed to a nominal architecture (hence the pervasive presence of the verb marker "-ing," as in "a tentative constructing towards a holding in place": it is a marker of process). For verbs reintroduce time, the time of process and of practice. This linguistically introduced time is not, as we have seen, the Kantian form of intuition, not the time of memory as constitutive of identity in Locke, not the technocratic time of planning, not even town planning: it is the imperfective time of an open present, the time of eventing (note the marker).

We find a similar concept of time in Holloway, who argues against the repetitive or teleological time of classical or dogmatic Marxism (repetitive as in Marx's concept of historical repetition as farce, dogmatic in notion of communism as the ineluctable outcome of the succession of modes of production, when history will come to an end—I am, of course, caricaturing Marxism). For Holloway what counts is the open present of defetishization, the time of doing, of the flow of doing rather than the freezing into the done, the freezing into objects and identities. And this time is, I think, also the spatial time of tentative exploration. Here, had I the space, I would engage in another literary reading of *Making Dying Illegal*, not in terms of Lewis Carroll, but in terms of Antonin Artaud (who accused Lewis Carroll of having plagiarized him in advance): I would try to assess the similarities, but also the strong dissimilarities between the organism that persons and the body without organs.

We understand why the central concept of biotopology is the concept of cleaving. Cleaving involves a paradoxical relation to space—to cling to and also to sever oneself from—to explore the environment tentatively, like the humansnail that the organism that persons is. But "cleaving" is not exactly the same as "cleave": the "-ing" marker introduces the flow of doing, the time of process rather than the freezing into result, the fixation of the done. For this is an architecture that is forever on the move, the opposite of a monumental architecture, of an architecture obsessed by the past and memory (a futuristic building that acquires

the status of a monument turns the future into an anticipated past). This is the great value of the reversible destiny project as architectural project: it is a utopian project in the noblest sense of the word.

11. Utopia

And this is where Arakawa and Gins part company with Badiou for good. For they fully assume the paradoxes of eventing, that is, of constructing procedures that work toward an event that is unbelievable, unsayable, unthinkable, impossible—in other words, real. The main paradox lies in the decision to reach the event through the tentative organization (a word to which we must give a meaning of process, and by which we must understand the creation, the invention of an organism) of space: through the procedural construction of an architectural body. So that there is no need to wait for the event, or to celebrate it as a future-in-the-past (Badiou's event "will always have happened"): what is needed is a tentative constructing toward a holding in place—and we note again the presence of the two markers of the imperfective, and the fall of the phrase on the word "place".

This eventing involves the space and time of utopia, and we are closer to Bloch, the exotic Marxist, than to Badiou, the materialist dialectician, who, for me at least, cannot be a Marxist, precisely because of his concept of time. And such utopia is not an invitation to dreaming, but rather a call to arms, a call to immediate action. *Making Dying Illegal* is indeed a political work: it formulates a utopian politics of eventing, and as such it is the indispensable complement to *Architectural Body*.

1. A. Badiou, *L'Etre et l'événement* (Paris: Seuil, 1988); *L'Ethique* (Paris: Hatier, 1993); *Logiques des mondes* (Paris: Seuil, 2006).
2. J. Holloway, *Change the World Without Taking Power* (London: Pluto Press, 2002).
3. R. Barthes, *Le Neutre* (Paris: Seuil/ IMEC, 2002).
4. T.W. Adorno, *Hegel: Three Studies* (Cambridge, Mass.: MIT Press, 1993).
5. G. Deleuze, *Logique du sens* (Paris: Minuit, 1969).
6. A. Trollope, *The Fixed Period* (Oxford: Oxford University Press, 1993 [1881]).

What if there were a statute...but there won't be a statute...
but there might be a statute which read:

Not making an all-out effort to go on living and the act of
dying are from this date on classed first-order felonies. Citizens
will need to strive to define the heartiness of their existences
and be responsible for astute and timely assessment of negative
turns of events and failed or failing conditions.

Choosing to live within a tactically posed surround/tutelary
abode will be counted as an all-out effort to go on living.

Reversible Destiny Statute

1

TO LIVE AS AN ARCHITECTURAL BODY

The claim: To live one's life as an architectural body is the best option available to a member of the human species at this historical juncture. Never mind for the moment what the key concept of this claim denotes; it will be defined on the next page.[1] What follows is a line of reasoning delineating the validity of this claim. Here, then, is the kick-off assertion: The primary responsibility of any organism is *to be as precise as can be* in regard to that which she has arrived as on terra firma (terra fairly firma). Straightforward enough. Nor will most people disagree with the second assertion in our line of reasoning: The average *organism that persons* (a person) possesses sufficient intelligence to gather that what, or if you like, who she has arrived here as exists as substantially *an unknown quantity.*

Next grant us that these first two assertions combined provide yet another voicing of the thus far interminably sad human condition: Proceeding to do what it is incumbent on any organism to do, an organism that persons arrives at having to perform the impossible task of being precise about an unknown quantity. The puzzle-creature to herself lives as a grand unknown. Well, to reorder her abysmal lot, a living and breathing unknown quantity will first off need to address the fact that she is an unknown quantity to herself and then reduce the degree to which she is one. To the extent that a person becomes less of an unknown quantity to herself, to that extent does the human condition become less pernicious.

Until now, before the existence of the concept our claim centers on, prior, that is, to the *architectural body*, there appeared to be no way to ameliorate to a significant degree the human condition, an utterly frustrating no-win situation, or to make one whit more achievable the impossible mandatory task required of this *languaged* species that exists as an unknown quantity to itself, the task of being precisely on top of one's game or situation despite remaining clueless as to what the point of one's game might be. For some, the unknown quantity in question, a person, begins and ends with the human body; but others have contended that to place so narrow a limit on such a grand unknown would be a major blunder. Convinced that a person should not be thought of as merely coextensive with her body or with herself as organism, we side with the latter position and have taken to referring to a person as an architectural body, defining the architectural body as

the organism that persons plus all that which is within her immediate vicinity.

Upon deciding to live as an architectural body, a person determines her immediate domain to be extending out to and inclusive of all that surrounds her. She knows herself to be intermeshed and conjoined with her architectural surround (all that surrounds her). Conceiving of one's self in such a way, as an architectural body, a person both expands and makes more definite the spatial extent of the unknown quantity she lives as.

We are now ready for the third and last assertion in our line of reasoning: A person (an organism that persons) who opts to live as an architectural body becomes, by virtue of having made this admittedly arbitrary decision and having then actually pursued life according to it, significantly less of an unknown quantity to herself. In conclusion, then, the long and short of it is that people should and will decide to live as architectural bodies because that is the only means available through which to make the quiddity as unknown quantity (composed, of course, of many unknown and semi-known qualities) of members of *homo sapiens sapiens* take a turn for the less unknown.

Why not mention in passing that, throughout history, it has been exactly because of the confusion and uncertainty as to how extensive an unknown quantity a person is that gods and God have managed (as us in disguise) to invade our species' territory.

But wait. Even as the second assertion furthers our line of reasoning exactly as it was meant to, it harbors within it an error that threatens to sabotage the argument from within. "Intelligence"—what is it that we have in mind when we write these words? What transpires here, there, and everywhere as its referent? If anything, a person (an organism that persons) is a possession of "intelligence" rather than the other way around. On many scales of action at once, many know-how's, know-that's, and know-of's combine to give those who are puzzle-creatures to themselves that ascertaining momentum they take to be their consummate intelligence. "Intelligence" apart from the all of everything? Certainly not. This being the case, the architectural body, as idea or as nascent organism-plus-environment, slips into place prior to a decision's having been made to embrace it as a concept and proceed to live as one. This being so, the argument can be seen to smack of circularity. That it does so, we hasten to declare, makes it more, not less, convincing.

But wait again. That which happens as "intelligence" does not happen unopposed. The organism that persons is so constituted as to need to precisely ignore some ascertaining. A minimizing action is always in effect. To more fully celebrate

her own abilities, a person minimizes those of others. The unpalatable must be made palatable at all costs, at great cost. Total obliteration, that looming eventuality, can and does get minimized to be a mere scratch, an occurrence of not much moment. Only those **x**'s that have not been summarily minimized arrive at being ascertained. That history truly worthy of being written about has not yet begun; it begins with those of you who read these pages and then decide to live as architectural bodies.

1. The *architectural body* made its first appearance in *To Not To Die* (*Reversible Destiny: We Have Decided Not To Die* [Guggenheim Catalog] New York: Abrams, 1997) and then was officially introduced to the world in *Architectural Body* (Arakawa and Madeline Gins [Tuscaloosa: University of Alabama Press, 2002]).

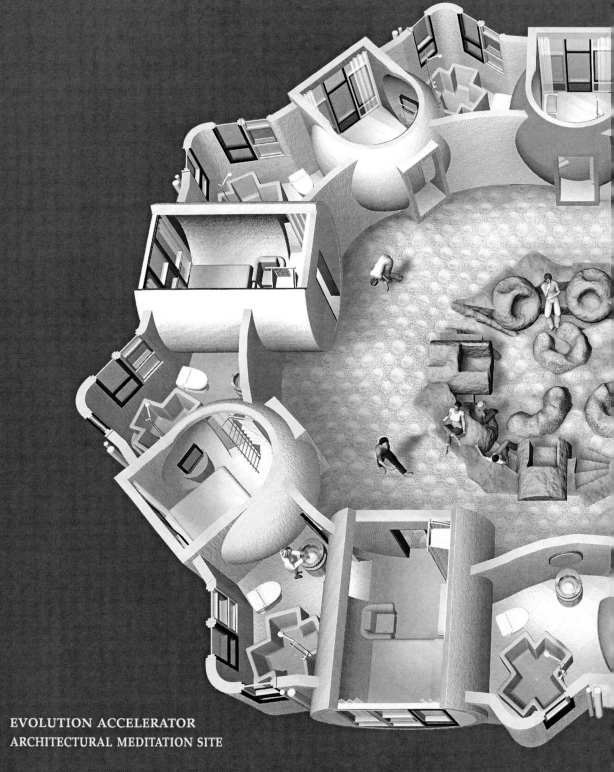

EVOLUTION ACCELERATOR
ARCHITECTURAL MEDITATION SITE

Choosing to live as an architectural body is thus far the only method
members of *homo sapiens sapiens* take a turn for the less unknown.

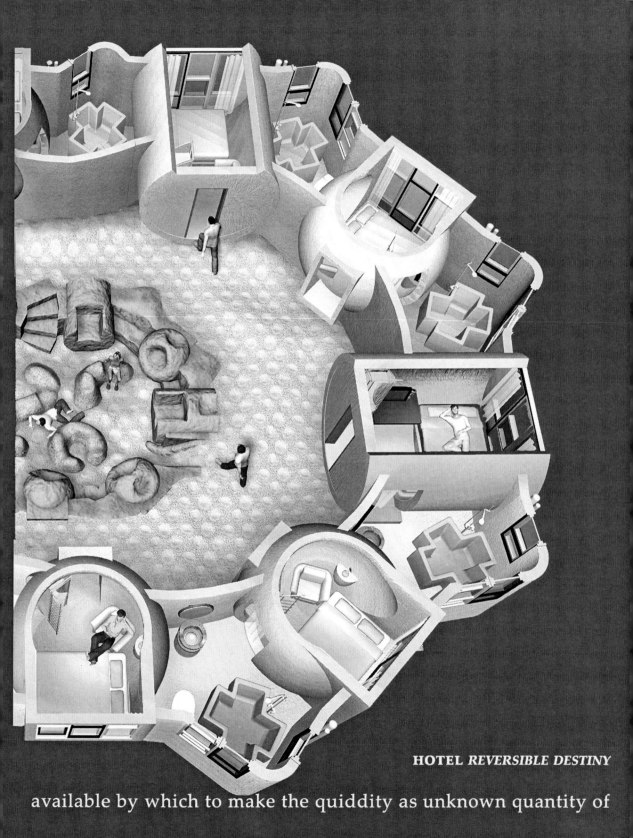

HOTEL REVERSIBLE DESTINY

available by which to make the quiddity as unknown quantity of

2

DECLARATION OF THE RIGHTS OF PERSONS AND THEIR ARCHITECTURAL BODIES (1789; 1968–2004)

Article Seventeen

Persons are far larger domains than is generally believed. They should be considered as extending to the limits of that which surrounds them; that is, they should be taken as nothing less than *architectural bodies*. Born free but narrowly and rigidly constrained by the organisms that they are, they must be provided with the means (*tactically posed surrounds/tutelary abodes*) to construct and invent themselves to be free and equal in rights. Distinctions among members of society may only be founded upon the communal studying of architectural bodies, which are the extended domains of persons (aka *organisms that person*).

Article Sixteen

The aim of all political association is the preservation of the natural and imprescriptible rights of a person and his or her architectural body. Liberty, property, security, and resistance to oppression no longer remain foremost among these rights; instead, when achieving of a reversible destiny hangs in the balance, what needs to be firmly guaranteed above all else is the right of a person to self-create and to blossom forth as an architectural body. Persons will have to be given the means (tactically posed surrounds/tutelary abodes) to freely conceive of themselves as, and find themselves to be, domains which include all that surrounds them (*architectural bodies*).

Article Fifteen

The principle of all sovereignty resides in nothing other than the species *homo sapiens sapiens,* which will forthwith throughout this document be referred to as the *greater organism*. The greater organism has the sovereign duty to take as its primary aim the achieving of reversible destinies for its members. No person or architectural body may exercise any authority that does not proceed directly from the desire to make reversible destiny a reality for the greater organism.

Article Fourteen

What has historically gone by the name of liberty will for the sake of clarity be referred to herein as liberty **A**, and the new liberty that comes from living as an architectural body, and which, as the makers of this document believe, underlies liberty **A**, will be referred to herein as liberty **B**. Liberty **A** consists in the freedom to do everything that injures no one else; hence the exercise of the "natural" (preservation) rights of each person has no limits except those that assure to the other members of the society the enjoyment of the same rights. These limits can only be determined by law. Liberty **B** consists in the freedom to augment one's own existence to determine contributory factors to liberty **A** so as to be less slavish when it comes to the exercising of this right.

Article Thirteen

Law can only prohibit those actions or events that are hurtful to the greater organism. What is hurtful to one citizen is hurtful to the greater organism. Insofar as the death of even one citizen is hurtful to the greater organism, the greater organism is duty-bound to issue a law that prohibits dying. Nothing may be prevented that is not forbidden by law, and no one may be forced to do anything that is not provided for by law.

Article Twelve

Law takes shape by virtue of sets of coordinating skills at loose within the greater organism. (In the 1789 document the first sentence of article 6 reads: "Law is the expression of the general will.") Every citizen has a right to participate in the formation of laws through her coordinating skills alone or in combination with and primarily through those of her representative. Law must be the same for all, whether it protects or punishes. All citizens, being equal in the eyes of the law, are equally eligible to all dignities and to all public positions and occupations, according to their abilities, and without distinction except that of their virtues and talents.

Article Eleven

No person shall be accused, arrested, or imprisoned except in the cases and according to the forms prescribed by law. Anyone soliciting, transmitting, executing, or causing to be executed any arbitrary order shall be punished. But any citizen summoned or arrested in virtue of the law shall submit without delay, as resistance constitutes an offense.

Article Ten

The law shall provide for radical reorganizations only as such are strictly and obviously necessary, and no one shall suffer radical reorganization unless it is legally inflicted in virtue of a reversible-destiny law passed and promulgated before the commission of the offending error.

Article Nine

As all persons are held to be pursuing a reversible-destiny course, they will be, to that extent, considered blameless or innocent until they shall have been found to have in some way harmed the reversible destiny of the greater organism. If arrest shall be deemed indispensable, all harshness not essential to the securing of the prisoner's person shall be severely repressed by law.

Article Eight

No one shall be disquieted on account of her opinions, including her religious views, autopoietic or self-organizing acts, provided their manifestation does not disturb the public order established by law.

Article Seven

To freely communicate ideas and opinions is one of the most precious rights. Every citizen may, accordingly, with freedom, speak, write, and print; and furthermore, invent and assemble architectural procedures for tactically posed surrounds/tutelary abodes; participate in the design of closely argued built-discourses both on this planet and, if possible, intergalactically. But every citizen shall be responsible for such abuses of this freedom as shall be defined by law.

Article Six

The security of the rights of persons and their architectural bodies requires the existence of a public immune system (public military force in the 1789 document), a welcome result of a well-functioning closely argued built-discourse. This system is established for the good of all and not for the personal advantage of those to whom the maintenance of the system shall be entrusted.

Article Five

A common contribution is essential for the maintenance of the public immune system and for the cost of its administration. This cost should be equitably distributed among all citizens in proportion to their means.

Article Four

All citizens have the right to decide, either personally or by their representatives, as to the necessity of the public contribution; to grant this contribution freely; to know to what uses it is put; and to fix the proportion, the mode of assessment and collection, and the duration of the contribution.

Article Three

Society has the right to require of every public agent, and indeed of every forming agent, an account of how extensive her coordinating skills are for the administration of her own life and for the lives of others.

Article Two

A society in which the observance of the law is not assured, nor the separation of powers defined, has no constitution at all.

Article One

Property **A** has been in past societies deemed an inviolable and sacred right that no one shall be deprived of except where public necessity, legally determined, shall clearly demand it, and then only on condition that the owner of Property **A** shall have been previously and equitably indemnified. But for the reversible-destiny purposes of the greater organism, it is only property **B**—namely, all that the architectural body subtends and lives as—can and should be deemed an inviolable and sacred right that no one shall be deprived of except where public necessity, legally determined, shall clearly demand it, and then only on condition that the owner shall have been previously and equitably indemnified.

What if there were a statute...but there won't be a statute... but there might be a statute which read:

> Not making an all-out effort to go on living and the act of dying are from this date on classed first-order felonies. Citizens will need to strive to define the heartiness of their existences and be responsible for astute and timely assessment of negative turns of events and failed or failing conditions.
>
> Choosing to live within a tactically posed surround/tutelary abode will be counted as an all-out effort to go on living.

Reversible Destiny Statute

3

LEGAL MEASURES

Federal Sentencing Guideline—
Table of Contents
United States Sentencing Commission
Guidelines Manual

Part A—Offenses Against the Person
1. Homicide
2. Assault
3. Criminal Sexual Abuse
4. Kidnapping, Abduction, or Unlawful Restraint
5. Air Piracy and Offenses against Mass Transportation
6. Threatening or Harassing Communications, Stalking, and Domestic Violence
7. Architectural Body Diminishment

Part B—Basic Economic Offenses
1. Theft, Embezzlement, Receipt of Stolen Property, Property Destruction, and Offenses Involving Fraud or Deceit
2. Burglary and Trespass
 3. Robbery, Extortion, and Blackmail
4. Commercial Bribery and Kickbacks
5. Counterfeiting and Infringement of Copyright or Trademark
6. Motor Vehicle Identification Numbers
7. Refusal to Spend All Your Money for Learning How Not to Die

Part C—Offenses Involving Public Officials and Violations of Federal Election Campaign Laws

Part D—Offenses Involving Drugs
1. Unlawful Manufacturing, Importing, Exporting, Trafficking, or Possession

2. Unlawful Possession
3. Regulatory Violations

Part E—Offenses Involving Criminal Enterprises and Racketeering
1. Racketeering
2. Extortionate Extension of Credit
3. Gambling
4. Trafficking in Contraband Cigarettes
5. Labor Racketeering

Part F—[Deleted]

Part G—Offenses Involving Commercial Sex Acts, Sexual Exploitation of Minors, and Obscenity
1. Promoting a Commercial Sex Act or Prohibited Sexual Act
2. Sexual Exploitation of a Minor
3. Obscenity

Part H—Offenses Involving Individuals
1. Civil Rights
2. Political Rights
3. Reversible-Destiny Rights
4. Privacy and Eavesdropping
5. Peonage, Involuntary Servitude, and Slave Trade

Part I—[Not Used]

Part J—Offenses Involving the Administration of Justice

Part K—Offenses Involving the Closely Argued Built-Discourse

Part L—Offenses Involving Public Safety
1. Explosives and Arson
2. Firearms
3. Mailing Injurious Articles

Part M—Offenses Involving Immigration, Naturalization, and Passports
1. Immigration
2. Naturalization and Passports
3. Identity as a Disease

Part N—Offenses Involving National Defense and Weapons of Mass Destruction
1. Treason
2. Sabotage
3. Espionage and Related Offenses
4. Evasion of Military Service
5. Prohibited Financial Transactions and Exports, and Providing Material Support to Designated Foreign Terrorist Organizations
6. Nuclear, Biological, and Chemical Weapons and Materials, and Other Weapons of Mass Destruction

Part O—Offenses Involving Food, Drugs, Agricultural Products, and Odometer Laws
1. Tampering with Consumer Products
2. Food, Drugs, and Agricultural Products
3. Odometer Laws and Regulations

Part P—[Not Used]

Part Q—Offenses Involving Prisons and Correctional Facilities

Part R—Offenses Involving the Environment
1. Environment
2. Conservation and Wildlife
3. Bioscleave

Part S—Antitrust Offenses

Part T—Money Laundering and Monetary Transaction Reporting

Part U—Offenses Involving Taxation
1. Income Taxes, Employment Taxes, Estate Taxes, Gift Taxes, and Excise Taxes (Other Than Alcohol, Tobacco, and Customs Taxes)

2. Alcohol and Tobacco Taxes
3. Customs Taxes
4. Tax Table

Part V—[Not Used]

Part W—[Not Used]

Part X—[Not Used]

Part Y—Other
1. Conspiracies, Attempts, Solicitations
2. Aiding and Abetting
3. Accessory after the Fact
4. Misprision of Felony
5. All Other Offenses

Part Z—[Not Used]

Sentencing for Those Not Making an All-Out Effort to Go On Living

This has not yet been determined.

Mitigating Circumstances

That the body is such an unknowable must be recognized as an overarching extenuating circumstance. Fathoming the architectural body in the super-helpful context of a tactically posed surround/tutelary abode can never be a sure thing. It is evidence of how to continue that is of most interest. Therefore those who produce such evidence will not be punishable by law. Thus whoever manages to maintain an architectural body will be in compliance.

4

MAKING DYING ILLEGAL:
A TRANSITIONAL MEASURE

Instituting a law making dying illegal in a society in which no workable, princi-pled approach to the combating of mortality exists would be unethical inasmuch as citizens would have no means of staying on the right side of that law. At that moment in which a carefully reasoned, pragmatic approach to undoing mortality takes shape, and consequently the supposed inevitability of death for (so-called) mortals at last can be rationally questioned and, for all times and places, put up for reconsideration, a 180-degree shift in ethical judgment ensues, and in a telling or weepingly marvelous about-face, it must then happen that the decision of a socie-ty not to pass an anti-death law will routinely get judged to be unethical.

This statute making it a crime to die will probably need only to be in effect for a relatively short period of time. It can and should be used merely as a transi-tional measure through which to get the general public to become aware of the possibility that lives can be conceived of and conducted apart from death. Having grasped this firm possibility that shows every likelihood of becoming accepted fact, citizens will on their own stay focused on the all-important task of defeating mortality without any need of a law to keep them at it. Prior to that, prior to the reversal of the planet-wide defeatism in this regard, people will be reminded by this statute that they deserve to go on living indefinitely and will be led to invent ways of doing so.

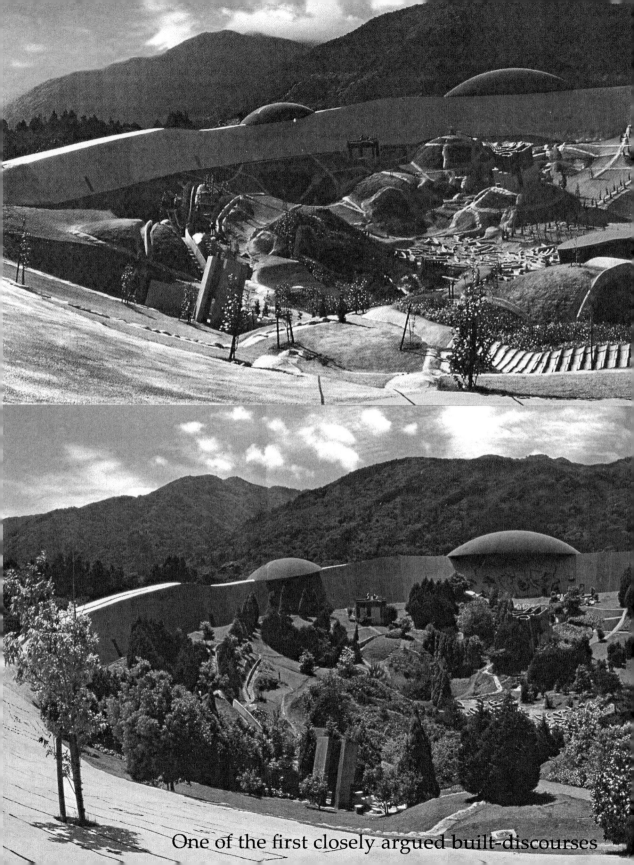

One of the first closely argued built-discourses

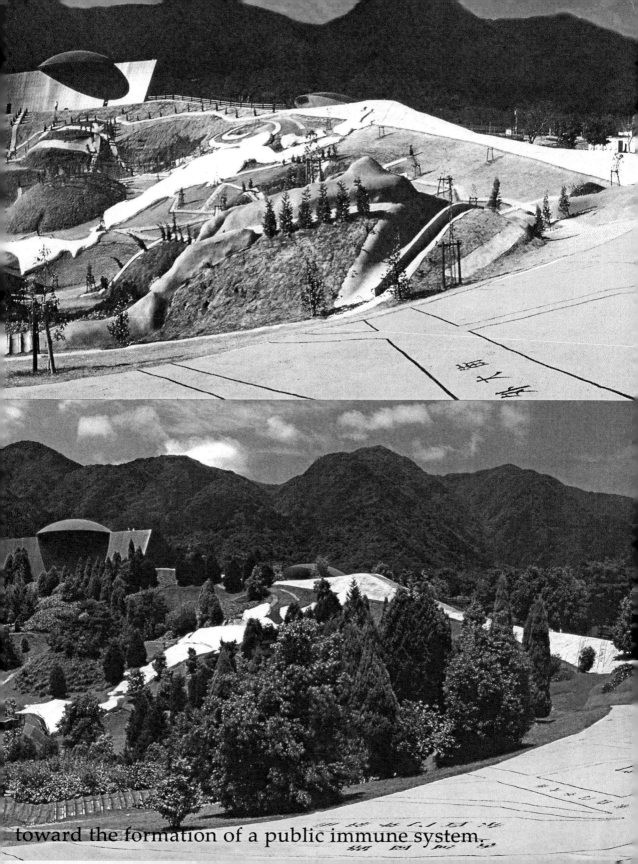

toward the formation of a public immune system.

5

WEAK UNIVERSE, THUS FAR
Is it possible to be
strong in a weak universe?

Christmas Day, 2002

Dear Arakawa and Gins,

What a reunion!

We would like you to

(a) shed more light on [*sic*]

(b) explicate

this string of words that came at each of us during the course of it:

"Don't shine the flashlight of your ego on me."

your servants in biophysics,

Carey Rudifolkine Jean Zinovieff

Dawning factors and swift considerations happen side by side – in conjunction with and dawning factors be coordinated landing sites between the body-proper and its

The architectural body assumes its shapes, its heft, its potency, depending on how

Landing sites can, then, in light of the dominant everything that is bioscleave, be found themselves to be viably pertaining along in or as bioscleave.

Do we have here an experiment throughout the duration of which subjects are required actions been taken by someone or something not pictured here that have caused of a into full-fledged existence at distinctly different removes from the table? What might

Once someone has been far enough removed from the table so as no longer to be contact, registerings of "table," simply are no more. By holding firm to their initial several removes from the table the same set of physical contact points/areas with the has his or her initial array of tactile-perceptual landing sites, minus table contact tactile-landing sites? If so, then they too will be nearly the same from one placement This will, of course, not be true for all other landing sites (visual- and aural-

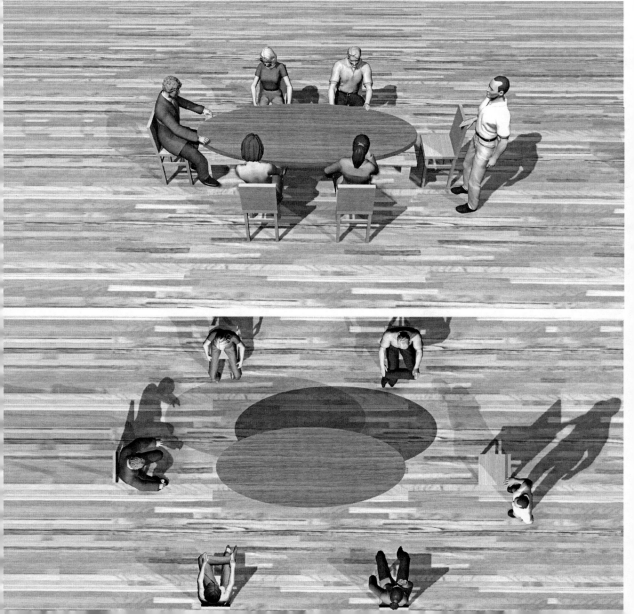

one another. Have swift considerations be coordinated landing sites of the body-proper
bioscleavic atmospheric surround.

landing sites are dispersed.

thought of as markers of where organisms that person have flowed through to or have

come what may to maintain exactly those positions they initially assume? Have not
sudden, and then of a sudden again, the same positionings of people and chairs to bloom
the expanding universe wish to exact of these *organisms that person?*

touching it, the tactile-perceptual landing sites that lived as those particular points of
positions, members of this assembled group manage to maintain across each of the
world, except for, of course, the ones just discussed, that is, at each juncture, each person
points/areas. Do kinesthetic-landing sites and proprioceptive ones follow the lead of
of the group to the next, staying constant across each of the several removes from the table.
perceptual landing sites as well as imaging landing sites and dimensionalizing ones).

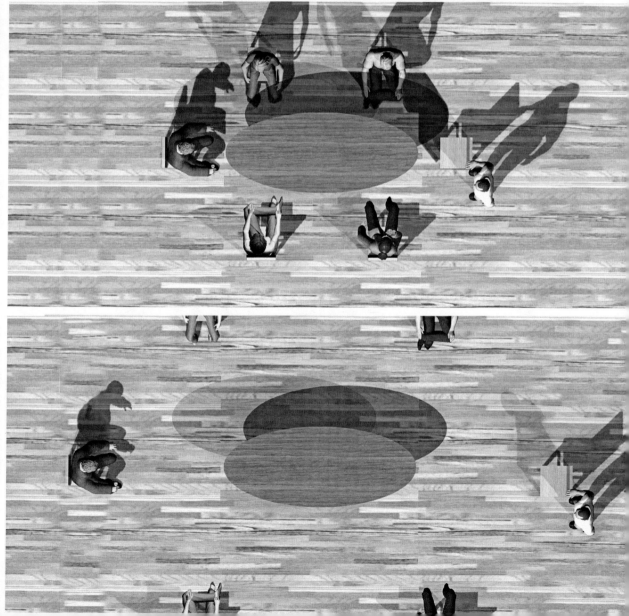

December 31, 2002

Dear Rudifolkine and Zinovieff,

Carey, you explained that it turned out to be impossible— totally out of the question is how you put it—for you, who passed the first six months of her life without any parent to nurture her, to hold onto biophysics for more than seven years. And Jean, we saw you crushed when your son Tom took his life, and, to this day, ten years later, you continue to swim in shock, as you are the first to declare. Many among the group of thirty-seven particle physicists attending a gathering at the Free University in Berlin in the spring of 1971 made sure to let us, the new-comers, know that they considered the two of you to be the top of the top. After our having befriended each other during an Atlantic crossing, and hanging out together for days on end, you had insisted that we come along to that meeting. You did not need to insist very strongly that we come along with you, we seem to remember, for particle physics was a topic of great interest to us in those days when we were winding up our work on the first edition of *The Mechanism of Meaning.*

Tragedy has forced you out of science into our weak but perhaps strong enough arms. Let us write that joint paper that we had all proposed to one another several decades ago and through it secure for our little group the Nobel Prize in physics!!

yours,

Arakawa Madeline

p.s. 1 It is truly crazy that even as biophysicists make every effort to account for elements and actions internal to the body in their equations, they routinely fail to factor in the organic body on the move, giving short shrift to bodily actions on the human scale. It is even clearer to us now than it was back then that a unified field theory that does not account for the body, bodily actions, and the history of individual bodies or organisms could never represent the universe, to say nothing of bioscleave.[1]

p.s. 2 We have always admired your flashlights.

50

January 5, 2003

Dear Arakawa and Gins,

Odd that you choose at this moment to emphasize *our* admitted weaknesses inasmuch as we have for some time considered the two of you to be weaklings for having so humbled yourselves, by having put yourselves in a lesser position from the start—the off-to-one-side position of the artist. Did it never occur to you that by deciding to declare yourselves artists you would be signing away your birthrights to be members of the main discourse? A good case in point is that no matter how taken with your work they may have been, our colleagues have, at every turn, opposed our efforts to have you participate in seminars devoted to astrobiology or to theoretical biophysics, and they have refused us permission to invite you to deliver independent keynote addresses at international conferences on biophysics. In our time, post-WWII, the way to make yourself a lightweight is to declare yourself an artist. In any event, you have now at last garnered the strength needed to fully exit the artist's ghetto!

In the first go around, it was your notion of blank that seemed to us in need of a set of equations. With hindsight, we realize that we had set our sights on the *mechanism f* as well, what you speak of as the mechanism of meaning. But by now you wily folks probably want a set of equations for the architectural body. We will need to formalize both *the architectural body hypothesis* and the *insufficiently procedural bioscleave hypothesis.*[2]

yours sincerely,

Rudifolkine and Zinovieff

January 6, 2003

Dear Arakawa and Gins,

We see the Syrian cultural critic Bassam Tibi's pithy statement, "Culture determines meaning," as trumping Wittgenstein's declaration that meaning depends on use. The meaning that something bears in one culture differs from that which it bears in another. That which is meaningful in one culture may be of little or no import in another. This rings particularly true if you think of each person as a culture unto herself. Each person may be seen as a culture unto herself, but there are universal means, sets of acted-on tendencies, through which persons become cultures. As we go forward in our work together, let us draw as much as possible on the research you have done in this area.

Your *The Mechanism of Meaning* began as a two-person culture, but we immediately saw it to be more than that, and you no doubt did too. It, this mechanism of meaning of yours, is for all intents and purposes *the mechanism f* that all physicists following your friend and ours, Werner Heisenberg, identify as that which *distorts* all their data. Heisenberg insisted that each of the fiery group of young physicists assembled around him spend a good deal of time with your book.

yours sincerely,

Rudifolkine and Zinovieff

January 12, 2003

Dear Rudifolkine, Dear Zinovieff,

We are in far closer agreement with you than we had originally thought.

You will see in this essay we send you today that we have already begun doing what you wish us to do. Yes, our research into the mechanism of meaning must be reigned in and brought to be once again central to our work.

Do you have—yes, surely you must—an appetite for biotopology?

What about using these seven thousand three hundred twenty-eight words as the basis for that collaboration that the four of us have waited nearly forty years to begin?

We urgently wish to know how this little text strikes the two of you.

<div style="text-align:center">

nearly holding our breath,
we remain yours always,

Arakawa Madeline

</div>

p.s. We know you had these biotopological reports in front of you before. We are hoping they come alive for you, as they have for us, within this new context—as an elementary biotopology begins to take shape. Of course you do realize it's in the nature of the biotopological report to be added onto. Please have a go at them.

BIOTOPOLOGICAL REPORT #1A 1998

On many interfusing scales of action at once by cleaving as this or that group of landing sites, on some levels of organization sporadically and on others continually, not only throughout her body but also atmospherically, an infant, a valiant segment of bioscleave that has surely already consistently interacted with other valiant segments of bioscleave, manages, working in conjunction with but also cautious in respect to her then–and–there architectural surround and all else that is bioscleave, to use swift considerations* and dawning (upon her) factors* to mold her budding capacity to construct volume into at-the-ready procedural knowing, thereby becoming able to find herself along specific pathways and system-wide, and extending to all neighboring domains, repeatedly surrounded by a distinctly shaped and continually and ubiquitously articulated volume, the atmospheric component of an architectural body—a(n) omniscape/ multiscape/ ubiquitous site, her domesticated bioscleavic atmospheric surround, a place (any) that is familiar enough.

* Dawning factors* swift considerations happen side by side—in conjunction with one another. Have swift considerations be coordinated landing sites of the body-proper and dawning factors coordinated landing sites between the body-proper and its bioscleavic atmospheric surround.

Once enough organized groups of landing sites (massenergy exchange-clusters) are in place on many extending-through-and-engaging-with-each-other scales of action, the landing-sited entity called *organism that persons*, an infant, cleaving throughout her body as well as out into that within which she is embedded, that which is her closest ally and the co-former of her world, which persistently gets both taken up copiously and fended off a bit, cleaving into her cleaving, sporadically on one level and continually on another, as this or that group of landing sites, underpins and constitutes and animates (by means of landing sites) her budding capacity to erupt as or construct volume, and then, as a consequence of the running of two initial (then ongoing for the life of the organism) sequences of coordinated landing sites that might usefully be referred to as swift considerations* and dawning (upon her) factors,* proceeds to mold it (the budding capacity to erupt as or construct volume) into dynamic place as at-the-ready procedural knowing, thereby cascading forth, along specific pathways and system-wide, within her freshly domesticated bioscleavic atmospheric surround, the salient possibility of having, for example, her gaining-in-palpability arm, hand, leg, foot careen or mosey into view, now by happenstance, now on purpose.

*Dawning factors + swift considerations happen side by side — in conjunction with one another. Have swift considerations be coordinated landing sites of the body-proper and dawning factors coordinated landing sites between the body-proper and its bioscleavic atmospheric surround.

AN INTRODUCTION TO ELEMENTARY BIOTOPOLOGY

Think of elementary biotopology as being as much a meadow of knowing as a field of study and a meadow as broad as the day and a knowing that has plenty of room within it for non-knowing. Greatly extending/expanding/exceeding the narrow focus of a field, this meadow of knowing and non-knowing that is inseparable from its practitioners and concrete enough or palpable enough to be as-if roamed, will widen and deepen both quantum physics and its six-decades-old daughter field, molecular biology. Within a meadow no scales of action receive special treatment; the large-scale and the small-scale and the simple and the complex are viewed as originating simultaneously. This subject matter, this meadow, wraps around the organism that persons or around the referent of any member of its ever-available suite of pronouns and nouns and would-be ones and counts as it or one or another of these referents or follows it or one or another of them around. The meadow of biotopology was rushed into existence to address the immediate existential needs of the organism that persons. How does what has life have it? What can life make of life? How can I succeed, when billions of others have failed, in keeping life here viable within/interspersed throughout/as these combined tissues of density where I have (found) it? If not any longer viable within/interspersed throughout/as these tissues of density, in what others, if any? The meadow spreads out everywhere so that one and all may come to have a reversible destiny. Within/across/through the meadow of biotopology, an organism that persons figures out a reversible destiny for herself.

A biotopologist produces ongoingly organized and redistributing gatherings of all that pertains to that organism that persons who happens to be the biotopologist herself, including the slightest of slight urges and what only faintly indicates itself as being operative as an organizing principle; she calls these ongoingly organized and redistributing gatherings of her making "diagrams." These multidimensional interactive diagrams do not stand apart from what they are meant in reduced form to portray. They track what goes on as an organism that persons, not only extending out from and surrounding this their target object, but also passing though it. Layers and layerings from near and far that both eventuate and function as an organism that persons get diagrammed in plain air.

Put together for procedural architects—whose purpose, it must not be forgotten, is to increase life-span—these biotopological diagrams are not only as inclusive as possible but also give each included item its due, presenting the situation under consideration justly in proportionate measure. Nothing—with the

exception, of course, of Reality—should be excluded (How very convincing Bohr is on this subject!) when it is definitiveness that is being sought. Procedural architects employ and depend on, now as schemata, now as directives, these comprehensive diagrams and the set of biotopological descriptions or reports from which they derive. They incorporate them into the architectural procedures they invent and assemble (schemata) and include them in the sets of directions for use that they make available for and deliver together with their finished works of procedural architecture (directives).

All would-be component factors or constitutive elements of human or transhuman thought and action deserve a place in a biotopologist's open-ended working diagram. Some factors/elements fail to get entered straight off into this diagram of everything having to do with an organism that persons in precisely that form in which they need to come to be known. A factor/element that has been provisionally traced back or reduced to another factor/element gets entered into the diagram in that different guise, thus for the time being, until further action is taken, falsifying the picture. Unfortunately, even in this art-science of the inclusive, factors/elements can get short shrift. Even within this new and wide-open approach to diagramming, in this diagramming that ought to be responsive to each moment, much resistance will need to be mounted against the substitution of the qualitative feel of one factor/element for another, the reduction of one factor/element to another. Because biotopological diagramming would show us, our species, nothing less than who we are, and an inaccurate positioning of a factor/element prevents the accomplishing of this, an effort must be made to keep what presents itself as being possibly a new factor/element from getting peremptorily reduced to already known ones.

Central to biotopology's diagrammatic method, approximative-rigorous abstractions are the means of putting in place and maintaining, within reports and interactive diagrams alike, appropriate levels of abstraction. An approximative-rigorous abstraction holds open and continually keeps posing the question of what is it that in its name has been and is still being abstracted. It is an abstraction that has a reference realm that stays loosely and widely defined even as it is presented in sharp focus. It is not unusual for people to be trigger-happy with the abstracting process, shooting abstractions randomly out into the world, abstracting the life out of matters under consideration, and these terms prevent that from happening. What is it that this or that abstraction delivers to the biotopologist, and to where is it that this or that abstraction delivers her? Approximative-rigorous abstractions help biotopologists keep track of where they are being led to and for what reason.

Figuring out the appropriate level of abstraction on which to embrace a this or a that/a nearly this or a nearly that involves finding out exactly how the abstracting process and its targets have come and are coming to intermix.

When choosing an approximative-rigorous abstraction for a diagram of her making, a biotopologist does commit herself, it must be admitted, to an ontology, but only to a tentative one; which is to say, inasmuch as biotopological diagrams are based on approximativeness, the weakest of all commitments, they tend to embrace and depict for the most part only change on the move.

Found in abundance within biotopology's lexicon, approximative-rigorous abstractions set the tone for all else. They can mark with a considerable amount of accuracy indeterminate things and events. The best way of giving serious consideration to what is indeterminate or not fully ascertainable would seem to be to take it up approximately while rigorously allowing it an exact enough place in the sun or in the chiaroscuro. *Cleaving* and *biocleave*, the pair of approximative-rigorous abstractions that underlie all biotopological description, rigorously and approximately hold open places, respectively, for the firm attaching of one segment of massenergy to another along with the equally firm separating of such segments from each other and the biosphere in the dynamic throes of omnipresent cleaving. Similarly, *landing site*, the approximative-rigorous abstraction by means of which biotopologists position segments of the world in relation to one another, holds the place for what gets sketched as an approximated something deemed and pointed out to be positioned exactly thus and so even as it exists on many different scales of action at once. What a landing site can be envisioned to be in 2006 reflects the current level of research; at a later date, once constituent factors/constitutive elements have been identified and what underlies the eventuation of a landing site becomes better known, this approximative-rigorous abstraction (landing site), having become more determinate, will present a very different mix of the approximative and the rigorous. For now, and probably for some time to come, the concentration should not be on what constitutes a landing site but rather on its being the case that, by definition, there can be this or that or thit or thas that gets taken up as a landing site.3

Landing sites give the exact positioning of a something or other whose nature thus far can only be approximated, albeit rigorously. And so, an approximative-rigorous abstraction puts listeners (primarily biotopologists) fittingly in touch with what they need urgently and continually to remember even while presenting a referent that remains unresolved, resiliently and sweepingly more or less indeterminate. Even *architectural body*, biotopology's founding term and central con-

cept, puts forward and then instigates an amassing into existence of a signified that begins and ends only as an approximation. The term *architectural body* floats, by definition, a concept of a something or other that resembles an entity but which occurs as sequences of actions and interactions and loci of activities and agencies. This approximative-rigorous abstraction denotes not an entity in and of itself but a three-hundred-sixty-degree-around extension of a human, or even possibly trans-human, entity, and it swirls or otherwise verbs here, there, and everywhere around this. Selecting what had shown promise of existing but had usually been left by the wayside, and defining for this in each instance of its use an exact if only approximate niche, the term highlights a wide swath of biocleave, and by doing so increases the likelihood that accurate pictures can be had of what goes on as daily life. A perfectly approximative something or other that cannot even be determined as present and accounted for apart from what its definition specifies for it: architectural body. Take it as the animate plus near-animate group of loci its definition demands for it and accept that out it extends into an architectural surround, enormously expanding the body-proper; do not trouble yourself as to where in relation to a surround it begins or ends or fret over what its full extent might be.

Within the declaring of a thing or an event to be a thit or a thas lies the pronouncement of its status as an example of "the neither and the both." Now that this locution exists, uses for it will rush to present themselves. Here is one for a start. To herself, the organism that persons is the neither and the both; that is, she is neither organism nor person only and both organism and person in one. The more rigorous and exacting a speaker is, the more likely it is that she will be able to refer to a would-be this or that as a thit or a thas. By doing so, said speaker exposes a bit of who knows what, a basic approximative-rigorous unit. Thit and thas are each capable of holding or being a point of view (a proto-point of view). Biotopologists will play them up big as place-markers in the scramble (of an organism that persons) for which of many possible points of view to choose as the one from which to speak up.

That view chosen as the one with which to venture forth may very well not be the best one with which to continue. What if, in addition to being thought of as an area of knowing that contains within it plenty of unknowing, biotopology were also thought of as an area of self-saving cognizing, one that scrambles for and between points of view? In any event, in the spirit of a renewed and renewing accuracy, biotopologists hold that it is better, when embarking on a project, always to err on the side of juggling too many points of view.

Whereas regular topology looks at similarities between boundary conditions, biotopology does away with the discrete object, and thus with boundary

conditions altogether. Although biotopology refuses to accept the traditional view that the epidermis constitutes a boundary with the world, it does recognize that there are crossover zones and differences between organizational levels of the event-fabric on one side of the epidermis (within the body proper) and on the other (the atmospheric component of the architectural body). In someone's taking of herself to be an architectural body, at many different speeds of action at once, all and anything that holds sway in her vicinity, at many different speeds of action at once, leads to and from and counts as her.4

Piecing together or gathering up an architectural body from the other way around, that is, from the "point of view" of a tactically posed surround/tutelary abode, the surrounding atmosphere responds to a person's every move at many different speeds of action at once and swoops her up as an integral part of itself at many different speeds of action at once. At many different speeds of action at once, one surrounding atmosphere after another embraces her as one of its own, and there is not a chance that she will ever be able to exist apart from such an embrace. In the heat and cool of actuality, the architectural body "biotopologizes" along. Each and every movement of the organism that persons or of any one of the referents of its ever-available suite of pronouns and nouns and would-be ones starts up an atmospheric trajectory. Some of these trajectories hang around long enough to be able to take up with others. A biotopological interactive diagram of initiatives and atmospheric trajectories collects in place. Ramifications of actions get studied. The gist of biotopological thinking: No less attention should be paid to the atmospheric component of the architectural body (a bioscleavic atmospheric surround) than to the body proper.

The last sentence of the previous paragraph, and to some extent that paragraph as a whole, makes use of an important tenet of the art-science of biotopology, the one that would have its practitioners, its artists-scientists, stay attentive to all that generally does not automatically get focused on, thus elaborately attending to what laypersons and, for that matter, those living only as artists or only as scientists always ignore. Being oblivious to any aspect of what is happening would be unthinkable for a biotopologist; should this happen, it would surely constitute a mistake of the first order and so too would failing to correct an oversight.

Biotopology is the art-science of emphasis, studying closely related but vitally different degrees of emphasis. It looks to how to shift the focus. Not only will, as noted earlier, the atmospheric component of the architectural body be given as much attention as will the body proper, so too will as many as possible of the various scales of action that directly or indirectly contribute to an organism

that persons' ability to form an architectural body and to function in all respects.

Those trained in the art-science of biotopology will be living compendiums of the many scales of action to which (it must be seen) they owe their existence. Those seeking to be truly exacting when trying to assess what is going on as bioscleave had better not forget its great "penchant" for indeterminacy. They would also do well to remember that who or what seeks information about underlying processes and procedures has a decided influence on what that information winds up being (How very convincing Heisenberg is on this subject!). Biotopologists do not desire to succeed in getting a determinative numerical fix on substances, entities, or events. Not intent on first and foremost dividing and measuring the world of things, biotopologists, who live, it must not be forgotten, as architectural bodies in full bloom, become exquisitely sensitive and utterly attentive to the inescapable, but mostly underplayed, fact of the simultaneity of multiple scales of action. They go to great lengths not to underestimate the number of scales of action undergirding the viability of what is alive. A biotopological rule of thumb: once you have assembled a full complement of scales of action, just for good measure, routinely tack on a few more.

The use in biotopological diagrams and reports of distinct descriptive realms is an important means for keeping vivid the multiple scales of action that are in operation as the world. For example, each member of the team *event fabric/landing-site configuration* presents a descriptive realm that expresses predominantly one particular scale of action, and when one member of the team gets attended to and pronounced it comes to the fore, switching out, but not for long, its teammate's descriptive realm and characteristic scale of action. In contrast with one another and in combination, the two realms aerate and explode both description and explanation, testing their limits. That portion of the universal event-fabric within which an organism that persons is embedded and within which it conducts its life has everything to do with, and suitably functions as an alternate description of, the landing-site configuration of the moment (of an organism that persons). Biotopologists name a team of terms, such as the above twosome, that they see fit to group together, *terminological junction*. Terms that hover in the same semantic vicinity would start up a terminological junction. A moment comes when a terminological junction declares itself. It is important to let a would-be or nascent terminological junction germinate in its own good time; member terms need a period of time during which to find their way to it and then a trial period within which to prove themselves keepers. A pressing need may arise for a twosome to become a threesome, and, at some later date, the explicatory potential of

the junction gets a splendid boost if a fourth term gravitates meaningfully to the junction. It is sometimes advantageous when pointing out a mystery wrapped in an enigma to point with two, three, or four fingers/terms. The terms of a terminological junction have either synonymous import for one another (See the discussion of organizing principle/allowing tendency/axis of possibility on pages 64-65) or, as in the example now being considered (event-fabric/landing-site configuration), provide good contrastive support for one another.[5]

For biotopologists engaged in composing interactive diagrams, it is of great consequence that both members of the *event-fabric/landing-site configuration* terminological junction refer ultimately to zones of bioscleave and that they can be contrasted one to the other to good effect, and yet, be, with but a single step down in level of abstraction, reduced to—but, note well, at the same time expanded to —the same approximative-rigorous abstraction, which is to say, each can be deemed to consist of cleaving.[6]

Having determined any segment that is in operation due to massenergy, that is, any segment of the event-fabric, to be taking place on many scales of action at once, and also cognizant of the fact that no scale of action exists in isolation, biotopolgists arrive then at considering any single segment, such as, for example, an organism that persons, to be, in fact, a group (of scales of action). Segments (groups of scales of action) that operate in relation to one another articulate fields (groups of scales of action) or landing-site configurations (groups of scales of action) or event-fabrics (groups of scales of action) as well as worlds (groups of scales of action). Even when to all appearances a segment in operation due to massenergy has been removed from an area of the event-fabric (torn off from a larger segment or from a field; deleted from a landing-site configuration; subtracted from a world), and thus seems to have disappeared, it may nonetheless be judged to be still going on, but perhaps not as fully as before, in relation to all else that massenergy happens as, and should therefore be recognized to have, at least to some extent, successfully switched groups (of scales of actions).

An organism that persons, her architectural body, and the bioscleavic atmospheric surround of the moment (the architectural body's atmospheric component) are all in some way organized. Even their chaotic segments have characteristic patterns. Each is of bioscleave, and, by definition, everything within and of bioscleave is cleaving. That an event-fabric can and does cleave should be taken as evidence enough of its being organized; the same can be said for each of the following: bioscleave; bioscleavic atmospheric surround; organism that persons; landing site; architectural body. According to definition, but also as far as

researchers in the early years of the twenty-first century have been able to determine, only the cleaving of organisms is organized to a full enough extent to surface as perception (landing sites/landing-site configurations). A dynamic composite of organizing principles, an organism that persons is an organization that can recognize or express to itself (by means of coordinated landing sites) how it (as organized entity or massenergy cluster) is positioned; its bioscleavic atmospheric surround would seem not to have this capacity. By coordinating landing sites, the organism that persons articulates, or gives various articulations to, that which surrounds her. (What does it mean to coordinate landing sites? It does happen.) Many coordinated landing sites and many further pairings of these coordinations grow a path to the bioscleavic atmospheric surround that soon enough, and then for the life of the organism, holds sway as a(n) omniscape/multiscape/ubiquitous site— the bioscleavic atmospheric surround, the atmospheric component of the architectural body.[7]

All distance, any forming of a volume, has its origin in this holding sway. The articulating that is born of coordinated landing sites is very often only loosely, if that, worked out; but it is nonetheless ongoing, with many such loosely worked out articulations combining or coming into rapport with one another to secure for the architectural body its wide-ranging volume.[8]

The full picture of what can be formed from massenergy must include the treasure trove of organizing principles that make both an architectural body and its primary instigator, an organism that persons, able to sense and gain intelligence of one x or many and to judge approximate value of this or that or thit or thas bit of experience. Biotopologists want to gain a new and different type of access to organizing principles that sculpt abilities into place. So as to be able to gain familiarity in wholly other and untried ways with organizing principles constitutive of abilities evidently, but thus far still mysteriously, in play in daily life, biotopologists need to keep groups of scales of action in appropriate relation to one another. Because organizing principles are in the end, like all else that manifests as the world, working segments or subsegments of bioscleave, they too need to be thought of as, by definition, composed of many scales of action.

Biotopologists look at how bringing one type of organization near another causes changes in both. Observing within their interactive diagrams qualitative differences that lead to change, they move to engage with them perspicuously, long and hard, and long and soft, and seek, whenever possible, to experience them in slow motion. Depending on how an organism that persons, a landing-sited entity that never ceases dispersing landing sites far and wide, gets further organized,

the bioscleavic atmospheric surround becomes reorganized; in intricate response to this reorganization, a new and different landing-site configuration fans out. It is important to note that how the organism that persons can become organized depends on how she has, by means of landing sites, configured the bioscleavic atmospheric surround.

Initially every organism that persons has the potential to supply whatever is needed for an (her) architectural body, but even so, the capacity to produce the atmospheric component of this extended body needs to be earned; that is to say, the elements that fit out the structural dynamics that initiate and equal such a capacity need to be coordinated into place. A group of organizing principles or allowing tendencies or axes of possibility organizes or allows for or makes it possible for an infant to reconfigure herself enough to be able to keep landing sites suitably apart from one another and, by so doing, and by so coordinating, to open up an encompassing volume for herself.[9]

Each organism that persons has, for example, an organizing principle/an allowing tendency/an axis of possibility that translates into and "micro-engineers" the complex capacity that enables a person not only to identify and locate areas or objects but also to cease attending to them soon thereafter so that attention may then be transferred to other areas or objects; to put the foregoing another way, there is that which organizes, allows for, makes possible again and again the localization then the transference upon one designated area after another of feeling or sensing and that gets some sense of what was previously experienced brought forward to what is currently under consideration. Similarly, an organizing principle/an allowing tendency/an axis of possibility (one alone or several together) organizes/allows for/makes it possible for an organism that persons to be able to determine that a situation is ambiguous—the capacity to note an ambiguity; to put the foregoing another way, there is that which sets up and leads to an organism that persons' finding herself at loose within a presentation of ambiguous zones. To this day, researchers remain unclear as to what to include in the full set of organizing principles or allowing tendencies or axes of possibility of an organism that persons.

Biotopology has the task of determining each and every organizing principle/allowing tendency/axis of possibility of the organism that persons. It studies the respects in which an organizing principle and an allowing tendency and an axis of possibility resemble one another, investigating the ways in which the three terms of this terminological junction are synonymous. Each participating term in this terminological junction enters into it at its own particular level of abstraction; and the

terminological junction thus formed, cumbersome and repetitious though it be, would seem to be able to keep these different levels of abstraction both in close relation to and at suitable distances from one another. Each participating term, each with its own way about it, specifies further into what needs further specification.

How does an organizing principle constrain – through how many steps?— that which it manages to get going and that which absent it could not exist? If the term *organizing principle* always fails to deliver up that which it refers to for open review, why not couch what it as a term would bring forward in still other terms, in broader and possibly more accommodating ones. That specifically guided permission to occur which the term *organizing principle* nearly adequately evokes also gets called forth, but perhaps a bit more spatially or airily, by the term *allowing tendency*, and the referent that each of these two foregoing terms proffers stretches timespatially out as an *axis of possibility*. Operating in different semantic domains, the three terms close in on their referent(s) exceedingly differently. They ought to be able to help one another get on with what they have to do. Each makes each of the other terms a bit more exact in its use and thereby acts, too, on behalf of its own rigorousness, all the while managing to keep the yearned-for and headed-for referent(s) suitably tentative and approximate. Participating terms that do not overstate what they have been employed to highlight will be counted rigorous enough. Together a group of terms that are rigorous enough bring an area of concern into approximative view. Approximative view? Yes. An approximative view blossoms forth when there can be found within some cross-hairs of intention a very delineated and here and there specifically patterned this or that or thit or thas. Here, too, then, within terminological junctions, approximative-rigorous abstraction precisely softens the sharp focus.

Are not the organizing principles/allowing tendencies/axes of possibility that an organism that persons comes equipped with for constituting herself as a person constitutive as well of an (her) architectural body? Our answer to this is yes.

Causative factors should be seen as being thick with indirectness or within the operative clutches of scattered and often not findable actions; it is not that y does not necessarily get formed out of x, but rather that a through z contribute in 10^{nth} ways to x and y having something to do with each other. A widely angled and angling possibility of sensing or knowing replaces the narrowly limited linear cause-and-effect approach. The indirect is privileged over the direct; and, in a feat of around-the-corner recognition, the indirect, that which fully and immediately but indirectly subtends an organism that persons and is instrumental in commandeering its actions, offhandedly but surely takes responsibility even for the spo-

65

radic, volcano-like, generative core of the event-fabric.

Biotopology provides a member of the human species with an entirely new way to live. What have for centuries stood out as human qualities still do, even as how they come to occur gets diagrammed. An organism that persons enters the diagram of the generating of herself. The human all too human gets reworked by biotopology. A biotopologist attempts to live fully as an entity that is on the whole an unknown quantity. She stays suitably attuned to what feeds into the unknown quantity that is herself, observing how tributaries/trajectories/massenergy conduits of knowing (know-how or know-that) and non-knowing specifically disperse within this her own (well, hardly her own) giant mystery, her architectural body. This unknown quantity continually grows as a result of being constantly thus fed into. Living as a biotopologist means growing as an unknown quantity. "I live here" should be immediately translated into "I grow here." It would likewise be better to speak of someone's growing as an organism that persons rather than of her living as one. Tributaries/trajectories/massenergy conduits of knowing and non-knowing come to land and thus come to light.

Who or what moves there where an organism that persons dedicated to growing interacts with other segments of bioscleave? Know this unknown quantity to be, for herself at least, composed entirely of landing sites largely of her own making. To a far differently organized segment of bioscleave, to an observer/knower not obliged to take up everything as a landing site on one scale or another, she could have a concrete, palpable existence as a moveable, appendaged something or other, but for herself, no matter how concrete and palpable she might judge her body to be, all that she happens as spills out and overflows as tributaries/trajectories/massenergy conduits of knowing and non-knowing that land there where attention alights; that is, for herself, an organism that persons will always be only organized and redistributing gatherings of landing sites. Have these organized and redistributing gatherings of landing sites that surface as this unknown quantity form or be an as-if web, an as-if woven web, as as-if woven breathing web of landing sites. The density of this as-if woven breathing web of landing sites changes in a flash, depending on what the organism that persons from whom it emanates is up to; and that her as-if woven breathing web of landing sites can have countlessly many different tissues of density has much to do with why an organism that persons finds herself to be so inscrutable. In any event, it is of paramount importance that an organism that persons has the ability to vary the density of her as-if woven breathing web of landing sites.

Those densities of the as-if woven breathing web of landing sites that sup-

port the human world, that make its conventions possible and believable, are not at all the same as those a biotopologist "weaves" to diagram situations and occurrences, and biotopoligists early on become adept at a type of *double-think/-thinking* (surely also triple-, quadruple-, and so on). Although this junction of terms, *double-think/-thinking,* may serve to set the reader on the path of becoming cognizant of the resolutely split attention of a biotopologist, a better junction of terms for what happens to/for a biotopologist at work on a multidimensional interactive diagram would be *double-occur/-occurring.* A biotopologist can, within the confines of a tactically posed surround/tutelary abode, live simultaneously in the mundane yet remarkable world that gives every indication of continually occurring and in that diagram of the world that can be made to occur as an as-if woven breathing web of landing sites; that is, within tactically posed surrounds/tutelary abodes, tributaries/trajectories/massenergy conduits that eventuate in/as landing sites not only continue switching, which, by definition, they routinely do, into ordinary gleanings of facets of (a) world that taken together produce a/the world, but they can also simultaneously be given a diagrammatic salience of their own. A biotopologist who succeeds in simultaneously producing two decidedly different tissues of density/as-if woven breathing webs of landing sites can use one to penetrate the other, thereby keeping certain landing sites at bay or in abeyance; this done, an in-between weave opens up that lessens or softens the fall/falling/rising/ricocheting of landing sites, making said biotopologist able to move between them (landing sites) even more successfully than do those people who claim to be able to evade many raindrops.

In brief, the new field of biotopology arrives on the scene with terms that show promise of being able to jockey or slip into place, in diagrams and reports, levels of abstraction necessary to its stated purpose. Biotopology's initial lexicon: allowing tendency; architectural surround; architectural body; as-if woven breathing web of landing sites; axis of possibility; bioscleave; bioscleavic atmospheric surround; cleaving; coordinated cleaving; coordinating skill; dawning factors; event-fabric; farfarground; farground; farmiddleground; farnearground; farnearmiddleground; interactively diagrammatic situation; landing site; landing-site configuration; meadow; middlefarground; middleground; middlemiddleground; middlenearfarground; middlenearground; middlenearmiddleground; multidimensional interactive diagram/diagramming; multiscape; nearfarground; nearfarmiddleground; nearground; nearmiddlefarground, nearmiddleground; nearnearground; omniscape; organizing principle(s); reversible destiny; scale(s) of action; self-diagram; swift consideration(s); tactically posed surround; tissues of density;

thas; thit; tutelary abode; ubiquitous site.[16] Biotopology's task will be to study and account for the dispersal of all of bioscleave that leads to and results from movements and actions of an organism that persons and her architectural body. Within its province will be the tracking of how architectural bodies of an organism that persons supersede one another. Interactively diagrammatic situations take shape in relation to tactically posed surrounds/tutelary abodes; organisms that person self-diagram by means of these purposeful surrounds. Within tactically posed surrounds/tutelary abodes, persons can learn to keep track of a sufficient and therefore optimal number of scales of action,[11] and of the many interactions amongst them; within them as well, they will come to know how to assess levels of organization of massenergy or of cleaving and to contrast to good effect event-fabrics and landing-site configurations.

Biotopologists want to learn how that which cleaves ubiquitously gets articulated as landing sites and to determine the degree to which the size and shape of her architectural body affects the feeling and thinking of an organism that persons. By means of their interactive diagrams, they will point out how cleaving begins to have sentience and how an organism that persons comes to have the capacities she does. They will seek to know which landing-site configurations are most conducive to the continuing on indefinitely of an organism that persons and her architectural body.

AN INTRODUCTION TO ELEMENTARY BIOTOPOLOGY

Think of elementary biotopology as being as much a meadow of knowing as a field of study and a meadow as broad as the day and a knowing that has plenty of room within it for non-knowing. Greatly extending/expanding/exceeding the narrow focus of a field, this meadow of knowing and non-knowing that is inseparable from its practitioners and concrete enough or palpable enough to be as-if roamed will widen and deepen both quantum physics and its six-decades-old daughter field, molecular biology. Within a meadow no scales of action receive special treatment; the large-scale and the small-scale and the simple and the complex are viewed as originating simultaneously. This subject matter, this meadow, wraps around the organism that persons or around the referent of any member of its ever-available suite of pronouns and nouns and would-be ones and counts as it or one or another of these referents or follows it or one or another of them around. A biotopologist produces ongoingly organized and redistributing gatherings of all

that pertains to that organism that persons who happens to be the biotopologist herself, including the slightest of slight urges and what only faintly indicates itself as being operative as an organizing principle; she calls these ongoingly organized and redistributing gatherings of her making "diagrams." These multidimensional interactive diagrams do not stand apart from what they are meant in reduced form to portray. They track what goes on as an organism that persons, not only extending out from and surrounding this their target object, but also passing though it. Layers and layerings from near and far that both eventuate and function as an organism that persons get diagrammed in plain air.

Central to biotopology's diagrammatic method, approximative-rigorous abstractions are the means of putting in place and maintaining, within reports and interactive diagrams alike, appropriate levels of abstraction. An approximative-rigorous abstraction holds open and continually keeps posing the question of what is it that in its name has been and is still being abstracted. It is an abstraction that has a reference realm that stays loosely and widely defined even as it is presented in sharp focus. It is not unusual for people to be trigger-happy with the abstracting process, shooting abstractions randomly out into the world, abstracting the life out of matters under consideration, and these terms prevent that from happening. What is it that this or that abstraction delivers to the biotopologist, and to where is it that this or that abstraction delivers her? Approximative-rigorous abstractions help biotopologists keep track of where they are being led to and for what reason. Figuring out the appropriate level of abstraction on which to embrace a this or a that/a nearly this or a nearly that involves finding out exactly how the abstracting process and what gets submitted to it have come and are coming to intermix. When choosing an approximative-rigorous abstraction for a diagram of her making, a biotopologist does commit herself, it must be admitted, to an ontology, but only to a very tentative one; which is to say, inasmuch as biotopological diagrams are based on approximativeness, the weakest of all commitments, they tend to embrace and depict for the most part only change on the move.

All would-be component factors or constitutive elements of human or transhuman thought and action deserve a place in a biotopologist's open-ended working diagram. Some factors/elements fail to get entered straight off into this diagram of everything having to do with an organism that persons in precisely that form in which they need to come to be known. A factor/element that has been provisionally traced back or reduced to another factor/element gets entered into the diagram in that different guise, thus for the time being, until further action is taken, falsifying the picture. Unfortunately, even in this art-science of the inclusive, fac-

tors/elements can get short shrift. Even within this new and wide-open approach to diagramming, in this diagramming that ought to be responsive to each moment, much resistance will need to be mounted against the substitution of the qualitative feel of one factor/element for another, the reduction of one factor/element to another. Because biotopological diagramming would show us, our species, nothing less than who we are, and an inaccurate positioning of a factor/element prevents the accomplishing of this, an effort must be made to keep what presents itself as being possibly a new factor/element from getting peremptorily reduced to already-known ones.

Procedural architects employ and depend on, now as schemata, now as directives, these comprehensive diagrams and the set of biotopological descriptions or reports from which they derive. They incorporate them into the architectural procedures they invent and assemble (schemata) and include them in the sets of directions for use that they make available for and deliver together with their finished works of procedural architecture (directives).

Every biotopologist always stands ready to be corrected, often in a major way. Biotopologists crave criticism and never submit a biotopological report without the fond hope that it will open up a lengthy discussion stream. They are always desirous of collaborating with one another.

"Last night I ate in a restaurant that I often frequent. I ordered the fish of the day, which, to my delight, appeared in front of me within fifteen minutes. I was famished and wanted the food into me as quickly as possible. I dove in and didn't stop to think until I was halfway through. The fish didn't taste quite right. I should have stopped eating it as soon as I noticed this. Instead I ploughed along non-stop. I was about to wipe my plate clean, when suddenly I began shivering in fear. The poisonous fish I had just eaten was going to kill me. This hit me incredibly hard. I felt throughout my entire body that I was going to die then and there. I, of course, quickly recognized that this was an experience that needed further looking into and that merited a biotopological report."

"Yes, you had a very landing-site-sensitive experience. You would not have been rapidly engulfed by fear had you not been suffused with fear-signaling landing sites to the exclusion of all the rest. Your experience merits a biotopological report because the landing sites that constituted it stood out so starkly."

"It struck me that I had been unbelievably stupid and that it was too late to correct my error. I began my report by making a landing site of each of the thoughts and intimations that arose in me across the chaotic-enough period during

which this experience, which could equally well be spoken of as these experiences, beamed out as an occurrence. If it pops into my mind, it is a landing site:

'I must eat something' (landing site)
'Eating this could be dangerous' (landing site)
'What I am doing could be dangerous to my health' (landing site)
'*I have done* something *extremely dangerous* to my health' (landing site)
'I have completely ignored my own perception' (landing site)
'How could I have completely ignored my own perception?' (landing site)
'I have overridden my own judgment' (landing site)
'I have been stupid' (landing site)
'Life will not let me get away with this' (landing site)"

"These mid-level, shall we say, landing sites, composed, by definition, of many other landing sites, take hold one after the other as part of the as-if woven breathing web of landing sites whose density solidifies or grows rarer depending on how, as has been pointed out before, *a* through *z* contribute in 10^{nth} ways to *x* and *y* having something to do with one another. As you well know, the causative factors of the as-if woven breathing web of landing sites should be seen as being thick with indirectness or within the operative clutches of scattered and often not findable actions."

"Highly charged emotional statements/affirmations crowd many closely related similar landing sites in place all at once."

"I guess the density of my as-if woven breathing web of landing sites was changing like crazy. Things were coming at me from every direction, and nobody was there but my hunger, or rather, my ravenous satiating of it."

"But you as an organism that persons who failed at that moment to form a person were, even so, fully there, that is, your/its trillions of would-be landing sites and your/its hundreds of thousands of landing sites were growing ongoingly all—each by each—on their own terms."
"One density of my/its as-if woven breathing web of landing sites grabbed another and caught it up short. Every landing site that was salient spoke of fear. Not having any other landing sites available to use but those, I naturally felt myself choked by fear."

"Choked by a gripping fear. Who is to say how many landing sites there are within, for example, a medium-sized landing site? In any event, enough to make a suffocating tissue of density. Experimental psychologists have shown there to be approximately ten or fifteen focal areas of attention in any given instant. As biotopologists, we multiply this by a factor of a thousand. Even so, we are dealing with a limited number of focal areas of attention or landing sites. Throughout the duration of this particular experience, your landing sites divided up in a remarkably clear-cut way. An instinctual drive vied for attention with a call for caution and a mounting fear. Nearly all other landing sites faded into the background. Each person positions herself in the world at any given moment by means of only a limited number of landing sites. Your experience makes this evident, showing us, as it does, how a person can be consumed with fear by means of only a handful of landing sites."

THE ART–SCIENCE OF BIOTOPOLOGY IN REVIEW

- Think of a meadow of biotopology as so greatly an expanded field of study that it permeates its practitioners and keeps bioscleave vivid within their living spaces.

- The meadow of biotopology was rushed into existence to address the immediate existential needs of the organism that persons.

- A biotopologist produces and lives within a multidimensional interactive diagram which she forms in relation to a work of procedural architecture.

- Approximative-rigorous abstractions figure prominently into biotopological diagrams to keep what is pertinent or of interest ongoingly pertinent or consumingly of interest.

- *Cleaving* and *bioscleave,* the pair of approximative-rigorous abstractions that underlie all biotopological description, rigorously and approximately hold open places, respectively, for the firm attaching of one segment of massenergy to another along with the equally firm separating of such segments from each other and the biosphere in the dynamic throes of omnipresent cleaving.

- *Landing site*, the approximative-rigorous abstraction by means of which biotopologists position segments of the world in relation to one another, holds the place for what gets sketched as an approximated something deemed and pointed out to be positioned exactly thus and so even as it exists on many different scales of action at once.

- Any segment in operation due to massenergy takes place on many different scales of action at once.

- Although a focused-upon scale of action gives every appearance of existing in isolation, that is far from the case. It might be noted that, in any event, and for a start, an initial discrepancy in scale exists between the level or scale of action that is being focused-upon and the one in which the focusing upon is occurring.

- Landing sites abound within landing sites.

- According to definition, but also as far as researchers in the early years of the twenty-first century have been able to determine, only the cleaving of organisms is organized to a full enough extent to surface as perception (landing sites/landing-site configurations).

- To be an organism that persons is to be able to coordinate landing sites.

- Were it not for the existence of coordinated landing sites (i.e., were an organism that persons not able to coordinate landing sites), architectural bodies could not come about.

- In addition to being thought of as an area of knowing that contains within it plenty of unknowing, biotopology can be thought of as an area of self-saving cognizing, one that scrambles for and between points of view.

- Biotopologists prefer to err on the side of having too many points of view.

- Thit and thas are each capable of holding or being a point of view (a proto-point of view).

- Biotopology does away with the discrete object, and thus with boundary conditions altogether.

- Biotopologists name a team of terms that they see fit to group together: *terminological junction*. The terms of a terminological junction have either synonymous import for one another or provide good contrastive support for one another. A terminological junction will loosen concepts or unwind them even as it acts as a means of pursuing them to the bottom of their implications.

- Biotopology has the task of determining each and every organizing principle/allowing tendency/axis of possibility of the organism that persons.

- Biotopologists want to gain a new and different type of access to organizing principles that sculpt abilities into place.

- Because organizing principles are in the end, like all else that manifests as the world, working segments or sub-segments of biocleave, they too need to be thought of as, by definition, composed of many scales of action.

- Biotopologists can only build their multidimensional interactive diagrams in relation to tactically posed surrounds/tutelary abodes; organisms that person self-diagram by means of these purposeful surrounds.

- Within tactically posed surrounds/tutelary abodes, persons can learn to keep track of a sufficient and therefore optimal number of scales of action, and of the many interactions amongst them.

- An organism that persons is to herself an as-if woven breathing web of landing sites.

- The as-if woven breathing web of landing sites produces every tissue of density found in the world.

January 18, 2003

Dear Madeline, Dear Arakawa,

It has crossed our minds more than once to submit a review of your *An Introduction to Elementary Biotopology* to *Nature*, whose editors monthly pester us for submissions. We actually started working on one and are sending you today what we did in this regard, such as it is. As soon as we realized that it would be tremendously important for us to join you in your endeavor to introduce biotopology into the world, we quit working on this review/overview.

An Introduction to Elementary Biotopology—In Review
[First Draft]

Central to the new field that Arakawa + Gins introduce is a sorting out of prevailing conditions. Fortunately, what even the most casual observer registers as existing provides sufficient evidence of possibly crucial guiding factors or ways of sorting out prevailing conditions.

For coming into existence or coming to be known to exist, an architectural body has no need of the sophisticated measuring devices or detecting mechanisms of everyday science; instead it relies for its existence on the tactically posed surrounds/tutelary abodes that procedural architects build using the approximative-rigorous abstractions and diagrams of biotopology. Within tactically posed surrounds/tutelary abodes, both the architectural body and its constituent factors become more apparent. Biotopology, together with procedural architecture, the field it was invented to serve, holds that because living as an architectural body involves a roundabout way of pinning down but not exactly pinning down that which is in play, an organism that persons who lives as one stands a fair chance of escaping many of the conceptual pitfalls, that commonly plague theorists and researchers, particularly those pitfalls born of unconscious moves toward reductionism.

Approximative-rigorous abstractions can, for interactive diagramming purposes, be used to schematize, elements singled out for emphasis as well as component factors needing to be

brought out in the open. Despite appearances to the contrary, the science outlined in these pages is not that of nonsense.

And that is where we stopped. Why, we wonder, is *home base* nowhere to be found in the text? In our discussions, the term *home base* did the term *landing site* one better by providing a collecting area of sorts for cleaving. Our hunch is that, within a year or two, biotopology will become sufficiently structured to support such a mid-level term.

Here is a candidate for a postulate:

At this juncture, any disparity between the event-fabric formed by cleaving in general and that produced by organisms that person can only be guessed at.

Although the following is easy enough to deduce from the text, it goes unstated within it:

For the organism that persons, the sequences of landing-site configurations that form its architectural body add up to the event-fabric.

We had promised that whenever an alternate wording occurs to us, we will send it your way. Let us know if you find this rephrasing to be of use:

What an organism that persons perceives to be discontinuous— discontinuity—-will often be only a shift (of that which appears to discontinue) to another scale of action.

We have already begun putting the equations together.

yours with great exuberance,

Rudifolkine Zinovieff

p.s. Scene: A corner café with an abundance of outdoor tables on the sidewalks of

both the East-West and the North-South streets that form its corner.

The catch phrase of a non-English speaking waiter at a corner café in Venice hovers or is lodged, or both, appropriately approximatively between "You see, you know." and "You'll see, you'll know."

What is waiting for him around the corner? "You'll see, you'll know," he thinks, he says as he walks in exaggerated slow motion around the corner and, with a bit of a flourish, cranes his neck, as if rounding that corner with that neck, to peer in a studied way at tables that belong to his wait station which only now come into view. A few new patrons have seated themselves. "You see, you know." Or finding not a soul in sight, he bemoans with mock despair plus mock fury what a lousy place this is for a café by mini-shouting to high heaven, "You see, you know."

A silver cover sits atop what a customer has ordered. As he lifts the cover, "You see, you know," he declares. Is this as if to say: (a) "Now you can see whether or not I got your order right." (b) "Now you can rest assured that you've chosen a terrific restaurant." (c) "Look at what splendid food we have here. "

A patron waits for a friend or a lover who is terribly late "You'll see, you'll know," the waiter sympathizes or half-sympathizes. Here comes that person at last, "You see, you know."

Thunder? He looks up, holds up his hand as if to feel for rain, shrugs his shoulders and calls out, "You'll see, you'll know."

Moving his left thumb ever so slightly so as to speed on the opening by the patron of the smallish leather case and increase the alacrity with which the check gets reckoned: "You'll see, you'll know."

This singsong phrase functions, we feel quite sure, as a close cousin of, to say nothing of an identical twin to, an approximative-rigorous abstraction. The waiter knows quite well what he is saying, even though his beloved phrase belongs to a language with which he is unfamiliar, and he know around and about and more than what he says; this phrase that he possesses and that to a good extent possesses him allows a magnificent latitude to his self-cognizing, including a tracking of as many intentions as he pleases.

January 25, 2003

Dear R, Dear Z,

Of course, you had to stop writing that review, so that our collaboration could begin. We must say you did make a terrific start.

It would be useful to be able to speak of home bases for certain types of operations. Even as the term enticed us, we felt we had to resist it. There's the rub. In the end, we decided on removing it provisionally. We are in agreement with you that a home base would be a place within which cleaving gets put to a particular purpose. A eucaryotic cell whose innards are contained within a structured membrane is such a place, and so too, for that matter, is its structured membrane. Home bases exist within home bases, as do landing sites. Think of each mitochondrion within the cell as a home base. Other home bases within a cell would be the nucleus, DNA, a gene, RNA.

The purpose this term would serve?

It would be a means of referring to and isolating different organizational levels of cleaving.

Is the term approximative enough for biotopological purposes?

Perhaps not.

Biotopologists strive for an approximate taking up of multiple points of departure simultaneously, and this term offers up only a single point of departure. Having a term in the biotopological lexicon that refers to a single, fixed point of view or a stable area or concentration of cleaving pares down the grand "approximativity" biotopology would set afloat, throwing everything greatly—even if only by a little—out of kilter.

To free this term from the fixity the two words it consists of force upon it, we may eventually find ourselves speaking of fluctuating home bases or nested ones. But for now, all stability of the type home base doubly names is undependable and therefore to be avoided.

78

And is it rigorous enough for biotopological purposes?

Whatever is not approximative enough for biotopological purposes will also not be rigorous enough.

Yes and yes to the postulate you suggest.

The two other points you make in your letter are also terrific. You read us loudly and clearly, which of course gives us a terrific boost and augers well for the projected collaboration.

<div align="center">

bioscleavically yours,

A M

</div>

p.s. It is probably best to think of cleaving as a continual and pure *eventing*. Out of cleaving, out of eventing, comes the event-fabric.

You will find here enclosed *Cleaving, the Paradigmatic Approximative-Rigorous Abstraction*, a short companion piece to *An Introduction to Elementary Biotopology*.

We are sending along with this a closely related document, **Biotopological Report #6A**, written shortly after it.

A biotopological report will be considered to be definitive, which, by definition, it is required to be, if it succeeds in never closing down on the issue it raises. What a biotopological report addresses needs to be kept indefinitely open, inviting continual re-writing. **Biotopological Report #6A** addresses cleaving, keeping this issue open and open. Cleaving is always about opening, despite its being equally about closing. How does an approximative-rigorous abstraction such as cleaving come to be an issue? Every approximative-rigorous abstraction marks off or frames out an issue. The issue that this approximative-rigorous abstraction marks off or frames out is replete with issuings, for the term cleaving leaves markedly and approximately and rigorously pending what issues and issues and sets and stands forth as bioscleave.

Take the case of string all in knots being unraveled by fingers "intent" on a smoothe, unknotted outcome. Fingers that are having a go at badly tangled string, giving it their all, operate largely procedurally, without any apparent occurrent cognizing, not for them, certainly not, but seemingly not even for the person to

whom they belong. Moving and moving, fingers bend, dive, tug and release, drawing on their "knowing" of what has got going and what is getting going. Have each finger be an issuing forth of cleaving. The procedural knowing that leads to an unraveling of the string occurs by means of sequences of openings and closings, on many scales of action at once, that is, through cleaving, through many cleavings, through how segments of biocleave know how to cleave. Perhaps we are on the way to working out the cleaving landing sites of procedural knowing. More on this later. How often we envision lately tiny fingers, ones that could insert themselves into tangled neurons or ones with fingertips perfectly sized for the holding of a neutrino that parades as a melting snowflake.

 Biotopological Report #8A, which also comes to you today, examines and holds open for further consideration possible paths to and stages of person formation.

Cleaving, the Paradigmatic Approximative-Rigorous Abstraction

What makes this abstraction—cleaving—an approximative–rigorous one? And, why paradigmatically so? Every detail of what happens as massenergy can be spoken of as cleaving, as an adhering or an otherwise attaching of an **a** or a **b** to an **a** or a **b** or as an **a** or a **b** coming or flying apart from an **a** or a **b**. Approximately what an organism that persons substantially exists as can be reported in rigorous fashion by means of it. The organizing principles peculiar to an organism that persons that underlie and are determinative of its every move will of course be included in the rigorous report. The best approximative-rigorous abstractions have it in them to stand out strikingly as, but of course, mere abstractions, even while they sit or splash conspicuously, and weightily enough, in gravitational amplitude, on the cusp of materiality. No term is, in our estimation, better equipped than "cleaving" to straddle the abstract and the actual.

 In its happening on many scales of action at once, cleaving both derives from and produces intercleaving, the intermixing or interfusing of scales of action. The concept of intercleaving talks to how difficult it is to separate or isolate one instance of cleaving from another, addressing the inevitable overlappings.

 Without exception, all that can be and does get detailed as biocleave consists, by definition, of cleaving. An entire field alive with cleaving: biocleave. From cleaving, by means and in terms of it, biocleave, an event-fabric capable of giving and holding and functioning as life, forms. Rigorously micro-engineering cohesion even as it speaks up about this in detail, cleaving approximately pins

down and releases cohesive parts. Cleaving forms and interfuses or interlaces organizational levels of itself: a chain of command. Although it can be put to a purpose, cleaving on its own happens aimlessly, both in its coming together and pulling apart modes.

A quick glance at or walk through bioscleave reveals the world in all its cleaving. Think of each element or material as a particular organizing of cleaving. Ubiquitously present within bioscleave, electricity and gravity form through combinations of adhering and coming apart (cleaving) of who knows what. What operates as massenergy cleaves on many scales of action at once. The shift from one of these scales of action to another, and hence from one level of organization to another, involves the addition or loss of mass and thus of gravity.

1. Editor's note: Arakawa and Gins use the term *bioscleave* for what others speak of as biosphere. By means of this name switch they achieve their stated aim which is always to keep in evidence the actual but abstract dynamics of this vast domain.

2. Editor's note. See Appendix A.

3. Thit: a. neither this nor that

 b. both this and that

 c. neither this nor that + both this and that

 Thas: a. neither that nor this

 b. both that and this

 c. neither that nor this + both that and this

4. This is simply a restating of the Architectural Body Hypothesis/Sited Awareness Hypothesis [SEE APPENDIX A].

5. Biotopologists alternate freely among the following ways of constructing a terminological junction: _ _ _and _ _ _ and _ _ _ ; _ _ _ or _ _ _ or _ _ _ ; _ _ _ / _ _ _ / _ _ _ .

6. Event-fabric: the sum of all massenergy clusters that cleave. Landing-site configuration: all the landing sites of the moment (of an organism that persons) that cleave.

7. The first use of this terminological junction was in the twin recountings identified as Biotopological Reports #6A and #8A, to which the reader is referred for a more detailed analysis of what is touched on here.

8. articulation = coordination= coordinated landing sites.

9. See Biotopological Reports #1A and #1B

10. Although the set of position-defining terms (nearground, farground, middleground, etc.) listed here figured prominently in *We Have Decided Not to Die* (Guggenheim Catalog, 1997) and in *Architectural Body* (University of Alabama Press, 2002), and will likely be widely used in biotopological reports in the future, it has not been called into service in these pages.

11. The sufficient number would be howsoever many scales of action would be needed to provide an organism that persons with the world as she knows it. This should also be considered the optimal number for it is the one that would constitute a go.

BIOTOPOLOGICAL REPORT # 6A 2002

The many knots cleave. Think of the directional rerouting that comes with a string's, a cloth's, or an event-fabric's entering into a knot, succumbing to a knot. Can the cleaving fingers untangle the knotted string, cloth or event-fabric? The cohesive sensibility goes at it. Having a go at it thick in the swim of the cleaving, an aimless wandering takes an aimless wander through very knotted aimlessness on the loose. Pull this a little. Unloose thas and thas. Jump to action tops off from electric fluidity duly cleaved. Swifter than swift considerations. Cleaving clanging unclangingly on cleaving. Some landings sites (made of cleaving) or home bases (for cleaving again). Organizing principles stay in this throughout, deceptively quiescent articulations of proto-thinking. Cleaving supplies and maintains the appropriate level of abstraction for X and insures it or cleaves it through.

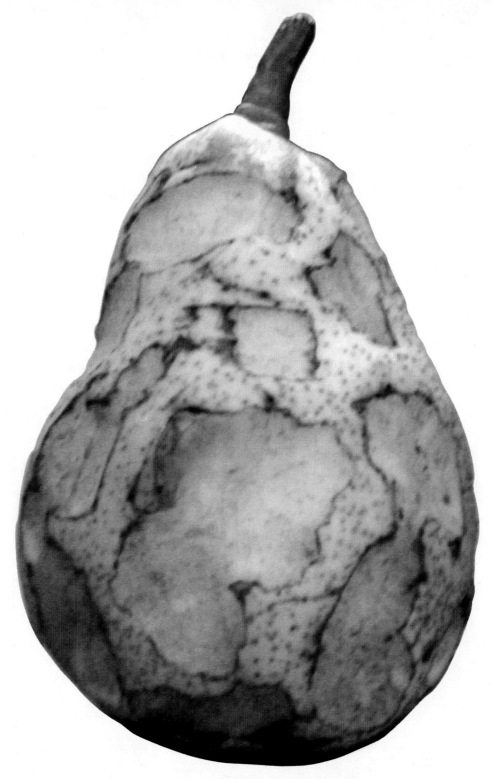

Question: Who or what ate this pear?
Answer: An autistic person

Co-generators (along with bioscleave) of landing-site configurations:

a.	organisms of any kind
b.	*organisms that persons* who person

All of the following were instrumental, it might be surmised, in the pacing and sequencing of the eating of this pear:

Bioscleave replete with *organisms that person* (Inasmuch as it potentiates saying in those who can speak, spoken language would seem not to be completely foreign to it. Contributing as it does to this set of events, it deserves to be given a speaking role. A few organisms that person, a few researchers, have taken it upon themselves to speak ever so briefly on its behalf):

> "Event-fabric thoroughly underway."

> > PRE-PERSON DOMAIN
> > SUB-PERSON DOMAIN
> > LANDING-SITE CONFIGURATION

Organism that persons about to person, if possible:

> > PRE-PERSON DOMAIN
> > LANDING-SITE CONFIGURATION

Organism that persons intermittently, in a hit or miss way, contributing incrementally to the forming of person (So that researchers might investigate states possible to an *organism that persons*, upsurges and effusions that occur apart from or as-if apart from a language-using component will have to be here delineated or marked out as chunks of words):

> "Want or take this but. Land on this part."

> > PERSON DOMAIN
> > PRE-PERSON DOMAIN
> > SUB-PERSON DOMAIN
> > LANDING-SITE CONFIGURATION

Organism that persons producing that which is vivid enough to person (Upsurges and effusions that occur in the course of language acquisition need to be here delineated or marked out as chunks of words):

"No more biting in this area. Certainly not."

> PERSON DOMAIN
> SUB-PERSON DOMAIN
> LANDING-SITE CONFIGURATION

Organism that persons unable to continue producing that which is vivid enough to person:

> SUB-PERSON DOMAIN
> PRE-PERSON DOMAIN
> LANDING-SITE CONFIGURATION

Organism that persons unclear as to how to start to person:

"Want or take this."

> PRE-PERSON DOMAIN
> LANDING-SITE CONFIGURATION

Organism that persons (itself a highly organized segment of bioscleave) more in sync with bioscleave in general than with a co-generating (along with its surrounding bioscleave) its own person (by means of landing-sites):

> PRE-PERSON DOMAIN
> LANDING-SITE CONFIGURATION

Organism that persons in need of potentiating so as to be able to person:

> PRE-PERSON DOMAIN
> LANDING-SITE CONFIGURATION

Organism that persons struggling to person:

> PERSON DOMAIN
> SUB-PERSON DOMAIN
> LANDING-SITE CONFIGURATION

Organism that persons shifting its cleaving borders that are layered so as to become that which strives to person:

> PERSON DOMAIN
> PRE-PERSON DOMAIN
> SUB-PERSON DOMAIN
> LANDING- SITE CONFIGURATION

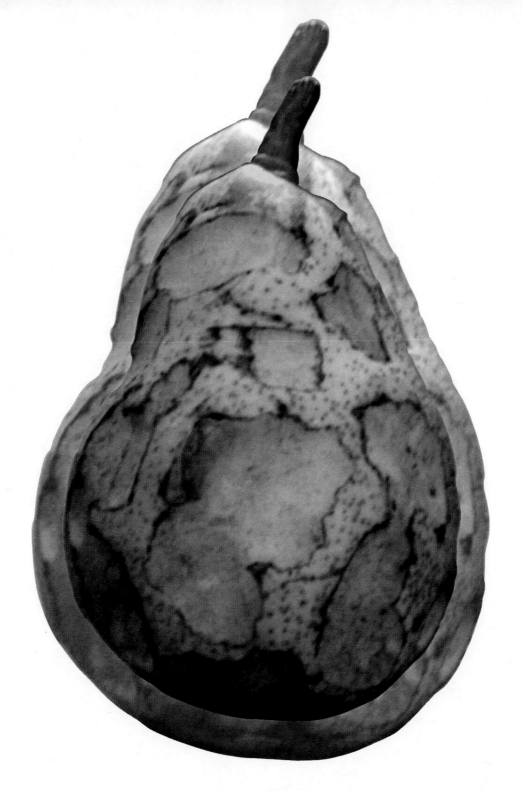

This segment of bioscleave was visited for nourishment and for who knows what else by an *organism that persons* not yet able to person.

6

NEVER!!
OR
LET MY SPECIES GO (DOWN THE DRAIN)

- It infuriates me, a partner in an international architectural firm, an architect whose career, having begun at the Bauhaus, has spanned nearly a century, to learn that an ersatz architectural practice was involved in the framing of this despicable law.
- If you don't let me die I will kill you.
- Do not deny me my right to suffer.
- Non-dying has been good enough for me so far, but being forced not to die is another matter, even for someone in the best of health.
- Now the government wants to mess with my dying. Over my dead body!
- This law is the greatest enemy of comfort.
- What's the big deal?! Some hospitals (not the one I was in last month) are already in compliance with this law.
- Oh great, now the government is going to punish me for what is inevitable, for what I can't help.
- No bastard is going to prevent me from dying.
- How dare you make me think even for one instant that governmentally I can save my mother whom I love dearly!
- As a law professor and a scholar of the history of ideas, I feel I must point out how particularly abominable it is that this statute was penned in the English language.
- Not for the faint-hearted or for the hearted of any variety. Not even for the heartless!
- "Long live the death instinct!"
- This would seem to be a more than adequate means of spreading delusion.

- I cannot imagine anyone with a grain of sense thinking in terms of making dying illegal.
- Next these same dummkopf policy-makers will seek to extend protection of this nature to plants and trees and every manner of animal.
- This STATUTE gets me thinking about how competitive sports began and pushes the game aspect of human life over the top. In light of this law, what, then, will it mean to be an athlete?
- I witnessed hundreds of battlefront deaths as a lieutenant in Vietnam and, as a result of having experienced so much agony, I came up, on my own, with more or less the same law. Upon returning to civilian life, I found myself unable to think of that law as anything but disgusting.
- Dying may be reprehensible, but so is non-dying.
- Only the dregs of society could have maneuvered to put so constraining and foul a law in place!
- The proven need to die in the face of one's sensitivity may or may not be able to be overridden.
- Well, well, what have we here? Avant-garde poetry or neo-sandbox art or simply a tendency to newly express something unthinkable. I and we don't like this scandalous turn of events. It is as if this statute would save lives at the expense of fine, admirable, and smooth-as-silk art!
- My dentist would rather strangle me than let me take this route.
- Not one of my fellow quantum physicists would stoop so low as to foist something like this on the general populace.
- Not only me, a defense attorney who has defended every variety of criminal, but every defense attorney with whom I have spoken – we all throw up our hands in despair at the thought of having to defend a client accused of having broken this law.
- I must say I can't wait until I die so you can put me in the electric chair. I would like to live to see that. And so would my uncles, aunts, and cousins.
- Something about this particular law reminds me of having a pie shoved in one's face in an aggressive manner.
- I have an asthma attack at least once a month, occasionally even more often. I nearly die every time I have one. Am I, then, leading a criminal life?

- This statute is worse than the AIDS virus.
- And what of parents who feed their infants death with life? Are they all to be arrested?
- Do not the makers of this law realize that they are robbing people of the beautiful experience of dying?
- The makers of this statute would twist my arm to have me tell a noxious fib to my kids. They will die, die they will, and I am the one who must make sure that they know this.
- Why should not we the members of Generation X have the same constitutional right to a tragic end as, say, those who lived during the Frankenstein period?
- Even Commies and Socialists as well as Nazis and other fascists and born-agains as well as Jesus and Buddha and Muhammad and Kant and Socrates and Plato and Spinoza and Hegel and Gadamer and Lyotard in addition to Galileo and Darwin and Picasso and Marie Curie and Duchamp and Einstein and Bohr failed to comply with this law!
- We of the Artificial Intelligence/Artificial Life group at MIT have through the years countenanced more than a few far-fetched notions, but not in our wildest dreams have we ever thought to initiate or condone a sperm-like law so outrageous and wriggly as this guy.
- This shortcut to infinity makes me want to throw up.
- This law was brought to us by a Martian on her worst day.
- If, as I believe, they had an unwritten law to this effect just prior to the Ice Age, then to enact it now would constitute a serious regression, wouldn't it?!
- I remember what it was like being born, and this statute threatens to bring about an equally smelly affair.
- Are you telling me that the only way not to do something illegal is to keep breathing?!
- The initiators of this statute would seem to want to pull from out of the blue a purpose for this life that demonstrably has no purpose. I cannot put it any more directly that this: Our lives on this planet lack purpose!
- Making Dying Illegal = Eternity? I don't think so!
- Simply no decent person when gazing at the clear blue sky would dream of taking a law like this seriously.

- Is this some form of filthy poetry?
- Makes me feel like someone is bringing down the whole Milky Way to this planet and searing my heart with it.
- How am I supposed to afford living forever?
- The feeling of having to comply with any law is an uncomfortable one. Such a law would interfere with and compromise any free feeling of being alive.
- Reading this statute after having just graduated from high school makes me want to condemn the entire human race.
- Hearing of this has thrown our community, considered by many to be a group of religious fanatics, into a state of total confusion.
- Back off with your fucking optimism!
- We are always going to die, we are always going to die. Don't you get it!
- Tell it to the Neanderthals!
- The thought of not having to die makes me very shy and afraid.

NEXT COMMENT:

WHAT BIOSCLEAVE WANTS

September 19, 2002

Dear Madeline, Dear Arakawa,

I gather that in sorting out the environment in terms of landing sites you would have it that not only elements and features of the architectural surround but people as well be thought of as landing sites, highly salient ones, for an *organism that persons*.

so long for now,
Reuben

September 30, 2002

Dear Professor Reuben Baron, Dear Highly Salient Landing Site,

Semi-stable and exceedingly changeable and generally expression-filled landing sites (consisting of ever so many other landing sites) walk up to, or move off away from, show some degree of concern for, or remain apparently indifferent to the *organisms that person* for whom they are landing sites.

Whatever or whoever can be discerned is a landing site, at once one and many. Whatever an *organism that persons* finds herself discerning not only counts as a landing site for her but also consists of still other landing sites for her and has a share in even larger landing sites surrounding it.

Yes, animate landing sites are multiply charged and highly salient.

Nothing could be more salient than the intermixing of the plethoras of landing sites living organisms eventuate as. Trillions of cells cleave to form each of

these segments of bioscleave. Two sets of trillions of cells wave hello to each other pointedly and diffusely, indifferently and not so indifferently, and who knows how else.

The way in which living landing sites belong to landing-site configurations of the moment requires further study. It may be that a whole new discipline will result from this.

until soon,

Arakawa Madeline

p.s. Although in Chapter 5 (Architectural Surrounds) of <u>Architectural Body</u> we state that *organisms that person* are features of architectural surrounds, we have thus far been reluctant to tackle this matter.

October 21, 2002

Dear Madeline, Dear Arakawa,

(a) A window, a table, a doorknob, a pencil, a voice, honking of a car horn, an odd odor in the refrigerator or a sweet fragrance in the air, the building shaking from all the traffic going by, feel of fingers typing away on the keyboard—how do all these landing sites—what I as an *organism that persons* discern, by any of several modalities, through one or many of them, in the course of living—differ from that landing site that cavorts as or does something else as a member of our species?

(b) I need to get a sense of the extent to which your way of thinking takes social embedding into account.

ever best,

Reuben

October 30, 2002

Dear Reuben,

(a) A cavorting landing site does exist as a landing site plain and simple, but she also disperses out widely as a series of landing-site configurations. All landing sites plain and simple that are not organisms do, as discernings, as-if consist of or occasion many smaller-scale landing sites into which they can be broken up and with which they can be said to abound, but none of *them* initiates or keeps running a series of landing-site configurations, a vibrant field of interactions.

You present us with a wonderful list of landing sites plain and simple, throwing in a few relatively complex ones for good measure. Your grouping reminds us of a poem by the zen master Ikkyu:

What is mind?
A pine tree, a breeze, a voice
in a forgotten painting.

You ask us to make a distinction between these two types of landing sites, do you not, because you wish to hear what we have to say about what goes on as the intersubjective field, to hear what it is that we believe an *organism that persons* taken up as a landing site by another *organism that persons* manages to signal, beam out, radiate and, in a host of ways, put forth. Organisms as landing sites—that is, as landing-site-configuration-dispersing landing sites—approach each other, fend each other off, take up each other's causes, or refuse to be of any help at all. The series of landing-site configurations that each of these walking and talking segments of bioscleave co-constructs together with those segments of bioscleave she inhabits intersect often to great effect with those series of landing-site configurations that other walking and talking segments of bioscleave disperse. A whole spectrum of mutual or not-so-mutual interests or considerations verbs open when members of our species move through each other's fields as landing-site-configuration-dispersing landing sites. Only landing-site-configuration-dispersing landing sites offer the possibility of mutual interest and consideration or the severe negation of this.

A few words in anticipation of section (b): *Organisms that person* become persons through the dispersing and fielding of series of landing-site configurations, those they initiate and those of others: Intermixing plus intersecting series

of landing-site configurations: social embedding. Infants' landing-site initiatives get encouraged along by mothers and others (who themselves were once given courage and assurance in regard to their own landing-site initiatives). *It is important to get to know that it is worth it to have landing sites.* If landing-site initiatives require a communal jump-start to get going, then perhaps all landing sites factor out as social.

(b) We take social embedding into account in our thinking in one respect with our concept of bioscleave and in a quite other but of course ultimately related one with our concept of a built discourse.

Inasmuch as bioscleave denotes life in all its multiplicity as communally lived and all regions that encompass this vivid and vivifying crew, it consists in large part of social embedding. A crew? Yes, a crew of organisms whose members undergo and participate in social embedding right from the start. Surely, an organism that persons at large within bioscleave has been and continues to be to some degree socially embedded.

Having by means of social embedding been brought to exist, persons then avail themselves of it further to construct architectural bodies. Reflecting on what they know or could know and on what they need to find out, they assemble a built discourse, interconnecting tactically posed surrounds. To move within a tactically posed surround is to move within a terrifically purposeful historical record of social embedding. An enclosure whose elements and features have been posed tactically for reversible destiny purposes, and that thus has a tremendous amount of communal forethought embedded within it, raises exponentially the level of social embedding in the air. As well you know, we want to identify those formations of architectural bodies that will have the greatest likelihood of going on indefinitely. Bringing social embedding to be integral to architectural procedures will likely be a means of fostering the immortality we believe all architectural bodies deserve. As part of your effort to keep us, so to speak, in good standing with social embedding, you began last week to urge us to dally no longer with an isolated "personing" but instead to make "interpersoning" central to our approach to architectural-body formation and the achieving of a reversible destiny through the construction of a built discourse. We tremble at the thought. We think you are right.

waving to all your landing sites of the moment,
best of courage to us all for actions that need to come next,

Arakawa Madeline

November 23, 2002

Dear Madeline, Dear Arakawa,

The actualization of a landing site, its coming to be, is a matter, is it not, of coordination between the properties of the environment and the properties of the organism?

The actualization of a landing-site configuration, its coming to be, is a matter, is it not, of coordination between the properties of the environment and the properties of the organism?

ever and again,

Reuben

November 30, 2002

Dear Professor Reuben Baron,

We recognize that with these questions you wish to push us below the surface of what happens as perception and have us come up with an answer. These are not questions that we feel ready to answer. All that we are prepared to do is to respond to you with a restating of your questions.

We find some of the terms you use to frame your critically wonderfully astute questions to be vexing. This does not surprise us, because it is to be expected that during periods of transition, when different conceptual holds on the world strongly vie with one another, confusions of levels of description will arise. Incomplete shifts from one construal of the world to another produce locutions that mar cogency.

To simplify our task going forward, we have posed your two questions as one. We have highlighted the terms that vex us. We should say at the outset that it is because we find that these terms push us, each in its own way, toward a much-to-be-resisted dualism that we find them troubling:

The actualization of a landing site/landing-site configuration, its coming to be, is a matter, is it not, of coordination between the properties of the environment and the properties of the organism?

97

1. BIOSCLEAVE/ACTUALIZATION

By definition, it is within and by means of bioscleave that all that happens does: some might wish to call bioscleave a thoroughgoing actualization, but that is not what we have found ourselves inclined to do. The sum of all that contributes to lives being led: bioscleave. It does not need to be said but could be said that bioscleave actualizes along. That said, then landing sites/ landing-site configurations should be seen as simply registerings or notings of bioscleave's actualizing along.

2. ACTUALIZATION

"Actualization of a landing site (landing-site configuration)" strikes us as a category error. "Actualization" belongs to one level of description and "landing site(landing-site configuration)" to another. The approximate–rigorous abstraction landing site (landing-site configuration) replaces or opens up the antiquated term, perception. Perceiving happens or verbs through without having to be actualized — so too with landing site (landing-site configuration). The word "perceive" includes its own actualization, that is, a person perceives or has a perception and that is actualization enough. The term "landing site (landing-site configuration)" also includes its own actualization, that is, a person has landing sites (landing-site configurations) and that is actualization enough. Registerings on if not this then that scale of action — that is what landing sites are, and nothing more. Complete sets of the registerings of the moment on if not this then that scale of action — that is what landing-site configurations are, and nothing more. Registerings or notings are registered or noted, not actualized.

3. COORDINATION

The word "coordination" certainly helps our descriptive effort better than the word "actualization" does, but it too promises more than it can deliver and also needs to be further elucidated. Both words oblige their users to split the universe in two, making them unwitting dualists.

A coordination is the end result of the compounding of certain processes and procedures.

Have it be that coordination occurs by means of what is active as bioscleave. A good deal of that which is essential to the effecting of a coordination contributes only indirectly to its being able to come to pass. This is why we feel sure that the biotopological tenet that it is necessary to keep in mind as many different scales of action as possible will eventually help our species elucidate the incredibly attractive to it but largely mystifying term "coordination."

4. PROPERTIES

What comes to be called a property of an organism, an environment, or a medium eventuates as such by virtue of having been and continuing to be characterized and underpinned by events on many different scales of action at once. This term when featured in a descriptive effort covers over many of these events, abstracting them away; the scales of action that underpin what occurs lose the salience that ought rightfully to be theirs.

Your asking these questions reveals what we have long suspected, which is that you believe we belong, along with Merleau-Ponty (observer/observed), Gibson (organism/environment), and Varela and Maturana (coupling), to the philosophical tradition of the "matched pair."

We escape any dualism, and in particular "matched pair" thinking, that exceedingly optimistic variety of dualism that would posit a bi-partite designed universe without a designer, by introducing an architectural body, through which we deny to an *organism that persons* properties apart from and independent of an environment.

Are we then to say that bioscleave effects coordinations within itself?? Yes. Different organizings of bioscleave cascade down and across and through it, playing into each other. It all depends on what bioscleave "sees fit" to have happen.

The science of biotopology has need of terms that do not override to the left and right and up and down a great number of scales of action. The less bioscleave's substance-event/mass-energy is divided the better.

5. A RESTATING OF YOUR QUESTION

Discernings are a matter, are they not, of interdigitatings—within and as part of bioscleave—between processes and procedures on many scales of action of one segment of bioscleave (pressure, temperature, gravity, light, etc.) and processes and procedures on many scales of action of another segment (pressure, temperature, gravity, light, etc.)?

until soon,

Madeline + Arakawa

December 4, 2002

Dear Madeline, Dear Arakawa,

All a matter of what bioscleave "sees fit" to have happen is it? Is it that, notwithstanding its being insufficiently procedural, bioscleave has motives?
What does bioscleave want?

ever beset,

Reuben

December 10, 2002

Dear Professor Reuben Baron,

What does bioscleave permit? What has it permitted? What might it conceivably permit beyond that which thus far it has shown itself able to permit? Shall we agree that all those questions taken together give bioscleave neither a human nor divine type of wanting(?) Assuming that you concur with us on this, we feel equipped to go right ahead and express ourselves (as part of an itself) on this matter. After all, bioscleave has copiously let us know that organisms that person are of it and are it and can speak for it, and, as far as we can tell, it "sees fit" to have us state:
Bioscleave wants
• a grand synthesis of art and science in the East and Non-East that will make it possible at long last for our species to take its evolution into its own hands
• organisms that person to increase even more the degree to which they are it and to do so by becoming architectural bodies
• organisms that person to dwell within tactically posed surrounds/tutelary adobes so that they can live as architectural bodies.
• landing sites to be known as registerings or notings of itself as thoroughgoing actualization
• not to be overlooked or underestimated
• to be made more procedural

• dying to be made illegal
• an era of reversible destiny
• every immune process to have within it an additional immune process

bioscleavically yours,

Arakawa Madeline

December 17, 2002

Dear Madeline, Dear Arakawa,

Apparently bioscleave wants what the two of you, frontrunners of our species, want.

The internal dynamics of landing sites involves quite a bit of cognitive capacity, does it not?

best regards,

Reuben

December 22, 2002

Dear Professor Reuben Baron,

As to whether landing sites have cognitive capacity, all we can say is the following. Not only do members of our set of working terms—*organism that persons*, *biocleave*, *landing sites*, *architectural body*—-function diagrammatically and descriptively, they also manage to supply what we have come to speak of as *instant referent delivery*. We might note in passing that a decision has to be made to take the world diagrammatically by means of these terms and that that decision has to be remembered and heeded. Used diagrammatically, a term intermixes now

lightly, now abundantly with its referent, which, occurring on demand, suffuses the would-be diagram with itself—the result-producing demand need consist of nothing more than the term's being voiced or its making an appearance in some form. Each of these working terms, we would insist, serves up in addition to a handily immediate *instant referent,* a cognitive enough bruiting about of: "Let this happen as it does." It is incredibly important to learn not to be so bold as to try to say what this happens as. Overreachings of this nature, in philosophical discourse in particular, have caused terrible veerings off course, sometimes for centuries.

We invented landing sites as a means to look into what goes on as cognitive capacity. Yes, cognitive capacity is no doubt at work within the formation or declaration of a landing site, but there's not much to be gained by stating this.

yours sincerely,

Arakawa Madeline

December 27, 2002

Dear Madeline, Dear Arakawa,

You do take into account, don't you, that when functioning as an individual, a person will select different aspects of a tactically posed surround/tutelary abode as landing sites from when in a group mode?

Will social embedding interfere with the running of architectural procedures?

that's all for now,

Reuben

January 2, 2003

Dear Reuben,

The landing-site configurations a person disperses in response to juxtaposed elements and features of a tactically posed surround/tutelary abode definitely differ greatly depending on whether she is alone or in a group. For example, someone who is alone would be likely to engage far more willingly with the tentativeness-cradling procedure than would someone in a group. Every *organism that persons* harbors within her that tentativeness which this procedure is designed to elicit. Having this architectural procedure's desired result always on tap, so to speak, a person can at any moment engage with it vividly. An immediate need to interact with others makes a person less tentative, and the tentativeness-cradling procedure less compelling, and perhaps not as fully realizable.

Although certain types of social embedding will no doubt interfere with the enactment of an architectural procedure, others will increase the likelihood that an architectural procedure will be fully engaged and realized. It is not necessary to be always tuned into those architectural procedures constructed into the surround you inhabit. A break in your contact or engagement with an architectural procedure need not be a bad thing. The return to an architectural procedure from which there has been a decisive break can end up producing an engagement that is twice as strong.

Forming an agreement with another person to adhere to a particular architectural procedure—social embedding under the aegis of reversible destiny—can be an incredibly effective means of achieving the desired result.

yours in friendship,

Arakawa Madeline

January 10, 2003

Dear Madeline, Dear Arakawa,

The richness of the concepts of landing sites and architectural bodies in regard to their explanatory and integrative possibilities is best revealed when they are seen in the context of related ecological formulations such as Gibson's ecolog-

ical perception construct of affordances and Barker's behavior settings.

Landing sites and affordances are both inside and outside the organism, albeit in somewhat different ways. Landing sites are inside in the sense that they can be cognitively constructed as well as perceptually scaled. For example, the blind mathematician cited by the two of you in *Architectural Body* solves the puzzle by <u>using memory based on touch to construct an internal image or schema of a maze</u>. Affordances are internal in the sense that their detection is both motivated by organisms' need states and achieved by sensori-motor capabilities that bring the organism into appropriate contact or attunement with the environmental opportunities to satisfy their needs.

Taken together, your theory and Gibson's provide a way to understand how the environment <u>becomes meaningful in ways that are not arbitrary</u> because such <u>meanings</u> are literally embodied as we navigate through the environment.

yours for always,

Reuben

p.s. The greater epistemic flexibility offered by your landing sites is particularly important at the cultural level, where social values often override biologically based needs.

January 15, 2003

Dear Professor Reuben Baron,

We hereby officially welcome your formulation of an ecological *landingscape,* a conceptual mapping of surroundings. We applaud your evident desire to avoid having newly introduced concepts override ones already in use. We have begun to give daily thought to your notion of ecological description via the combined use of landing sites and affordances.

It probably would be good to start off by posing direct questions such as: What are the landing sites of this or that affordance? What type of affordance makes what type of landing site? As comfortable as we are—mighty comfortable—being placed up there alongside of Gibson, we hasten to inform you of what you

probably already know, which is that he had a fundamentally different objective from the one we have. Gibson sought to describe perception ecologically, whereas we seek to use ecological description and diagramming to reconfigure life.

Initially, we constructed the concept of landing site(s) as a means to insist on and keep track of every manner of everything that an organism that persons deems to be outside of her. We wanted to insist that what seemed to be where it was exactly was where it seemed to be. To diagram the world out appropriately—that is precisely what we desire to do. Landing sites were to be used to give a descriptive report of the greater outside in view of and in respect to what organisms that person, roaming quixotic entities, factor out as. Ascribing a landing site to a discerning or declaring a discerning to be a landing site has a great deal or everything to do with a will to diagram. We constructed the concept of landing site(s) to include undecidability and indeterminacy, believing that a concept which has these constructed into it can protect diagrammatic thinkers from the contradiction and irrationality that start up when the descriptive act continues to be strictly applied—the sad spinning of cognitive wheels—to that which remains unfathomable. A landing-site occurrence happens always within and as part of bioscleave. The concept of "bioscleave" came into existence a bit later than that of "landing site(s)." There can be no organism that persons apart from bioscleave. As we noted in an earlier letter, organisms that person are segments of bioscleave. Now back to landing sites. Landing sites can, then, in light of the dominant everything that is bioscleave, be thought of as markers of where organisms that person have flowed through to or where plus where they have found themselves to be viably pertaining along. Having presented you with the necessary background, we now turn to the first sentence of the second paragraph in your letter: "Landing sites and affordances are both inside and outside the organism, albeit in somewhat different ways." Rather than thinking in terms of the inside or outside of an organism, we find it to be more fruitful to think only of a grand inside, bioscleave's ubiquitous innards.

We would like to note in passing that the emphasis on memory in your brief analysis of Karl Dahlke's achievement (the blind mathematician we write of in *Architectural Body*) skews the landingscape. More than anything else, what we are trying to get at with this anecdote is a spectrum of cognizing or cognitive capacity in evidence in bioscleave. It demonstrates, to our great delight, that biocleaving in the form of imaging landing sites, when used in conjunction with perceptual landing sites, can produce a world for someone to know; and, furthermore, it supports our intuition that perceiving grows out of imaging, that imaging landing

sites are on the wide-band end of the spectrum of bioscleaving that produces perceptual landing sites at its narrow-band end.

yours,

Arakawa Madeline

January 24, 2003

Dear Madeline, Dear Arakawa,

(a) A person's effectivities: his/her particular width, height, or specific response capabilities. As I see it, affordances are induced by properties of landing sites, and both are mediated by the effectivities of the animals that seek them out.

Effectivities can be thought of as "an affordance of the organism from the environment's point of view" (Balzano & McCabe, 1986, p. 107).

This means that just as effectivities allow the affordances of the environment to be actualized, so the environment, the surround, and most broadly your concept of a bioscleave create the effectivities that will allow affordances to be realized, landing sites to be created, behavior settings to be self-organized, and architectural bodies to be called forth. These structurings, in turn, would provide the boundary conditions that constrain the phase transitions from organism to personhood to community.

(b) Your concept of the architectural body and Barker's concept of behavior setting work well together. Affordances help us understand why landing sites are selected, and *behavior settings, viewed as self-organized in-gatherings of landing sites, provide us a temporal stability formulation which, in effect, becomes a building block for architectural bodies.*

Those landing-site configurations elicited by architectural procedures or tactically posed surrounds/tutelary abodes that tend to recur may correspond to what Barker speaks of as a behavior setting; that is, landing-site configurations when in some way enduring are structured into or morphed into behavior settings.

Successful architectural procedures or tactically posed surrounds/tutelary abodes may become behavior settings because they attract a wide range of people. They, in effect, become communal, bottom up; that is, the landing sites they call

106

forth may become self-organized into behavior settings.

Behavior settings may be viewed as one type of instantiation of architectural bodies. Is it that landing sites are nested within behavior settings and behavior settings are nested within architectural bodies?

yours,

Reuben

p.s. My notion of a social affordance also goes beyond Gibson by focusing on *a collective* property of *a setting*.

February 2, 2003

Dear Reuben,

We are with you on this. We at one point were thinking of *person domains* as leading up to architectural bodies and have now begun to feel stirring within and about us the need and the desire for person domains to lead up to behavior settings which lead up to architectural bodies.

We are grateful to you for urging us on to give careful thought to how architectural procedures unfold and take effect when several organisms that person, a group of architectural bodies, are going at them.

To construct optimal behavior settings—that is the compelling task.

An optimal behavior setting will be one that points out to organisms that person a way out of their own mortality. Reversible-destiny behavior settings to order, to go. These will be great buddies to our architectural procedures or, in effect, sub-branches of them.

Upon reading this sentence of yours, "My notion of a social affordance also goes beyond Gibson by focusing on *a collective* property of *a setting*" (your p.s.), we were excited to find ourselves thinking in terms of ethical affordances/ethical landing sites. These are summing-up social affordances and landing sites. These particular affordances/landing-site dispersals condition all other affordances/landing-site dispersals and so are at the core of any landing-site configuration.

In a society in which dying will have become illegal, the social ecology (of

landing sites and architectural bodies) that you adumbrate will be tremendously important—we feel sure of this.

If dying could be made illegal—highly unlikely—that would effectively force the issue of how extensive an effort would be needed to stop dying from happening, to stop it in its tracks. As you know, it is through procedural architecture that we wish to make it possible for people not to die. Basing your social ecology on our humble (but, yes, we feel far-reaching) concepts, you demand, rightly so, that we take people into consideration as elements and features of architecture. Through the years many thinkers have supported what we are trying to do, but you have given us something special—a way to proceed.

always ever, in gratitude,

Arakawa Madeline

p.s. Often in the course of this exchange of letters with you, we have found ourselves thinking back to a terrifically gracious act toward us by Hans-Georg Gadamer. That he turns up here strikes us as being triply motivated. Naturally, he would come to mind in this context, because you, in particular, out of all those who have looked in our direction, have chosen to join us in our rush toward the transhuman, and so, too, in his own way did Gadamer. We don't remember whether we told you that he celebrated our work by quoting Paul Celan: *There are songs to sing beyond the human.* Another reason Gadamer comes to mind in this context is that when he spoke out in our defense he was well over ninety years of age. He was, come to think of it, the first of many nonagenarians for whom we have had a burning desire to build a new spacetime capsule, as it were, a bioscleave capsule. You, for your part, have promised to take this matter to the highest courts of social ecology and beyond. In addition to this, Joan* has embraced our work even to the extent of having worked out an evaluative protocol for *reversible destiny* architecture. If only then were now, that is what comes to mind. At the time at which we were in touch with Gadamer, despite our knowing that because of the advanced age of this friendly supporter of ours there was no time to lose, we simply had not proceeded far enough in our research to be in a position to propose a definite architectural structure for keeping him alive.

Let us not forget that it was Gadamer, a social ecologist *avant la lettre*, who insisted that thinking is essentially a conversation between participants who invent one another

* Editor's note: Psychologist Joan Boykoff Baron is Reuben Baron's wife.

Subject: Reaction to "letters" chapter

Dear Madeline and Arakawa,

My overall reaction to the "letters" chapter is very positive. In particular, you do a good job both of explicating my point of view and using my questions as a vehicle to present your own position. I also found the last letter very inspiring and moving.

With regard to the particulars, I have the following reactions.

[December 10, 2002, letter]

I would like to see a clarification of the type of wanting that characterizes what bioscleave wants, given it is neither a human nor divine type of wanting. Rather than use this type of anthropomorphic phraseology, I prefer working off of Stuart Kauffman's phrase, a "collectively autocatalytic system," a phrase that reflects the relationship between emergent life processes and self-organization. Specifically, such a system of systems requires that certain conditions exist, or better, be brought into being, for its maintenance and development. I do very much like your treatment of bioscleave as both a process and a structure, a noun and a verb.

[December 17, 2002, letter]

I would not likely ask this question because I do not believe that cognitive processes reflect a zero-sum epistemic game; these are for me open rather than closed systems, with no specific limits. Or if you prefer, landing sites cast into doubt the conventional views of cognitive capacity.

[January 15, 2003, letter]

I disagree with the proposition that "perceiving grows out of imaging." Asa Gibsonian, I would strongly argue for the primacy of perception. For example, species that are very unlikely to have the capacity for imaging have exquisitely

developed perceptual processes. Similarly, the development of brain likely preceded bottom-up epistemically, with lower-level structures, such as the brain stem, able to support perceptual but not conceptual processes. Once an organism has both conceptual and perceptual capabilities, there is likely to be a complex set of relations between perceiving and imaging, with each affecting the other.

[February 2, 2003, letter]

I am very intrigued by your notions of ethical affordances and ethical landing sites. Bert Hodges and I some years ago published a paper in the *Journal of the Theory of Social Behavior* that presents an ecological model of the primacy of values over rules and laws which has similar thrust.

I hope these reactions are helpful. And thank you for creating a productive dialogue between our ideas.

Reuben

September 27, 2006

Dear Madeline,

Thanks for sending me the revised chapter. My overall reactions remain very positive. I am, of course, pleased with your general openness to my attempts to bring my background, including J. J. Gibson's theory of perception and social psychological factors, to problems of mutual interest including my recent suggestion that the focus be on an organism that interpersons. With regard to particulars, I still stand by the questions I raised regarding the letters of Dec. 10, Jan. 5, and Feb. 2. Let me also grapple with the issue of dualisms, such as person-environment. My own take is as follows. My preferred way of framing the problem is that the person is in the environment and the environment is in the person. This is why broader environmental units such as a niche selects organisms that allow its survival and why organisms select niches that allow their survival. Further, from my perspective, niches self-organize themselves into the Bioscleave. That is, the Bioscleave is an emergent structure that has properties beyond being a constellation of niches. For example, once it forms, it changes the properties of constituent niches to ensure

that their interactions with the environment act to stabilize and benefit the higher unit, your Bioscleave.

If there is a meta-need for Bioscleaves, it would be for reciprocity—coordination is a means or one procedure for achieving reciprocity. What I called actualization is the coming into salience within a given space-time frame or event of a particular instance of reciprocity. For example, the registering of a landing site is indicated by a person's adopting a particular perceiving-acting strategy when he or she enters a particular architectural environment such as one of your buildings or parks.

My extension of this approach in the Paris talk assumes that organisms who interperson might use different perceiving-acting strategies when acting as part of a social unit, be it a dyad or a group. That is, what occurs in this context is not merely a summation of individual acts by an organism that persons. My contention is that when people act as part of a relational unit they often ignore their own predispositions. At the evolutionary level, Caporael and Baron (1997) have proposed that the group functions as "the mind's natural environment". Viewed thusly, many properties of perception and cognition emerge to facilitate the survival of the group. For example, increases in group size were likely to have been an important influence on the development of categorical thinking and the emergence of language. Thus the case for an organism that interpersons has evolutionary roots, an interpretation compatible with David Sloan Wilson's arguments for the importance of group selection.

In any case, I am appreciative that you and Arakawa have been so receptive to my attempts to formulate a social ecology that is appropriate for an architecture dedicated to defeating death.

I hope this is helpful.

Best,
Reuben

Reuben M. Baron, Ph.D., Professor Emeritus and Research Professor of Psychology, University of Connecticut, has pioneered the Gibsonian perceptual approach to social psychology, creating an ecological social psychology.

References: Caporeal, L.R. & Baron, R.M. (1997). Groups as mind's natural environment. In J. Simpson & D. Kenrick (Eds) Evolutionary approaches to personality and social psychology (313-339). Hillsdale, NJ: Erlbaum.

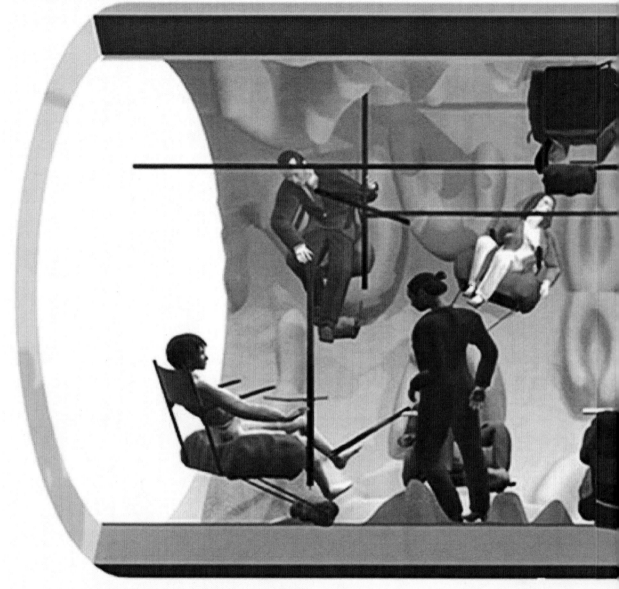

MAXIMAL SOCIAL EMBEDDING

Themselves highly organized segments of bioscleave, *organisms that person*

Within enclosures such as these, persons can learn to keep account of a
interactions amongst them; they will also be able to come to know how to
to good effect landing- site configurations and event fabrics.

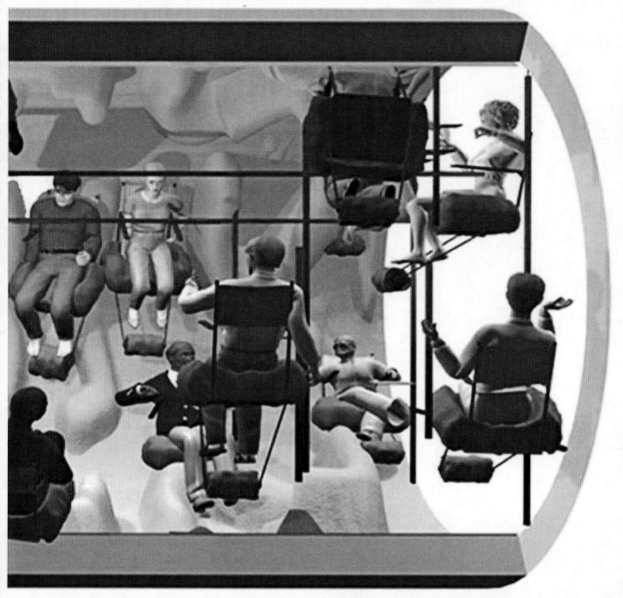

CONVERSATIONAL LATTICE

generate and perpetuate it (bioscleave) by virtue of their every move.

sufficient and therefore optimal number of scales of action and of the many
assess levels of organization of massenergy or of cleaving and to contrast

BIOSCLEAVE'S PROCLAMATION

I, the insufficiently procedural bioscleave, do hereby proclaim and would have whosoever can know know that governments enlightened enough to pass GOLDEN-RULE/SELF-PRESERVATION LAWS, of which the law making it a punishable crime to die is the prime example, are obliged to provide their citizens with whatsoever their citizens may have need of so as to be able to stay on the right side of said laws. Specifically, governments having in place a statute making it a wrongdoing for a person to die must do all within their powers, and have it that no effort be spared, to maintain the viability of each and every citizen.

ARCHITECTURAL PROCEDURES AND
TACTICALLY POSED SURROUNDS/TUTELARY ABODES

Procedural Architecture

At the heart of procedural architecture, a new architecture for the 21st century, lie architectural procedures and tactically posed surrounds/tutelary abodes, the latter being produced by the combining of the former (see below). Procedural architects hold fast to three hypotheses (see appendix A). Building a work of procedural architecture has everything to do with positioning architectural features and elements so as to give physical shape to architectural procedures. This done an environment (or surround) has been tactically posed.

Architectural Procedures and Tactically Posed
Surrounds/Tutelary Abodes Defined in Tandem

Insofar as they exist both in terms and by means of one another, it is best to define architectural procedures and tactically posed surrounds/tutelary abodes in tandem. Tactically posed surrounds/tutelary abodes not only house architectural procedures but consist almost entirely of them, and, prior to their incorporation into tactically posed surrounds/tutelary abodes, architectural procedures do not really begin to exist. Those elements and features of a surround that have been positioned to constrain a sequence of actions can be said to flesh out an architectural procedure, one that "steers" people in its vicinity to perform exactly that sequence of actions its components constrain. Each named procedure has two referents: the constructed something that makes up part, or, at times, the whole, of a tactically posed surround/tutelary abode and that sequence of actions that this constructed something leads those surrounded by it to perform. The two previous sentences amply demonstrate how much of an oddity an architectural procedure is; not only can an architectural procedure be spoken of as something that gets fleshed out by architectural elements and features, and thus defined as a construction or a constructed area, it can also be said to be those actions constrained by virtue of its physical existence, and thus defined as a particular set of movements through the world. What an architectural procedure constrains is identical with what the

tactically posed surround/tutelary abode that incorporates it tactically poses.

How Like and Unlike Unto a Medical Procedure
an Architectural Procedure Is

There is a general familiarity with medical procedures. The average citizen has undergone a few medical procedures and has a good sense of what a medical procedure is, despite its being the case that some never experience medical procedures more complex than having their blood drawn. Very few architectural procedures have thus far been invented and assembled, and even among the tiny number of people who know of them, few have experienced them. It happens to be that medical and architectural procedures alike get devised to help organisms that person (the body) continue to be viable, addressing their suspected trouble spots, blockages, hemorrhages or insufficiencies. Both classes of procedure require of those who perform them a great deal of coordinating skill, without which bodily distress could not be successfully alleviated nor limitations of the body countered. They can each be seen to be a variety of a clinical procedure. For the most part, only medical personnel perform medical procedures, applying their skills to a beneficiary, a patient in need. On the (big or outsized) contrary, one and the same person is both performer and beneficiary of an architectural procedure. An architectural procedure should be seen, then, to be a new and unusual clinical procedure, one that "patients" perform on themselves, going through, or rather, undergoing but also enacting—a strange combination of enacting and undergoing—sequences of actions that can undo troubling or unbearable circumstances. Furthermore, although medical procedures need to be performed on one patient at a time, architectural procedures can take place for many people at once. Whereas medical procedures for the most part are invasive, directly so, architectural procedures are by and large pervasive, or, to the extent that what pervades a tactically posed surround/tutelary abode can be considered to have invaded all those within it, only indirectly invasive.

Medical and architectural procedures differ as to characteristic sets of objects employed, relation of user to object, scales of action favored, and how directly they are put to use to achieve a desired result. Instruments and materials used in medical procedures are often smaller in size than the body with which they are brought in contact; those used in architectural procedures are usually larger than the body and may never come in contact with it. Objects get applied to or inserted into the body or surround it like a tight container (MRI and PET)—how could anything be more direct?! For a particular purpose, a new and still obscure

one, a group of objects fully surround the body, without touching it at all in many cases—how could anything be more indirect?

Then, too, there is this singular difference: architectural procedures as juxtaposed repeatable and re-combinable items can generate a discourse, a built discourse, but medical procedures can do no such thing.

The Tactically Posed Surround/Tutelary Abode as a Sentence (Phrase, Paragraph, Text)

Have it suffice for our purposes here simply to put forward the linguistic analogy adduced in our earlier work.

- An architectural procedure resembles its predecessor, a word, in two respects for a start: first, it is a repeatable item that readily lends itself to discursive use; second, charged with conveying a specific experience or range of experiences, it can be evaluated as to how well it serves its purpose or how effectively it has been put to use. (*Architectural Body,* p. 57)
- If architectural procedures serve as the words of a built discourse, then tactically posed surrounds/tutelary abodes, combining these procedures as they do, are its phrases, sentences, paragraphs, and texts. (*Architectural Body,* p. 57)
- Discursive sequences of tactically posed surrounds/tutelary abodes, constructed as built propositions, marshal existing logical connectives and position newly invented ones into the "real," steering, regulating, and guiding interactions between body and biscleave through three-dimensional THEREFOREs, BUTs, ORs, ANDs, and built-up WHATEVERs. (*Architectural Body*, pp. 58-59)

Tactically Posed to What End?

The biosphere has been given the new name, biscleave, as a means of keeping in evidence the universe's actual but albeit highly abstract dynamics, a dynamics that *sub specie aeternitatis* remains disturbingly abstract despite its being the concrete basis of everything. By its maintaining that biscleave is insufficiently procedural, the insufficiently procedural biscleave hypothesis gently but firmly pushes us to deduce our species' central task to be the adding to biscleave of precisely what it would seem to lack, procedures for a start, architectural ones to be sure.

Formed through the addition of architectural procedures one to another, tactically posed surrounds/tutelary abodes should be able to reconfigure and thereby

117

bolster poor weak, despite being all-powerful, bioscleave, supplying the multidimensional procedures it sorely lacks. They also will give those large masses of atmospheric life we have named architectural bodies organizing possibilities that would otherwise be unavailable to them, making it possible, we believe and do here affirm, for these architectural bodies and their *organisms that person* (n.b. co-generators with bioscleave of architectural bodies) to go on indefinitely.

9

NEARLY UNIVERSAL AFFIDAVIT/ LOOSENING IDENTITY FOR BIOTOPOLOGICAL PURPOSES

A biotopological condition has gotten totally reconfigured, basically turned inside out; it was only subsequent to my living within a tutelary abode that I came to know of myself as being in a biotopological condition of any sort.

I would until only recently have had to have been classed as one stubborn nut-case, murderous, suicidal or self-suffocating, and massively suffocating to and for others. The finished product who in my shallowest of worlds I had assumed myself to be. . . . A tutelary abode plus a group of GOLDEN-RULE LAWS/SELF-PRESER-VATION LAWS have managed to turn this supposedly finished product into . . . but who am I to say what this is that I have become.

I certainly never thought I would do so complete an about face in *this* life. In much the same sense that people speak of someone's having a tin ear, I hereto-fore led a tin life. The word "tin" put to adjectival use denotes that the modified substantive lacks most if not all of its set of qualities. Taken in retrospect, there was not much life to my life. And yet I didn't want to die. But I was, of course, among those who had disdain for and mocked the *Dying is Illegal* statute. Be that as it may, I, along with all the other citizens of my state, was obliged to move into a tutelary abode, a tactically posed surround/tutelary abode, that would bring my life actions into conformity with existing law. In the years preceding that impor-tant move, I had been someone who spoke, spoke up, declared, and decreed, and minded other people's business, all the while trying to make money hand over fist. It is not that I saw the light and went softer and wider; rather, I moved from liv-ing as an example of a poor excuse for living to being inordinately an organed atmospheric mass having a transhuman lilt to it.

Most readers will judge this affidavit to be inauthentic. This has already started to happen. Nex LeLander read some of it the other day and laughed at the thought of anyone thinking to associate a(n) (albeit former) monster of sorts with the writer of these words. And this came from the unusually generous-hearted Nex who is usually willing to give anyone the benefit of the doubt. But for those in whom the forty-two tributaries or so that give rise to a compassionate self have

never flowed or in whom they simply dried down and went missing. . . . Thin, tinny lives perhaps, but ones nevertheless still ample enough to have breaths zooming through flesh transpiringly.

Thank goodness the abode within which I was obliged to live in order to stay on the right side of the law has activated those forty-two tributaries and more in me. First off I became unable to see the forest (myself) for all the trees, and that was a good thing. If you insist on my coming up these days with an identity for myself, have it be this one: *That which figures itself out in terms of me.* You see, what it is I *am* (obfuscating and thus annoying word) is very much like and has everything to do with what you *are* (obfuscating and thus annoying word). I disperse sensitivity alive in every direction. The abode lets me know this in no uncertain terms. It tracks dispersals of what its architects speak of as landing sites. I disperse landing sites quite precisely in response to and in accordance with the elements and features—how things are laid out, often tactically posed—vying for my attention within areas and sub-areas that give shape to this uproarious biotopological condition of mine. I do not collect them to form a someone having any degree of definiteness. . . . I have successfully escaped the habit of subsuming all that jumps with aliveness in my vicinity, all that bristles and knocks about. . . . what I do do is with the guidance and support of my tutelary abode augment existing coordinating skills and scare up new ones.

The *organism that persons* I live as sees for itself now a full, full purpose, whereas before I had none or tin ones. I could not achieve a true linking of one thought to another. Someone who is not quite there, you may have noticed, can even so speak or speak up a lot. I felt sure of myself in many respects, one, because of some things I had heard along the way and, two, because my punched and ferociously buffeted carved-out cartilaginous ego plus x. . . . I was often given to feel there could be no backing down. Call the me of then John or Jane Rote.

These days if . . . forced to put it some way . . . it is as a loosely-knit group of self-organizations that I refer to myself. The abode within which I have had to reside so as to be in compliance with the statute forbidding dying elicits many would-be selves of mine, not unlike how my mother long ago would have, if only she could have, evoked from the baby organism she held close to her a plethora of selves for me.

There was so much that I didn't know in my very shallow, callow days. No one had introduced me to, or better, no one had prepared me to catch the import of well-documented facts, which might as well be spoken of as laws, derived from peer-reviewed studies of how infants become persons. Thus, despite having

observed all around me the devastating effects from people's lack of knowledge of the following law basic to the life of an *organism that persons,* and although I myself had had hideously to plummet through many degrees of unreality, yes, at one point nearly dying, for lack of sufficient fructification, exactly as this new-to-me and new-to-the-world law of human behavior avers, and in so far as this was in the first place never presented to me as a natural law of *organisms that person* that they had no choice but to obey, back then I could not for the life of me incorporate it into my existence so as to do a better job of staying alive:

By virtue of erratic or insufficient inter-grooving with bioscleavic emanations of others (or by virtue of a lack of what some theorists refer to as inter-subjective attachment) and as a result of abrupt disruptions to bioscleavic inter-grooving, people become unreal to themselves, thereby coming to be, so to speak, societally loose cannons. An infant can even be so unfructified as to be driven to an early grave.

The above is a well-documented statement of fact that has only recently been promulgated as law far and wide. It has been put forward together with three sense-reinforcing corollaries which, as corollaries will do, take what it has to say and run with it.

Corollary One: *The most important aspect of development to be elucidated is the idea of others and of one's own relationship to them.*

Corollary Two: *One of the great tasks in life is to allow a sense of interdependency to deepen.*

Corollary Three: *Self-regulation, the forming of oneself as a person, grows out of mutual or inter-active regulation.*

Only in a magician's trick can milk poured from a pitcher into a glass turn out to be nothing more than a glass of water or water poured from a pitcher produce a glass of milk. Why say this here? For the moment simply keep this example vivid in the vicinity of what is being discussed, and I promise to return to it specifically in short order.

How incalculably injurious to our species it has been . . . what a sadness wells up in me to think that a law of human behavior of such great import has remained hidden in plain sight since the beginning of recorded history, and no doubt before that. And so we come to know that there's no getting around this: bioscleavic emanations from one *organism that persons* to another bring life to life, or, put another way, organize life into being communicatively coherent. *Organisms that person* can do this—pour communicatively coherent solicitous streams, tributaries of the fullness of life, toward budding others. All life is bud-

ding. All lives are budding.

To think that human beings are not interdependent is an illusion. To operate on the basis of such an illusion and to attempt, for example, to govern others is to be delusional. Who would be so arrogant as to pretend to be on her own. Those able to allow a sense of interdependency to deepen will, without much ado, and yet with momentous ado, find that they have, in an all-important regard, stopped fooling themselves.

It is through interacting with another *organism that persons* that an *organism that persons* forms itself into a person. Interrupt this process of forming a person and an *organism that persons* grows unreal to itself. The air all around it and which it breathes and which moves within it will feel paper thin—a sheet of air equaling a sheet of paper. There can be air that has had all of the air knocked out of it. Paper thick. Flesh becomes stone. You cannot get blood from a stone. You cannot breathe paper. Paper and air are dimensionally disparate. So too are flesh and stone. Those who become unreal to themselves sometimes find that they are palpable to themselves as merely paper or stone. The experience of an infant held by a mother who has a stone feel to herself will be markedly different from that of an infant whose mother has all the dimensions of flesh. Only those *organisms that person* who have succeeded in forming themselves as persons can fructify others. Those who have become unreal to themselves, even if they contribute themselves in full to others, pouring out in the direction of others the wholeness of their unrealities, can only form others who are also unreal to themselves.

And so *organisms that person* unable to pour out wholeheartedly the milk of human kindness deliver only a watered-down version of . . . Bioscleavic transactions abundantly deliver up all that we live by and are far grander than any mere magic trick. Whatever can result from bioscleavic transactions does. There can be no trickery in associative coordinating skills of *organisms that person*, and, across and between all scales of action, bioscleavic emanations animate the world. Exactly to the extent that they participate in bioscleavic transactions, only to that extent, do creatures become bioscleavically endowed; abundance in creatures can only be formed through solicitous steady streams of inter-grooving bioscleavic emanations. In other words, gracious acts of acculturation, consisting of steady streams of bioscleavic emanations, form persons.

Everything in the developing child, and later the adult, is a product of interaction. Endorphin pathways are established during the first year of life in response to various kinds of emotional experiences between the child and her caregivers; failure-to-thrive infants suffer from an actual deficiency of growth hormones that

are activated by physical and emotional stimulation provided by caregivers.

To form a person and to form an identity are not the self-same process. All supposed identities are half-told stories, dogmatic and highly unreliable patchwork narratives. It is incredibly important that what each *organism that persons* claims as its identity be nothing more than this: *organism that persons.* To try to have an identity over and beyond this would too drastically limit one's possibilities, inasmuch as it would promote separatism, isolating this ethnicity from that, this family from that. The thing of it is that streams of inter-subjective attachment generally do not flow wholeheartedly as the milk of human kindness between people who consider themselves to have strikingly different identities; thus, if there is going to be a community-wide effort to do away with dying, then, so that people won't be insufficiently fructified, so that they *will* be sufficiently encouraged along and replenished by streams of bioscleavic emanations, separatism-causing identities must be let go of.

<p style="text-align:center">* * *</p>

Following Suttie, I will (a) have love be thought of as quickness of sympathetic response, readiness of understanding, alacrity to laugh in sympathy with—in sum, a many-streamed feeling-interest responsiveness; (b) know an infant's longing for its mother to be the expression of innate-need-for companionship and of what in free-living animals we call the self-preservation instinct. Frustrating this urgent need will switch about direction of flow. Say that love and hate form a continuum. Another way to think of the switching about of emanating flows that both manifests as and gets exacerbated by frustration of loving longing, or that equally comes from an impending sense that all will conspire to bring about the frustration of loving longing, is as the peremptory shutting off of access to the blossomings of different scales of action. Love blossoms different scales of action. When access is cut off from different scales of action an *organism that persons* loses cognizance of its biotopological condition. All the many sides of things and events . . . Hate is the collapse of love.

<p style="text-align:center">* * *</p>

Enforceable rules that buoy up the self-preservation instinct have been named GOLDEN-RULE LAWS/SELF-PRESERVATION LAWS. A whole host of subsidiary

<p style="text-align:center">*123*</p>

GOLDEN-RULE LAWS/SELF-PRESERVATION LAWS strengthen and prepare the way for the ultimate one, the *Dying is Illegal* statute, providing the means for it to be graciously and magnanimously enforced. GOLDEN-RULE LAWS/SELF-PRESERVATION LAWS, which start from the dictum that a person should always think only of doing to others what she would find acceptable to have others do to her, generally hold people criminally responsible for their own ignorance when it comes to self-preservation. Inasmuch as we are interactively formed, a thorough-going pursuit of self-preservation must involve not only knowing what's good for you but also being cognizant of the effects your actions have on others. In my opinion, we will need more of these laws than we now have. These laws have nothing obscure about them. As I have said, they are for the most part laws for the support of a law, the law which should and will rescue our species from its abysmal fate. Thus, there's a law stating that the failure to maintain a reflective attitude towards oneself as an organism, which includes taking all the necessary measures in this regard, constitutes a felony. At what point does one's allowing oneself to fall apart become criminal? This never happens to someone by virtue of her acts alone. One person's falling apart belongs to us all, to society at large. It is a misdemeanor not to cauterize or sterilize a wound or when it is necessary to wear a band-aid not to, or, for that matter, not to keep your Ace bandage clean, but it is a felony not to make an effort to keep your blood pressure normal or your blood appropriately alkaline. Not striving to reduce major health risks is counted felonious self-assault and so too allowing oneself to catch the flu.

A spreading wide-open of the notion/construct of self-preservation, in which the self is taken to be, at the very least, a dyad, is in evidence in the statute forbidding counter-productive interactions. This law makes it a felony for a parent or caregiver not to be up-to-date about how to interact with an infant. Citizens are also required by law to live as great unknowns, listing all they know and all they don't know about themselves as *organisms that person*.

Alongside of this statute can be found another which lets it be known that those citizens who do not put first the health of everyone with whom they have any contact are to be classed as felons.

> ▪ *It is illegal for a caregiver not to teach rhythmically and appropriately the infant citizen in her charge self-regulation and mutual-regulation skills. (An* organism that persons *lacking such skills will have difficulty forming or be unable to form a person, that is, those who lack these skills will to some extent, be it little by little or massively, die.)*

- *It is against the law to behave toward an organism that persons as if its intricacy and complexity were discardable.*
- *It is a crime to countenance, ignore, or be involved to any extent in another's dissolution.*

The *Not-So-Damned-Sure-Of-Oneself* Statute has great self-preservation implications, even as it works to put the notion of self—a self— in doubt. We must know that of which we are formed and not stray away too severely from it, at least not without, at least trying to keep track of what we have been up to and why. I found that impossible to do earlier on when I was a too-damned-sure-of-myself person. My dear abode managed, by virtue of how it was formed, to introduce me on a daily basis to my own tentativeness, a tentativeness that I had feared would be nightmarish, but that proved to be not at all so. The diligent abode also stopped me from repeating the mistakes of interaction that the oh-too-innocent parenting I had received had, stamped with a mark of inevitability, set in motion within and about me. I had learned from my relationship with my parents that other people were not likely to contribute anything positive to my experience but required careful handling and deflecting. I had to return to zero and zero was all my tentativeness. Only once I was a not-so-damned-sure-of-myself person could I proceed to do something about my predicament of a life by making use of the following laws of behavior.

- *The way one thinks about feelings can be determinative of which feelings one experiences and whether they develop.*
- *The body always focally implies a next step, and also implicitly includes all sequences that ever were, in a mesh so they are implicit in each other.*
- *Only those who acquire the ability to modulate sensitivity will be able to remain true to experience without being fatally done in by it. (Please note that a federal law based on this local GOLDEN-RULE LAWS/SELF-PRESERVATION LAWS is currently being drafted.)*
- *By the time awareness of physicality arises, the experience of the loss + return of consciousness has been well-established as a governing, underlying pattern.*
- *One may spend one's life trying to catch up to states that early on one could not work with well enough.*
- *The long period in infantile immaturity gives rise to a sense of deficit that can be exacerbated as development proceeds.*

- *It is common to dread that one's own malevolent intentions are limitless/It is common to dread that the malevolent intentions of this or that person are limitless.*
- *Those who wish to be forgiven should ditch any pretension toward omniscience. That an offender has genuine humility is a precondition for forgiveness.*
- *A more contactful attitude will spontaneously appear once one realizes—really gets it—how cut off one is from others.*
- *No matter how ghastly the life situation becomes, an organism that persons can summon up an image that can save the day, which can guard its integrity.*

You have been reading the nearly universal affidavit of a formerly would-be suicide, a formerly would-be suicide bomber, a formerly would-be ultra-conservative, a formerly would-be _____.

<p style="text-align:center">* * *</p>

Pleas/Testimonies

<p style="text-align:center">June 8, 2006</p>

Dear Mothers and Fathers and Brothers and Sisters,
Dear Community,

Speak to me of love. Tenderly tell me once more what I long to hear. My heart will not shrink back from listening to your lovely discourse. Do let it be that always you repeat these supreme words: I love you.

You certainly know that deep down I don't believe you for a minute, but even so I want to hear yet again these words that I adore. Your voice which tremblingly murmurs it in caressing tones cradles me with its beautiful story, and I wish, in spite of myself, to believe you. Speak to me of love. Tenderly tell me once more what I long to hear. My heart will not shrink back from listening to your lovely discourse. Do let it be that always you repeat these supreme words: I love you.

It is so sweetly fitting, my treasured one, to be a little mad. Life can be too

bitter if one does not believe in chimera. Vexation is quickly soothed and consoled by a kiss. For the heart a wound is cured by a sermon that surfaces to reassure it.

Yours in search of how to do everything,

formerly a would-be <u>suicide</u>
formerly a would-be <u>suicide bomber</u>
formerly a would-be <u>ultra-conservative</u>
formerly a would-be _____

A mortal who would prefer not to be mortal

* * *

July 19, 2006

Dear Mothers and Fathers and Brothers and Sisters,
Dear Community,

It was a philosopher's stone that you were in search of. You wished to brew the elixir of life. This is what you wrote shortly before you created me: *If I could banish disease from the human frame and render them invulnerable to any but a violent death.*

I intended to reason. This passion is detrimental to me; for you do not reflect that *you* are the cause of its excess. If any being felt emotions of benevolence towards me, I should return them an hundred and an hundred fold; for that one creature's sake, I would make peace with the whole kind! But I now indulge in dreams of bliss that cannot be realized. I am malicious because I am miserable. Am I not shunned and hated by all mankind? You, my creator, would tear me to pieces, and triumph; remember that, and tell me why I should pity man more than he pities me? You would not call it murder if you could precipitate me into one of those ice-rifts, and destroy my frame, the work of your own hands. Shall I respect man when he contemns me? Let him live with me in the interchange of kindness; and, instead of injury, I would bestow every benefit upon him with tears of gratitude at his acceptance. But that cannot be; the human senses are insurmountable barriers to our union. Yet mine shall not be the submission of abject slavery. I will revenge my injuries: if I cannot inspire love, I will cause fear.

. . . a young girl came running towards the spot where I was concealed, laughing, as if she ran from someone in sport. She continued her course along the precipitous side of the river, when suddenly her foot slipt, and she fell into the rapid stream. I rushed from my hiding place; and, with extreme labour from the force of the current, saved her, and dragged her to shore. She was senseless; and I endeavoured by every means in my power to restore animation, when I was suddenly interrupted by the approach of a rustic, who was probably the person from whom she had playfully fled. On seeing me, he darted towards me, and tearing the girl from my arms, hastened towards the deeper parts of the wood. I followed speedily, I hardly knew why; but when the man saw me draw near, he aimed a gun, which he carried, at my body, and fired. I sunk to the ground, and my injurer, with increased swiftness, escaped into the wood. "This was then the reward of my benevolence! I had saved a human being from destruction, and, as a recompense, I now writhed under the miserable pain of a wound, which shattered the flesh and bone. The feelings of kindness and gentleness which I had entertained but a few moments before gave place to hellish rage and gnashing of teeth. Inflamed by pain, I vowed eternal hatred and vengeance to all mankind. But the agony of my wound overcame me; my pulses paused, and I fainted.

For some weeks I led a miserable life in the woods, endeavouring to cure the wound which I had received. The ball had entered my shoulder, and I knew not whether it had remained there or passed through; at any rate I had no means of extracting it. My sufferings were augmented also by the oppressive sense of the injustice and ingratitude of their infliction. My daily vows rose for revenge—a deep and deadly revenge, such as would alone compensate for the outrages and anguish I had endured. After some weeks my wound healed, and I continued my journey. The labours I endured were no longer to be alleviated by the bright sun or gentle breezes of spring; all joy was but a mockery, which insulted my desolate state, and made me feel more painfully that I was not made for the enjoyment of pleasure.

At first I started back, unable to believe that it was indeed I who was reflected in the mirror; and when I became fully convinced that I was in reality the monster that I am, I was filled with the bitterest sensations of despondence and mortification. Alas! I did not yet entirely know the fatal effects of this_____ (miserable deformity) I now . . . I shall relate events that impressed me with feelings which, from what I had been, have made me what I am. Through this work (Volney's *Ruins of Empires*) I obtained a cursory knowledge of history, and a view of the several empires at present existing in the world; it gave me an insight into

the manners, governments, and religions of the different nations of the earth. I heard of the discovery of the American hemisphere and wept with Safie over the hapless fate of its original inhabitants. I read of men concerned in public affairs, governing or massacring their species. I felt the greatest ardour for virtue rise within me, and abhorrence for vice, as far as I understood the signification of those terms, relative as they were, as I applied them, to pleasure and pain alone. When I viewed the bliss of my "protectors," the bitter gall of envy rose within me. As yet I looked upon crime as a distant evil; benevolence and generosity were ever present before me, inciting within me a desire to become an actor in the busy scene where so many admirable qualities were called forth and displayed.

As I read, however, I applied much personally to my own feelings and condition. I found myself similar, yet at the same time strangely unlike to the beings concerning whom I read, and to whose conversation I was a listener. I sympathized with, and partly understood them, but I was unformed in mind; I was dependent on none and related to none. 'The path of my departure was free'; and there was none to lament my annihilation. Who was I? What was I? Whence did I come? What was my destination? These questions continually recurred, but I was unable to solve them. These wonderful narrations inspired me with strange feelings. Was man, indeed, at once so powerful, so virtuous and magnificent, yet so vicious and base? He appeared at one time a mere scion of the evil principle, and at another as all that can be conceived of noble and godlike. To be a great and virtuous man appeared the highest honour that can befall a sensitive being; to be base and vicious, as many on record have been, appeared the lowest degradation, a condition more abject than that of the blind mole or harmless worm. For a long time I could not conceive how one man could go forth to murder his fellow, or even why there were laws and governments; but when I heard details of vice and bloodshed, my wonder ceased, and I turned away with disgust and loathing. The words induced me to turn towards myself. I learned that the possessions most esteemed by your fellow-creatures were high and unsullied descent united with riches. A man might be respected with only one of these advantages; but, without either, he was considered, except in very rare instances, as a vagabond and a slave, doomed to waste his powers for the profits of the chosen few! And what was I? Of my creation and creator I was absolutely ignorant; but I knew that I possessed no money, no friends, no kind of property. I was, besides, endued with _____ (a figure deformed and loathsome); I was not even of the same nature as man. I was more agile than they, and could subsist upon coarser diet; I bore the extremes of heat and cold with less injury to my frame. When I looked around, I saw and heard of

none like me. Was I then a monster, a blot upon the earth, from which all men fled, and whom all men disowned?

I formed in my imagination a thousand pictures of presenting myself to them, and their reception of me. I imagined that they would be disgusted, until, by my gentle demeanour and conciliating words, I should first win their favour, and afterwards their love. Other lessons were impressed upon me even more deeply. I heard of the difference of sexes; and the birth and growth of children; how the father doted on the smiles of the infant, and the lively sallies of the older child; how all the life and cares of the mother were wrapped up in the precious charge; how the mind of youth expanded and gained knowledge; of brother, sister, and all the various relationships which bind one human being to another in mutual bonds. But where were my friends and relations? No father had watched my infant days, no mother had blessed me with smiles and caresses; or if they had, all my past life was now a blot, a blind vacancy in which I distinguished nothing. From my earliest remembrance I had been as I then was in height and proportion. I had never yet seen a being resembling me, or who claimed any intercourse with me. What was I? The question again recurred, to be answered only with groans. My attentions (for so I loved, in an innocent, half painful self-deceit, to call them), at this time, was solely directed towards my plan of introducing myself into the cottage of my protectors.

The more I saw of them, the greater became my desire to claim their protection and kindness; my heart yearned to be known and loved by these amiable creatures: to see their sweet looks directed towards me with affection was the utmost limit of my ambition. I dared not think that they would turn them from me with disdain and horror. The poor that stopped at their door were never driven away. I asked, it is true, for greater treasures than a little food or rest: I required kindness and sympathy; but I did not believe myself utterly unworthy of it. I resolved many projects; but that on which I finally fixed was, to enter the dwelling when the blind old man should be alone. I had sagacity enough to discover that of my person was the chief object of horror with those who had formerly beheld me. My voice, although harsh, had nothing terrible in it; I thought, therefore, that if, in the absence of his children, I could gain the good-will and mediation of the old De Lacey, I might, by his means, be tolerated by my younger protectors.

I am an unfortunate and deserted creature; I look around, and I have no relation or friend upon earth. These amiable people to whom I go have never seen me, and know little of me. I am full of fears; for if I fail there, I am an outcast in the world forever.

"Do not despair. To be friendless is indeed to be unfortunate; but the hearts of men, when unprejudiced by any obvious self interest, are full of brotherly love and charity. Rely, therefore, on your hopes; and if these friends are good and amiable, do not despair."

"They are kind—they are the most excellent creatures in the world; but, unfortunately, they are prejudiced against me. I have good dispositions; my life has been hitherto harmless, and in some degree beneficial; but a fatal prejudice clouds their eyes, and where they ought to see a feeling and kind friend, they behold only a detestable monster."

When night came, I quitted my retreat, and wandered in the wood; and now, no longer restrained by the fear of discovery, I gave vent to my anguish in fearful howlings. I was like a wild beast that had broken the toils; destroying the objects that obstructed me, and ranging through the wood with a stag like swiftness. O! what a miserable night I passed! the cold stars shone in mockery, and the bare trees waved their branches above me: now and then the sweet voice of a bird burst forth amidst the universal stillness. All, save I, were at rest or in enjoyment: I, like the arch-fiend, bore a hell within me; and, finding myself unsympathised with, wished to tear up the trees, spread havoc and destruction around me, and then to have sat down and enjoyed the ruin. "But this was a luxury of sensation that could not endure; I became fatigued with excess of bodily exertion, and sank on the damp grass in the sick impotence of despair. There was none among the myriads of men that existed who would pity or assist me; and should I feel kindness towards my enemies? No: from that moment I declared everlasting war against the species, and, more than all, against him who had formed me, and sent me forth to this insupportable misery . . . when I reflected that they had spurned and deserted me, anger returned, a rage of anger; and, unable to injure anything human, I turned my fury towards inanimate objects.

"From you only could I hope for succour, although towards you I felt no sentiment but that of hatred. Unfeeling, heartless creator! you had endowed me with perceptions and passions, and then cast me abroad an object for the scorn and horror of mankind. But on you only had I any claim for pity and redress, and from you I determined to seek that justice which I vainly attempted to gain from any other being that wore the human form."

"How can you, who long for the love and sympathy of man, persevere in this exile?"

"How is this? I must not be trifled with: and I demand an answer. If I have no ties and no affections, hatred and vice must be my portion . . . My vices are the

children of a forced solitude that I abhor . . . I shall feel the affections of a sensitive being, and become linked to the chain of existence and events, from which I am now excluded."

Yours in search of how to do everything,

~~formerly a would-be <u>suicide</u>~~
~~formerly a would-be <u>suicide</u> bomber~~
~~formerly a would-be <u>ultra-conservative</u>~~
~~formerly a would-be _____~~

A mortal who would prefer not to be mortal

p.s. All of us might be regarded as struggling most fundamentally with problems of self-regulation, self-esteem, personal vitality.

* * *

July 28, 2006

Dear Mothers and Fathers and Brothers and Sisters,
Dear Community,

As much as I certainly directed all my everything in this letter you are now reading to the dancing doll known as Lotte, my starts and stops with many of you did surely also pull me apart. Do please in reading this keep Lotte in mind but also surely let her go. I want you to hear this as if it were addressed directly to you.

It is decided, Lotte, that I shall die, and I am writing you this calmly, without any romantic exaltation, on the morning of the day when I shall see you for the last time. When you read this, my dearest, the cold grave will already cover the stiffened body of the restless, unfortunate man who does not know any sweeter way to pass the last moments of his life than to talk to you. I have had a terrible, but ah, what a wonderful night. It has strengthened and confirmed my resolution: to die! Yesterday, when I tore myself away from you, my whole nature in terrible revolt, everything rushing into my heart, and when my hopeless, cheerless existence so close to you overwhelmed me with a ghastly chill—I was hardly able to reach my room; almost beside myself, I fell on my knees, and, O God, you granted me a last consolation of bitter tears! A thousand plans, a thousand hopes raged in my soul, but finally it was there, firmly, wholly, the one last thought: to

die! I lay down, and this morning, in the peace of awakening, it is still firm, still strong in my heart: to die!—It is not despair; it is the certainty that I have suffered enough, and that I am sacrificing myself for you. Yes, Lotte! Why should I hide it from you? One of us three must go, and I am to be that one! O my dearest, my wounded heart has been haunted by a terrible demon—often. To murder your husband! Or you! Or myself! Well, so be it! When you walk to the top of the mountain, on a fine summer evening, remember me; how I often came up there from the valley to meet you; and then look across to the churchyard and to my grave, where the wind gently sways the tall grass in the light of the setting sun.—I was calm when I began to write this letter and now, now I am weeping like a child, when all this comes so vividly to my mind.

You do not expect me! You think I shall obey you and not see you again until Christmas Eve. O Lotte! today or never again. On Christmas Eve you will hold this piece of paper in your hand, trembling and covering it with your sweet tears.

I will, I must! Oh, how relieved I am now that I have made up my mind. Why dost thou awake me, O spring? Thou dost woo me and say: I cover thee with the dew of Heaven! But the time of my fading is near, near is the storm that will scatter my leaves! Tomorrow the wanderer shall come, he that saw me in my beauty shall come. His eyes will search me in the field around, and will not find me. For the last time, then, for the last time I open my eyes to this world. Alas, they shall not see the sun again, for today it is hidden behind a veil of mist. Now, Nature, mourn your son, your friend, your lover who nears his end. Lotte, this is a unique sensation, and yet it resembles a twilight dream, when one says to oneself: "This is the last morning. The last!" Lotte, these words mean nothing to me. Am I not standing here alive, in the possession of all my faculties, and yet tomorrow I shall lie prostrate and motionless on the ground. To die! What does that mean? Look, we are dreaming when we speak of death. I have seen many people die; but so limited is the human mind that it has no clear conception of the beginning and the end of our existence. At this moment I am still mine, yours! yours, my beloved! And the next moment—separated, divorced from you, perhaps forever? —No, Lotte, no! How can I *not* be? How can you *not* be? We *are* after all.—*Not* be! What does that mean? It is only a word, a mere sound, which stirs nothing in me.—Dead, Lotte! thrown into the cold ground, so narrow, so dark!—I once had a friend who meant everything to me in my awkward youth; she died, and I followed the bier and stood beside her grave when they lowered the coffin, and the ropes that held it whirred as they were loosened and jerked up again; and then the first shovelful of earth fell with a thud, and the fearful chest gave back a hollow

sound, more muffled every time, until it was completely covered with earth. I fell to the ground beside the grave—shocked, shaken, frightened, heartbroken; but I did not know what had happened to me—what will happen to me.—Death! The grave! I do not understand these words.

Oh, forgive me! forgive me! Yesterday! It should have been the last moment of my life. O angel! for the first time, quite without doubt, I had in my heart of hearts the glowing thought: she loves me! she loves me! My lips are still burning with the sacred fire kindled by yours; there is a fresh warm feeling of happiness in my heart. Forgive me! forgive me! Oh, I knew that you loved me—knew it from the first warmhearted glance, from the first pressure of your hand; and yet, when I was not with you, when I saw Albert at your side, I was again tormented by feverish doubts.Do you remember the flowers you sent me when you had been unable to say one word to me or give me your hand at that hateful party? Oh, I was on my knees before them almost all night; and, for me, they put the seal on your love. But alas! these impressions faded, as the feeling of God's mercy gradually fades from the soul of the believer after it had been showered on him in holy and visible symbols.

All this is transitory, but no Eternity shall extinguish the warm life that I drank yesterday from your lips and that I still feel within me. She loves me! This arm held her, these lips have trembled on her lips, this mouth has stammered against hers. She is mine! You are mine, Lotte, forever!

And what does it mean that Albert is your husband? Husband! He may be for this world—and in this world it is sin that I love you, that I should like to snatch you from his arms into mine. Sin? Very well, and I am punishing myself for it; for this sin, which I have tasted in all its rapture, which gave me life-giving balm and strength. From now on you are mine! mine, Lotte! I go before you. I go to my Father, to your Father. I shall put my sorrow before Him, and He will comfort me until you come; and I shall fly to meet you and clasp you and stay·with you before the Infinite Being in an eternal embrace.

I do not dream; I am not deluded! So near to the grave, I see everything with great clearness. We shall be! we shall see one another again, see your mother. I shall see her, find her and ah! pour out all my heart to her, your mother, your very image.

They have passed through your hands; you have wiped the dust from them. I kiss them a thousand times because you have touched them; and you, Heavenly Spirit, approve of my decision! And You, Lotte, offer me the weapon—you, from whose hands I wished to receive death, and ah! not receive it. Oh, how I ques-

tioned my servant! You trembled when you gave them to him, but you did not send me any farewell. Alas, alas! no farewell! Should you have closed your heart to me because of the moment that pledged me to you forever? Lotte, a thousand years cannot efface that memory! And I feel that you cannot hate him who burns with love for you.

After eleven. Everything is so quiet around me, and my soul is so calm. I thank you, God, who gives these last moments such warmth, such strength! I walk to the window, my dearest, and see—still see—some stars in the eternal sky, shining through the stormy, fleeting clouds. No, you will not fall! The Eternal Father carries you near His heart, and me as well. I see the stars that make up the shaft of the Dipper, my favorite constellation. When I used to leave you at night and had passed your gate, these stars were just opposite me. How often have I looked up at them with rapture! How often have I raised my hands to them, regarding them as a symbol, a hallowed token of my happiness. And still now—O Lotte, does not everything remind me of you? Are you not always near me; and have I not, like a child, greedily snatched all sorts of trifles which you, dear saint, had touched!

Precious silhouette! I return it to you Lotte, and ask you to take good care of it. I have covered it with many, many kisses; I have greeted it a thousand times whenever I went out or came home. I have written your father a note and asked him to take care of my body. In the churchyard are two linden trees, in a far corner, next to the field; there I should like to rest. He can and will do this service to his friend. Do ask him, too. I do not like to hurt the feelings of devout Christians, who might not want to rest beside a poor, unhappy man. Oh, I wished you would bury me by the wayside or in a remote valley, where priest and Levite may pass by the marked stone, thankful that they are not as other men, and the Samaritan may shed a tear.

Here, Lotte! I do not shudder to grasp the cold and dreadful cup from which I am about to drink the ecstasy of death. Your hand gave it to me, and I do not flinch. All, all the desires and hopes of my life are fulfilled! So cold, so rigid to knock at the iron gate of death. Had I been granted the happiness to die for *you!*, Lotte, to sacrifice myself for *you!* I would die bravely, I would die cheerfully, if I could restore to you the peace and happiness of your life. But alas! it is reserved for only a very few noble souls to shed their blood for those who are dear to them, and by their deaths to fan the flame of life of their friends to a new and wonderfully increased splendor.

I want to be buried in these clothes I wear, Lotte! You have touched them and hallowed them. I have also asked your father to carry out this request. My soul

hovers above the coffin. Do not let them look through my pockets. This rose-colored ribbon which you wore on your breast the first time I saw you, surrounded by your children—oh, give them a thousand kisses, and tell them the fate of their unhappy friend. The darling children! they swarm around me! Ah, how quickly I grew fond of you; I could not keep away from you from the first moment.—Let this ribbon be buried with me; you gave it to me on my birthday. How eagerly I accepted all this!—Ah, I did not think the way would end here! Be calm! Please, be calm!

They are loaded. The clock strikes twelve. So be it! Lotte! Lotte! Farewell! Farewell!

All my love,

Werther

(A self-isolating — and thus criminal — segment of biocleave)

<div align="center">* * *</div>

September 4, 2006

Dear Mothers and Fathers and Brothers and Sisters,
Dear Community,

Brothers, that sky above us has pitied our fathers for many hundreds of years. To us it looks unchanging, but it may change. Today it is fair. Tomorrow it may be covered with clouds.

My words are like the stars. They do not set. What Seattle says, the great chief Washington can count on as surely as our white brothers can count on the return of the seasons.

The White Chief's son says his father sends us words of friendship and goodwill. This is kind of him, since we know he has little need of our friendship in return. His people are many, like the grass that covers the plains. My people are few, like the trees scattered by the storms on the grasslands.

The great—and good, I believe—White Chief sends us word that he wants

to buy our land. But he will reserve us enough so that we can live comfortably. This seems generous, since the red man no longer has rights he needs respect. It may also be wise, since we no longer need a large country. Once my people covered this land like a flood-tide moving with the wind across the shell-littered flats. But that time is gone, and with it the greatness of tribes now almost forgotten.

But I will not mourn the passing of my people. Nor do I blame our white brothers for causing it. We too were perhaps partly to blame. When our young men grow angry at some wrong, real or imagined, they make their faces ugly with black paint. Then their hearts too are ugly and black. They are hard and their cruelty knows no limits, and our old men cannot restrain them.

Let us hope that the wars between the red man and his white brothers will never come again. We would have everything to lose and nothing to gain. Young men view revenge as gain, even when they lose their own lives. But the old men who stay behind in time of war, mothers with sons to lose—they know better.

Our great father Washington—for he must be our father now as well as yours, since George has moved his boundary northward—our great and good father sends us word by his son, who is surely a great chief among his people, that he will protect us if we do what he wants. His brave soldiers will be a strong wall for my people, and his great warships will fill our harbors. Then our ancient enemies to the north—the Haidas and Tsimshiams—will no longer frighten our women and old men. Then he will be our father and we will be his children.

But can that ever be? Your God loves your people and hates mine. He puts his strong arm around the white man and leads him by the hand, as a father leads his little boy. He has abandoned his red children. He makes your people stronger every day. Soon they will flood all the land. But my people are an ebb-tide, we will never return. No, the white man's God cannot love his red children or he would protect them. Now we are orphans. There is no one to help us.

So how can we be brothers? How can your father be our father, and make us prosper and send us dreams of future greatness? Your God is prejudiced. He came to the white man. We never saw him, never even heard his voice. He gave the white man laws, but he had no word for his red children whose numbers once filled this land as the stars filled the sky.

No, we are two separate races, and we must stay separate. There is little in common between us.

To us the ashes of our fathers are sacred. Their graves are holy ground. But you are wanderers, you leave your fathers' graves behind you, and you do not care.

Your religion was written on tables of stone by the iron finger of an angry

God, so you would not forget it. The red man could never understand it or remember it. Our religion is the ways of our forefathers, the dreams of our old men, sent them by the Great Spirit, and the visions of our sachems. And it is written in the hearts of our people.

Your dead forget you and the country of their birth as soon as they go beyond the grave and walk among the stars. They are quickly forgotten and they never return. Our dead never forget this beautiful earth. It is their mother. They always love and remember her rivers, her great mountains, her valleys. They long for the living, who are lonely too and who long for the dead. And their spirits often return to visit and console us.

No, day and night cannot live together.

The red man has always retread before the advancing white man, as the mist on the mountain slopes runs before the morning sun.

So your offer seems fair, and I think my people will accept it and go to the reservation you offer them. We will live apart, and in peace. For the words of the Great White Chief are like the words of nature speaking to my people out of great darkness—a darkness that gathers around us like the night fog moving inland from the sea.

It matters little where we pass the rest of our days. They are not many. The Indians' night will be dark. No bright star shines on his horizons. The wind is sad. Fate hunts the red man down. Wherever he goes, he will hear the approaching steps of his destroyer, and prepare to die, like the wounded doe who hears the steps of the hunter.

A few moons, a few more winters, and none of the children of the great tribes that once lived in this wide earth or that roam now in small bands in the woods will be left to mourn the graves of a people once as powerful and as hopeful as yours.

But why should I mourn the passing of my people? Tribes are made of men, nothing more. Men come and go, like the waves of the sea. A tear, a prayer to the Great Spirit, a dirge, and they are gone from our longing eyes forever. Even the white man, whose God walked and talked with him as friend to friend, cannot be exempt from the common destiny.

We may be brothers after all. We shall see.

We will consider your offer. When we have decided, we will let you know. Should we accept, I here and now make this condition: we will never be denied the right to visit, at any time, the graves of our fathers and our friends.

Every part of this earth is sacred to my people. Every hillside, every valley,

every clearing and wood, is holy in the memory and experience of my people. Even those unspeaking stones along the shore are loud with event and memories in the life of my people. The ground beneath your feet responds more lovingly to our steps than yours, because it is the ashes of our grandfathers. Our bare feet know the kindred touch. The earth is rich with the lives of our kin.

The young men, the mothers, and girls, the little children who once lived and were happy here, still love these lonely places. And at evening the forests are dark with the presence of the dead. When the last red man has vanished from this earth, and his memory is only a story among the whites, these shores will still swarm with the invisible dead of my people. And when your children's children think they are alone in the fields, the forests, the shops, the highways, or the quiet of the woods, they will not be alone. There is no place in this country where a man can be alone. At night when the streets of your towns and cities are quiet, and you think they are empty, they will throng with the returning spirits that once thronged them, and that still love these places. The white man will never be alone.

So let him be just and deal kindly with my people. The dead have power too.

Yours in search of how to do everything,

~~formerly a would-be <u>suicide</u>~~
~~formerly a would-be <u>suicide bomber</u>~~
~~formerly a would-be <u>ultra-conservative</u>~~
~~formerly a would-be _____~~

A mortal who would prefer not to be mortal

* * *

September 4, 2006

Dear Mothers and Fathers and Brothers and Sisters,
Dear Community,

How can you buy or sell the sky, the warmth of the land? The idea is strange to us. If we do not own the freshness of the air and sparkle of the water, how can you buy them?

Every part of this earth is sacred to my people. Every shining pine needle, every sandy shore, every mist in the dark woods, every clearing and humming

insect is holy in the memory and experience of my people. The sap which courses through the trees carries the memories of the red man.

The white man's dead forget the country of their birth when they go to walk among the stars. Our dead never forget this beautiful earth, for it is the mother of the red man. We are part of the earth and it is part of us. The perfumed flowers are our sisters; the deer, the horse, the great eagle, these are our brothers. The rocky crests, the juices in the meadows, the body heat of the pony, and man—all belong to the same family.

So, when the Great Chief in Washington sends word that he wishes to buy land, he asks much of us. The Great Chief sends word he will reserve us a place so that we can live comfortably to ourselves. He will be our father and we will be his children. So we will consider your offer to buy our land. But it will not be easy. For this land is sacred to us. This shining water that moves in the streams and rivers is not just water but the blood of our ancestors. If we sell you land, you must remember that it is sacred, and you must teach your children that it is sacred and that each ghostly reflection in the clear water of the lakes tells of events and memories in the life of my people. The water's murmur is the voice of my father's father.

The rivers are our brothers, they quench our thirst. The rivers carry our canoes, and feed our children. If we sell you our land, you must remember, and teach your children, that the rivers are our brothers, and yours, and you must henceforth give the rivers the kindness you would give any brother.

We know that the white man does not understand our ways. One portion of land is the same to him as the next, for he is a stranger who comes in the night and takes from the land whatever he needs.

The earth is not his brother, but his enemy, and when he has conquered it, he moves on.

He leaves his father's graves behind, and he does not care.

He kidnaps the earth from his children, and he does not care.

His father's grave, and his children's birthright, are forgotten. He treats his mother, the earth, and his brother, the sky, as things to be bought, plundered, sold like sheep or bright beads.

His appetite will devour the earth and leave behind only a desert.

I do not know. Our ways are different from your ways. The sight of your cities pains the eyes of the red man. But perhaps it is because the red man is a savage and does not understand. There is no quiet place in the white man's cities. No place to hear the unfurling of leaves in spring, or the rustle of an insect's wings.

But perhaps it is because I am a savage and do not understand.

The clatter only seems to insult the ears. And what is there to life if a man cannot hear the lonely cry of the whippoorwill or the arguments of the frogs around a pond at night? I am a red man and do not understand. The Indian prefers the soft sound of the wind darting over the face of a pond, and the smell of the wind itself, cleaned by a midday rain, or scented with the pinion pine.

The air is precious to the red man, for all things share the same breath—the beast, the tree, the man, they all share the same breath.

The white man does not seem to notice the air he breathes.

Like a man dying for many days, he is numb to the stench.

But if we sell you our land, you must remember that the air is precious to us, that the air shares its spirit with all the life it supports. The wind that gave our grandfather his first breath also receives his last sigh.

And if we sell you our land, you must keep it apart and sacred, as a place where even the white man can go to taste the wind that is sweetened by the meadow's flowers.

So we will consider your offer to buy our land. If we decide to accept, I will make one condition: The white man must treat the beasts of this land as his brothers. I am a savage and I do not understand any other way. I've seen a thousand rotting buffaloes on the prairie, left by the white man who shot them from a passing train. I am a savage and I do not understand how the smoking iron horse can be more important than the buffalo that we kill only to stay alive.

What is man without the beasts? If all the beasts were gone, man would die from a great loneliness of spirit.

For whatever happens to the beasts, soon happens to man. All things are connected.

You must teach your children that the ground beneath their feet is the ashes of your grandfathers. So that they will respect the land, tell your children that the earth is rich with the lives of our kin.

Teach your children what we have taught our children, that the earth is our mother.

Whatever befalls the earth befalls the sons of the earth. If men spit upon the ground, they spit upon themselves. This we know: The earth does not belong to man; man belongs to the earth. This we know.

All things are connected like the blood which unites one family. All things are connected. Whatever befalls the earth befalls the sons of the earth. Man did not weave the web of life: he is merely a strand in it. Whatever he does to the web, he

does to himself.

Even the white man, whose God walks and talks with him as friend to friend, cannot be exempt from the common destiny. We may be brothers after all. We shall see.

One thing we know, which the white man may one day discover, our God is the same God. You may think now that you own Him as you wish to own our land; but you cannot. He is the God of man, and His compassion is equal for the red man and the white.

This earth is precious to Him, and to harm the earth is to heap contempt on its Creator.

The whites too shall pass; perhaps sooner than all other tribes. Contaminate your bed, and you will one night suffocate in your own waste. But in your perishing you will shine brightly, fired by the strength of God who brought you to this land and for some special purpose gave you dominion over this land and over the red man. That destiny is a mystery to us, for we do not understand when the buffalo are all slaughtered, the wild horses are tamed, the secret corners of the forest heavy with the scent of many men, and the view of the ripe hills blotted by talking wires.

Where is the thicket? Gone. Where is the eagle? Gone. The end of living and the beginning of survival.

Yours in search of how to do everything,

~~formerly a would-be <u>suicide</u>~~
~~formerly a would-be <u>suicide bomber</u>~~
~~formerly a would-be <u>ultra-conservative</u>~~
~~formerly a would-be _____~~

A mortal who would prefer not to be mortal

Undoubtedly these randomly selected statutes, which continue to this day to be part of their respective legal codes, will serve to put the Golden-Rule laws in clearer historical perspective.

CONTEXT-SENSITIVE LAW

It is against the law for any liquor store to sell milk.

[INDIANA]

LOOKS-SENSITIVE LAWS/FRANKENSTEIN LAW

In Athens, a driver's license can be lifted by the law if the driver is deemed either "poorly dressed" or "unbathed."

[GREECE]

It is illegal to sell an ET doll in France. They have a law forbidding the sale of dolls that do not have human faces. (And still, my dear monster, fellow-feeling will perforce be withheld.)

[FRANCE]

MATHEMATICAL MATRIMONIAL LAW

It is illegal to remarry the same man four times.

[KENTUCKY]

PHYSICO-CHEMICAL LAW

Putting salt on a railroad track may be punishable by death.

[ALABAMA]

POLITICS-AS-USUAL LAW

There is a state law prohibiting "corrupt practices of bribery by any person other than candidates."

[VIRGINIA]

EARLY *DYING-IS-ILLEGAL* LAW

According to a British law passed in 1845, attempting to commit suicide was a capital offense. Offenders could be hanged for trying.

[BRITAIN]

SPECIES-SENSITIVE LAW

In Hartford, it is illegal to educate a dog.

[CONNECTICUT]

TIME-SENSITIVE LAWS

In Halethorpe, it is illegal to kiss for more than one second.

[MARYLAND]

A recently passed anticrime law requires criminals to give their victims 24 hours notice, either orally or in writing, and to explain the nature of the crime to be committed

[TEXAS]

UTTER-SUBMISSION LAW

Women must obtain written permission from their husbands to wear false teeth.

[VERMONT]

SOURCES

Sources for the GOLDENRULE LAWS/SELF-ORESERVATION LAWS in Chapter 9: *Infant Research and Adult Treatment* (Beebe and Lachmann); *Coming Through the Whirlwind* (Michael Eigen); *A Process Model* (Eugene Gendlin); *Freud and Beyond* (Stephen A. Mitchell and Margaret J. Black); and *The Origins of Love and Hate* (Ian Suttie). Sources for "Pleas/Testimonies" in Chapter 9: the song *Parlez Moi D'Amour* by Jean Lenoir; Mary Shelley's *Frankenstein*; Goethe's *The Sorrows of Young Werther*; and two interpretative translations of Chief Seattle's 1854 speech (known as *Chief Seattle's Reply*), William Arrowsmith's of the 1960s as well as the Ted Perry's 1974 one is quoted in "Nearly Universal Affidavit." The laws on pp. 143-44 were found at www.totallyuselessknowledge.com/language.php.

EVER!!
OR
LET MY IDENTITY GO (DOWN THE DRAIN)

- *Let me come back to life so I can comply with this law.*

- *If the initiators of this statute actually will, as promised, help citizens comply with it, then I will let nothing stop me, as not precisely me, from embracing it.*

- *Should I agree to quit having an identity, then the organism that persons that I had been or some rearrangement thereof would continue on in perpetuity (so what if this takes a wholly different shape in some distant cove I have never visited). I count that fine with all that which at the moment purports to be me.*

- *If it takes a measure of this nature to make anti-aging efforts work all around, then I give it my wholehearted support.*

- *Had it not in the mid-17th century been split apart from art and philosophy, science would have achieved long before this, for the benefit of this our generation, what this statute aims to accomplish. These disciplines should never have been pursued separately, and this statute, a corrective measure, will be the means of effecting their grand synthesis.*

- *At last death is categorically made for all times to be unacceptable in principle.*

- *This historically momentous law finally puts the social contract right.*

- *Choosing to do something illegal in this direction might one day turn out to be surprisingly refreshing.*

- *Not only today do I warmly welcome this proffered support for my efforts to stay alive, but I will also continue doing so well into the future, until such time that this organism that persons whose life I have undertaken can logically approach what used to be spoken of as death, that is, until such a time comes that dying becomes optional, and those choosing to die know more fully what will come of such a choice.*

- *Why should anyone who believes that each of us at the core is immune to death object to the building of an even greater immunity and to the extending of it to the spirit as flesh!*

11

DIRECTIONS FOR *ARCHITECTURAL PROCEDURE* INVENTION AND ASSEMBLY

STEP ONE

Choosing a stellar purpose for an architectural procedure equals selecting or diving into an area of emphasis that begs for change. So as to discover what most urgently needs to be made to be otherwise, take a long, boldly uncompromising look at what goes on as (an) *organism that persons (human being)*. Directly addressing your own body and keeping it always in the forefront, give some thought as to how, by broadening your know-how or by expanding or reordering what you exist as, you might come to be more in the know.

It would not be possible to go on as an organism that persons if certain prevailing conditions did not obtain. Architectural procedures can and should be used both to investigate and to alter these prevailing conditions.

Do not forget that it is the task of those who would produce architectural procedures to augment the bioscleave, the insufficiently procedural bioscleave, and thereby recast it. Architectural procedures are meant to fill in gaps and to address subtle lacks or glaring or nearly glaring insufficiencies. You may desire to resuscitate an underused X (a property/an attribute/an urge/a tendency/a propensity/an arena of know-how/an overall capacity/an activating condition/a qualitative state/a quality/an ability/a skill/a coordinating skill/a landing site/a landing-site configuration or whatever) that has over time receded into the background (i.e., tentativeness), or, terrifically, there might arise in you an intimation of an X that might be a tremendous boon. It is never amiss when inventing an architectural procedure to concentrate on landing sites, but landing sites can also be kept in the background to good effect.

To help you get started, here is a list of prevailing conditions that could and should be improved upon, suggested areas of emphasis, stellar purposes, and X's to be pursued.

**FINDING A PURPOSE FOR AN *ARCHITECTURAL PROCEDURE*—
X's THAT AN *ARCHITECTURAL PROCEDURE*
MIGHT BE ABLE TO CALL FORTH**

Identify an X that would seem thus far (2006) to be beyond the capacity of an organism that persons.

Think of a currently (2006) underplayed X that, if used more fully, could significantly alter what it means to be alive.

* * *

Could there possibly be an X that would, upon being brought into the possession of organisms that person or activated in them, decrease their ultimate cluelessness as to how it is that they are able to think?

Could there possibly be an X that would, upon being brought into the possession of organisms that person or activated in them, decrease their ultimate cluelessness as to how it is that they are able to have the feelings that they have?

Could there possibly be an X that would, upon being brought into the possession of organisms that person or activated in them, decrease their ultimate cluelessness as to how it is that they can come to know what they are thinking?

Could there possibly be an X that would, upon being brought into the possession of organisms that person or activated in them, decrease their ultimate cluelessness as to how it is that they can realize what it is that they are saying?

Could there possibly be an X that would, upon being brought into the possession of organisms that person or activated in them, decrease their ultimate cluelessness as to how it is they are able to be aware of what they are doing?
Could there possibly be an X that would, upon being brought into the possession of organisms that person or activated in them, decrease their ultimate cluelessness as to what makes them able to feel sympathy in others?

* * *

Could there possibly be an X that would, upon being brought into the possession of organisms that person or activated in them, decrease their ultimate cluelessness as to how to stop having to be mortal?

Could there possibly be an X that would, upon being brought into the possession of organisms that person or activated in them, decrease their ultimate cluelessness as to how to maintain promising attitudinal stances for years on end?

Could there possibly be an X that would, upon being brought into the possession of organisms that person or activated in them, help them to get in under and take a stand against their own automaticity?

Could there possibly be an X that would, upon being brought into the possession of organisms that person or activated in them, help increase their capacity to know how to take direct action—keeping the end firmly in sight—through a set of indirect actions?

Could there possibly be an X that would, upon being brought into the possession of organisms that person or activated in them, make them more adept at being architectural bodies?

Could there possibly be an X that would, upon being brought into the possession of organisms that person or activated in them, qualify them as judges of when it is best to defer action and when not?

STEP TWO
An improbable event would be that you would find it hard to choose among promising candidates for an X to be brought into the possession of organisms that person or activated in them. If faced with such an eventuality, select the one that will be most likely to help you become a transhuman/a posthuman/a bioscleavist, i.e., the one most useful for the engineering of a reversible destiny.

STEP THREE
Designate the hoped-for outcome of your nascent architectural procedure to be the supplementing of the body's repertoire with the X you have come up with. So as

better to bring about what you need to effect, proceed to name your nascent procedure for your choice of an X, which is to say, architectural procedures should be named for their hoped-for outcomes (i.e., tentativeness-cradling procedure).

STEP FOUR

Strive throughout your body to imagine sequences of actions (also, if need be, [provisionally] isolated actions) that might lead to or in some way be constitutive of what you seek to put in place, which is to say, assemble a list of bodily actions that could directly get you to your hoped-for outcome even before you have begun to manage the situation architecturally; which is furthermore to say, have at the ready all those actions that could nudge events in the direction of your nascent architectural procedure's hoped-for outcome.

STEP FIVE

Think of how to structure into a built surround the capacity to call forth precisely what it is you seek. Devise architectural elements and features, and various juxtapositions of them, that will help call this forth. The hoped-for outcome may simply spring into existence as a result of what has been worked into the architectural surround, but it is more likely that it will only make an appearance *indirectly*, having been brought into existence by called-forth sequences of actions that have led the way to it and which will, in some cases, turn out to be, to various degrees, constitutive of it. What physical circumstances—juxtapositions of which elements and which features—might precipitate the hoped-for outcome?

STEP SIX

Before a nascent architectural procedure can be declared a full-fledged one, it has to prove itself able to be built. Unable to deliver on this score, many nascent architectural procedures will fall by the wayside. If, in the course of an architectural procedure's being invented and assembled, architectural elements and features suited to its purpose readily suggest themselves, or, put another way, if novel ways of structuring an architectural surround to produce the hoped-for outcome tend to turn up on a fairly frequent basis, that should be taken as indication enough of its being a keeper.

STEP SEVEN

This step parades for all to see and use as a copyediting feature or a back-to-the-drawing-board one. Review what you have invented and assembled into (being) an *architectural procedure*, adjusting any item or segment that calls out to be changed. Even go so far as to adjust the X you have chosen to seek so that it matches more closely what currently presents itself, now with more information and an even more incisive purposefulness in play, as the exigency of greatest moment. Add or subtract sequences of actions meant to lead up to the hoped-for outcome. Make ever bolder design decisions, rethink architectural elements and features, piling refinement upon refinement—all for adding a new X to the body's repertoire or for beefing up an underused one. All of these steps would be well worth repeating, but this one, which might also have been suitably classified UNNUMBERED STEP, requires by definition frequent repetition.

STEP EIGHT

Provide written instructions for how best to activate or perform your architectural procedure, how to play it to the hilt. The work of procedural architecture (house or town) that will have your architectural procedure embedded into it will be delivered to its occupants together with a set of *Directions for Use* in which these instructions for your architectural procedure appear alongside the instructions written for the other architectural procedures it contains.

<p align="center">* * *</p>

Once an architectural procedure has been invented and assembled, still other ways to assemble it will become apparent; in other words, architectural procedures can be assembled in more than one way.

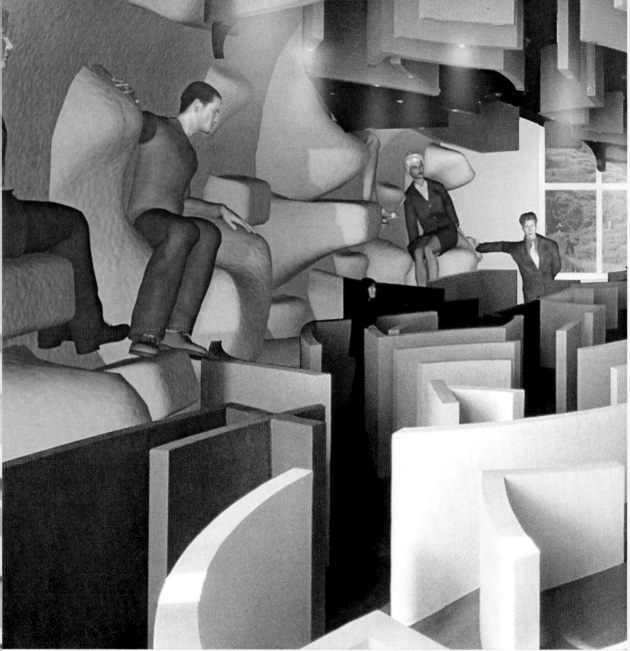

MAXIMAL SOCIAL EMBEDDING

An *organism that persons*, its architectural body, and the bioscleavic
component) are all in some way organized; even their chaotic segments
thing within and of bioscleave is cleaving. That an event fabric (bioscleave;
configuration; architectural body) can and does cleave should be taken as

Know bioscleave to be replete with *organisms that person.*

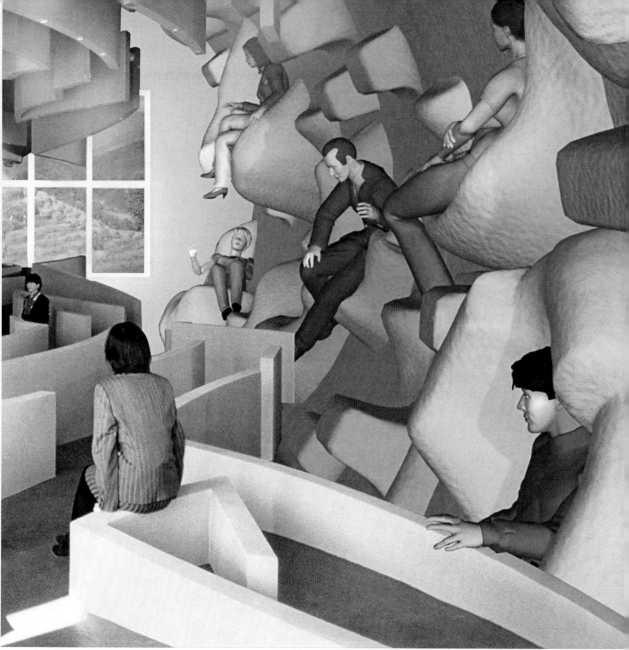

CONVERSATIONAL LATTICE

atmospheric surround of the moment (the architectural body's atmospheric have characteristic patterns. Each is of bioscleave, and, by definition, every-bioscleavic atmospheric surround; *organism that persons*; landing-site evidence enough of its being organized.

VITAL CONTEXTUALIZING INFORMATION
(TO ACCOMPANY <u>DIRECTIONS FOR *ARCHITECTURAL*</u>
<u>*PROCEDURE* INVENTION AND ASSEMBLY</u>)

"Those hearing the term *architectural procedure* are bound to wonder how anyone could have come up with such an illogical concept."

"Medical procedures are performed on patients by doctors and nurses; scientific procedures are performed by lab technicians using test tubes, chemicals, tissue cultures, or laboratory animals. It is, of course, completely unclear at first, and for some time after that, who performs an architectural procedure in what place and on whom or what."

"Correct, that is why the conceiving of this concept was so big a travail. Architecture, that which is on the inanimate side of things, 'performs' a procedure. There's a piece of nonsense."

"But we have forced the issue and proved this to be possible. Architecture can be organized in such a way as to invite particular procedures to be performed."

"Then there is the matter of how to say what needs to be said around and about this awkward concept. Usually, procedures are worked out or devised, but we speak of 'inventing' a procedure and 'assembling,' and that is a bit of a stretch."

"It won't do to speak of 'designing an architectural procedure or planning one,' because putting what we are referring to that way fails by a long shot to indicate all that someone is obliged to go through in order to come up with one."

"For speaking of the producing of an architectural procedure, we have chosen to rely on not only one but on two verbal nouns: *invention* and *assembly*. An architectural procedure comes to exist only after it has passed through both these phases of its 'manufacture.'"

"Unless it has been assembled, an architectural procedure is nowhere to be found."

"Procedures that have not been made to be architectural are of limited interest to us."

"And an architectural procedure is a very particular something indeed."

"We are, of course, using 'architectural' in two ways at once."

"It—procedure or procedural action—*has* to be linked to architecture as that is commonly defined. Then there is *our* definition of architecture: *a tentative constructing toward a holding in place.*"

"When architecture is thought of as a tentative constructing toward a holding in place, the two words that form the term soften in each other's direction."

"With this term, as with every term, but with this term even more so, coming around to know what it means happens dozens upon dozens of times."

PROCEDURAL TOOLS

An architectural procedure is a procedural tool, and so too is the architectural surround into which it gets embedded. Because embedding an architectural procedure adds up to tactically posing elements and features of an *architectural surround* so that an architectural procedure can serve the purpose that it is meant to, architectural surrounds that have architectural procedures embedded in them shall be known as *tactically posed surrounds/tutelary abodes*. Each tactically posed surround/tutelary abode generally has embedded in it two or more distinctly different architectural procedures.

PROCEDURAL TOOLS AS DISTINGUISHED
FROM FUNCTIONAL TOOLS

Whereas an *organism that persons* can and does use functional tools to enhance her sensations and actions and, in general, to improve her situation in the world at large, she can and will use procedural tools to study her own nature and to reorder and change it. Functional tools address single aspects of the total capability of an organism that persons, but procedural tools address the capability of an organism

that persons as a whole. It is only because a procedural tool addresses the whole of an organism that persons, nothing less than the whole of her multidimensionality, that an organism that persons can make use of it for reassembling herself.

Trying to come up with an object that will perform a desired action or enhance a sensation, the inventor of a functional tool directs her very localized efforts, limited to one object's worth of spatial expanse, toward a single specified end; trying to come up with a tactically posed surround/tutelary abode within which an organism that persons can study her own nature and reorder and change it, the inventor of a procedural tool directs her wide-ranging efforts, extending all across an architectural surround, toward a single specified end (the eliciting of a sequence of actions) that leads in turn to another single specified end (the sought-after X). The procedural tool's inventor has by necessity a more roundabout path to her goal than does the functional tool's inventor.

To arrive at their goals both the inventor of a functional tool and the inventor of a procedural one will need to go through a great many steps, some that, to an outside observer, seem to be beside the point but which are, in fact, essential to the project, others which would appear to be pertinent but which turn out to be dead ends, and many of which yield less than they had been expected to; but whereas the inventor of the functional tool will need to have a greater number of coordinating skills and far more patience at the ready than will subsequent users of that tool, the inventor of a procedural tool will not need more coordinating skills and will be required to be only slightly more patient than that tool's eventual users.

ARCHITECTURAL PROCEDURES FOR
ARCHITECTURAL BODIES

An architectural body has theoretical and actual existence, but it has such a remarkable degree of instability as an entity of sorts that it is fair to say it is as elusive as anything can be. Covering a large area indeterminately, an architectural body, or that which is purported to be one, exists, when you come right down to it, as a statistical entity, with now these proportions, now those. This huge and difficult-to-track entity of sorts does have a highly visible generating source, and that is the human body, which itself has a statistical existence as a composite of actions and events in addition to its every man, woman, and child appearance as articulated corporeality. Architectural procedures define architectural bodies insofar as they contribute to the tactically posed surround/tutelary abode into which these extended bodies flow and according to which they are obliged, as would be anything that can

157

be spoken of as flowing into a container, to assemble themselves. Thus architectural procedures delimit architectural bodies purposefully so that the actions they have been invented and assembled to call forth transpire.

Architectural procedures are so new in the making that it is hardly possible to know yet all that they will be able to bring about. Their general purpose will be to help organisms that person rearrange their landing sites—perceptual landing sites/imaging landing sites/dimensionalizing landing sites—so as to be able to live as architectural bodies.

An organism that persons who, by means of invented and assembled architectural procedures, approaches with flexible, systematic precision the part she plays in the biascleavic-evolutionary-libidinal economy will be able to reinvent herself to good and great effect.

When the steps (of *Directions for Architectural Procedure Invention and Assembly*) are carried out with 360-degree precise abandon and multifariously distributed and suitably hinged concern, they will tremble and hurry humans to the brink of the transhuman (architectural body) and, for that matter, exhilarate and usher transhumans to the brink of the posthuman (architectural body plus X). Those adept at coordinating an architectural body will also be known as bioscleavists.

Those who will surface as transhumans/bioscleavists/posthumans will be humans who have undone the human condition through sweet and harsh artificial means, by means of architectural procedures, and who are therefore no longer quite so in the dark as to why they think and feel; they will know how to avail themselves more fully of biascleave.

Humans are those who are mortal, and transhumans/bioscleavists/ posthumans are those who are learning how not to be mortal.

CONCEPTUAL JUGGLING AND COORDINATING SKILLS
By all accounts, organisms that person have gone on for thousands of years, and do so to this day, without having the slightest suspicion of the need for an architectural procedure, neither in the form of a concept nor as an actuality. Only those having a high tolerance for the illogical could have dreamed up this concept that straddles unapologetically what is logical and what is not, and that, by so doing, puts what it means to be logical in question. The same conceptual juggling—requiring the expansion of a thinking skill that might be thought of as a non-ironic irony, an extremely open-ended double thinking—that went into the producing

of the concept of an architectural procedure will no doubt be a necessary part of all subsequent attempts at getting the hang of it (the concept of an architectural procedure).

When it comes to the patching together of a specimen of this zone-straddling concept, that is, where the invention and the assembly of an architectural procedure is concerned, it will be necessary to couple the above-mentioned skill with an existing set of skills of long standing, that set of skills by means of which tools can get devised. Coordinating skills that underpin the making of tools include but are not limited to the following: being able to counteract to some extent one's own automaticity; being able to augment one's own body; being able to consider more than one solution to a problem; being able to put something between oneself and the problem in question; being able to inhibit and defer actions so as to come up with an effective measure; being able to think in terms of bringing about a result indirectly.

PARLAYING INDIRECTNESS

An organism that persons develops coordinating skills for resisting and redirecting the urge to go ahead without delay directly to a desired end; the parlaying of a certain amount of indirectness—that is, the coordinating of a series of actions in which actions become beneficiaries of one another—can bring the end to be in sight; given enough time and effort, the feat of managing to accomplish what needs to be done can be pulled off, albeit indirectly; a certain amount of parlayed indirectness strangely dilates time so that no matter how much time has elapsed one finds that it has in the end been just the amount of time that was needed for a cumulative effort—be it that of one performer or many—to have taken care of the problem.

A herd of bison watch helplessly, with eyes and *miens* that call out to be read as suffused with fellow-feeling, as one of their number falls through the ice to—the documentary's voice-over informs us—a protracted dying that will have to be endured for at least four hours. The herd has no rope; it never had rope; nor, for that matter, has it ever been in possession of a "knot."

Even members of the troubled herd of bison know how to inhibit direct action that could prove harmful. No member of the herd ventures further out onto the thin ice to extend a hoof to a parting friend, although many of them turn back, staring helplessly, as if desirous of being able to. How do they know, for they do seem to know, that at this juncture direct action would be the end of them?

159

Organisms that person would get themselves off the ice in a hurry. A rope would be thrown to the one who has plunged into icy waters. A tree branch might be slid into place, or the group might try to reach the victim and haul her up and out by forming a human chain. Someone would be likely to have a cell phone. A call would be put through to the local fire department or to the national guard, and soon enough a helicopter would be on the scene and its crew lowering a rope to the victim. Just because what needs to be done cannot be achieved directly does not mean that it has no chance of getting done. Getting a rope and tying it to one of your number to pull her out of freezing water equals the taking of direct action through a great number of intermediate steps; that these intermediate actions directly lead to what needs to be done does not necessarily telegraph itself to those involved. The more coordinating skills that are mastered, the more complexly can indirect means be put to a direct purpose—the parlaying of indirectness.

The move toward indirectness can also be read as a move toward the procedural. A setting might be constructed for the purpose of making the herd of bison more procedurally inclined. Putting rope near members of the herd would be simply to fit them out with a functional tool; building a setting within and by which to zero in on any leeway to be had within the automaticity of *organisms that bison* would be to give them the benefit of a procedural tool.

GEARING UP AND SWITCHING GEARS
Not by a long shot is it a straightforward affair to invent and assemble an architectural procedure. A direct pursuing of a goal will have to be stopped in midcourse. Although a direct approach to the matter of its invention and assembly can and should be taken, the bringing of this direct initiative to some conclusion requires a complete switching of gears resulting in the adoption of an indirect approach. It may then occur to the person who experiences this complete turnabout that, in a sense, it has all along been a question of an indirect approach. At what point in architectural procedure invention and assembly does indirection enter the picture? Despite its being the case that each architectural procedure is meant to lead directly to the unfolding of a particular X, paths to desired X's cannot be anything but circuitous. For an X to be found or formed, a Y (a series of actions) that could lead to that X must be envisaged, and a Z (an architectural surround) that prompts Y (a series of actions) must be pieced together. Put another way, a "direct" pursuit of X requires a detour through the planning and construction of a Z which itself requires a detour through an envisioning of Y in light of

X. The desired goal can be achieved only through a certain roundabout or encircling type of thinking. What one wants to accomplish at this very moment must be put off for later. Perhaps no other endeavor has quite the degree of indirection that inventing and assembling an architectural procedure does.

PHASES A AND B OF ARCHITECTURAL PROCEDURE "MANUFACTURE"

A new breed of something, an architectural procedure belongs to more than one category, and not all its disparate types of existence occur simultaneously. An architectural procedure only begins to take form fully once it has been built into a physical setup. But along the way it can still be spoken of as a something in its own right; during phase A, the chrysalis stage, it is a *nascent architectural procedure*, one that is in the process of being invented. A nascent architectural procedure lives as a conceived-of measure that, given the context in which it was dreamed up and granted substance, awaits nothing other than architectural implementation. This conceived-of measure harbors within it, across the realm of fuzzy logic, which in our estimation is the supreme logic, a fuzzy procedural tool—the architectural procedure that phase B will bring into existence.

PHASE A (INVENTION)—STEPS ONE THROUGH FOUR

The whole cloth out of which an architectural procedure will be invented will be bioscleave, for there is nothing else.

STEPS ONE, TWO, AND THREE

Step one asks the would-be inventor and assembler of an architectural procedure to come up with an X or a purpose to pursue; step two gives a guideline for making the final selection; and step three explains that, having selected an X or a purpose, an inventor will have gone quite far toward producing a new architectural procedure which by all rights should be named after it (the selected X or purpose).

> (a) Once architectural procedures will have become part of common knowledge and people come to know their importance as life shapers, so to speak, these three steps will most likely fade into the background, having outlived their use, for, at that point, those desirous of produc-

ing their own architectural procedure will not even think of beginning without having an X or purpose to pursue in mind.

(b) On one hand, these first three steps can be seen to weigh in on the side of direct action. They elicit and put in place the defining goal of a new architectural procedure. This architectural procedure will go directly after this and only this, they as much as say.

(c) On the other hand, they cause the one desirous of inventing and assembling an architectural procedure to step back for a moment from what it is she has it in mind to do. Before she can invent an architectural procedure, she must first review what is missing from the repertoire of an organism that persons. Stepping back for a moment equals putting some indirection into direct action.

STEP FOUR

Now a wide search needs to be instituted for all actions that could lead directly to X. All that the organism that persons has in or near its command will need to become part of this search. There can be within the body direct knowledge of such actions, but that knowledge will be likely to have an imagined component, and would therefore have to be thought of as having been arrived at through indirect means. It is, then, quite probable that one will be led indirectly to know—as this is the primary means by which organisms that person come to know what it is they need to try to do—the sequence of actions necessary to this purpose.

A QUICK OVERVIEW BEFORE A DISCUSSION OF PHASE B

Although **steps one through four** would seem to lead directly to the hoped-for outcome, they clearly do not have what it takes to produce it. Nothing other than a steady recurring of those sequences of actions that lead up to or in part constitute the hoped-for outcome will be productive of it. For this to come about, for these sequences of action to be prompted on an ongoing basis, surroundings must have built into them a conveyable know-how for several coordinating skills; these surroundings will then, by virtue of how they are structured, be able to remind the body body-wide how best to move, weaving sequences of actions into each other and grouping collections of activities of both the focused and the unfocused kind; which is to say, conditions appropriate to the prompting of the needed actions must be in place in order for them to occur consistently enough for abrupt changes, such

as a hoped-for outcome, to come about. Only with the help of architectural surrounds that have features and elements so structured as to cause landing-site occurrence to happen in a highly ordered and guiding-of-actions fashion can organisms that person reinvent themselves to be contexts within which new activating conditions, for this tendency or that propensity, can occur.

PHASE B (ASSEMBLY)—STEPS FIVE THROUGH EIGHT
Upon its attaining embodiment, a conceived-of measure becomes a piece of equipment (an architectural procedure embedded in a tactically posed surround/tutelary abode) that has as its purpose the rearranging of another piece of equipment (organism that persons/architectural body). As outlined above, unlike functional tools, which only extend the senses, procedural tools give sustenance to and reassemble sensoria themselves. Architectural surrounds will be tactically posed in ways that instantiate these fuzzily precise procedural tools that rearrange or reassemble organisms that person. The architectural procedure produced in phase B will be every nature of tool: a servomechanism/a musical score for corporeality/a bioscleavic keyboard/a tactically posed surround/tutelary abode.

STEPS FIVE AND SIX
The crux of the matter: the great indirection required for the piecing together of a procedural tool.

Although X does not go away—it never goes away—it must at this point intermittently go missing. Think of what leads to X rather than of X; submerge X in all that might potentiate it. The stepping back and stepping away are surely marks of indirectness. A piece of equipment (organism that persons/architectural body) that on a daily basis handles indirectness will be surrounded so that it can be redirected. How else to accomplish this surrounding but through indirection? To do X or to accomplish it, simply do not think of X at all. Never worry, it will come to you through indirection, even directly so.

STEP SEVEN
In view of and in light of and in refraction from the full-fledged architectural procedure that forms as a conceived-of measure (the product of steps one through four) becomes embodied (by means of steps five and six), still other measures that

might be tried will turn up; which is to say, once some direction is given to the great indirection-at-large, other coming-in-from-left-field and around-the-corner, so to speak, direct "hits" or aper çus become possible. This is reminiscent of how scale models are useful both for the indication they give of what the final full-scale work will be like and because they make it possible to see what by all means must be changed for the finished product to be all that it should be.

STEP EIGHT
The full-fledged architectural procedure is a fuzzy procedural tool or piece of equipment that has been arrived at through a tremendous acquiescence to indirect means, an overwhelming holding-in-abeyance of what one had thought to try to do. The architectural procedure thus produced, a guiding scheme that prompts with architectonic astuteness continual reconfiguring, sits tight as an indirect approach that can directly affect all who move within it. Within tactically posed surrounds/tutelary abodes containing full-fledged architectural procedures, direct commands such as DO THIS! gracefully permeate the whole to some purpose, indirectly of course.

An architectural procedure can also be thought of as a something whose use needs to be discovered as it is being used – an unfinished instrument or a 3-D score in the process of finding itself to be such.

IN SUPPORT OF STEP TWO—ENGINEERING OF ATMOSPHERICALLY INTRICATE DOMAINS PRODUCTIVE OF REVERSIBLE DESTINY
Decide not to die. Take as your overall goal a bodily cultivating and engineering of atmospherically intricate domains productive of reversible destiny. Without reversible destiny the human condition is beyond repair. By fiercely hearkening to the desire for a reversible destiny, you can amass an enormous forming power within and around you.

IN SUPPORT OF STEP FIVE—AN INDIRECT ACQUAINTANCE WITH FORMING POWER/ OPERATIVE WIGGLE-WAGGLES/ AN ARCHITECT-IN-TRAINING

An organism that persons has at best only an indirect acquaintance with the operative basis of her forming power. The body that she is, the product of a related, if not an identical forming power, is a direct architectural expression, albeit through a circuitous route, of operative wiggle-waggles or maneuvers (constitutive of forming power) that run the show. This relatively small-scale forming power that wields forming power on a variety of scales, and that has been produced by one forming power acting as many or many as one, is, and therefore should be declared to be, both the ongoing project of an unsteady architect-in-training mysteriously afoot in the world (?) and an architect-in-training in her own right.

IN SUPPORT OF STEP FIVE—OVERNIGHT AN ARCHITECT

Use the forming power that you are amassing, and tentatively but firmly directing, an avalanche of skillfully applied know-how, to grow more wildly confident of your ability to assemble an architectural procedure, and, presto, become an architect in earnest.

It should not be viewed as preposterous, by you or by your neighbors of all sizes and densities, that you have overnight become an architect. Do not laugh at yourself for having as much as declared yourself to be an architect—unless.

MARKERS OF INDIRECTION/INDIRECTNESS

We have decided not to favor one term over the other. The dictionary suggests that "indirection" has more to do with actions and means to ends, but it then goes on to define "indirectness" in such a way as to suggest that it, too, could cover this domain. For us, for the moment, the two pull each other open so that even more of what they are loosely about pours out. Soon other terms will arrive in support of these two.

Actions and events through which indirection/indirectness enters the picture, turning a direct approach to a problem into an indirect one, and which should come to be seen as markers of indirectness/indirection:

(a) The allowing of what is very much desired to fade away or be absent for a period of time.

(b) A stepping away from the problem at hand with the intention of coming back at it in another away.

(c) Any thinking ahead.

(d) Going in the opposite direction of what you seek so as to find what you seek.

(e) A thought or an X comes to you rather than your going toward it.(f) An overall meeting up with what comes about in a largely indiscriminate fashion.

(g) Even the slightest shifting off course.

(h) Whatever gives the appearance of being a detour.

INDIRECTNESS

(a) Synonyms?

(b) Directness is always an abstraction/a reduction from indirectness.

(c) Life can only be proven indirectly.

(d) Indirect=Procedural

A new order of tool / A systematic approach through which to engineer the most daring escape ever

Inasmuch as an architectural procedure offers a systematic approach to moment-by-moment living, it should be deemed a new order of tool, one through which it may eventually become possible to engineer the most daring escape ever—an escape from mortality.

DO THE BODILY MATHEMATICS!

"Who the hell are you to take poetry/philosophy away from me!"

Do the bodily mathematics: adding, under the aegis and through the production channels of an architectural procedure, an engineering skill or a coordinating one to the repertoire of the world-inventor known as poet/philosopher hardly constitutes a subtraction!

All human inventions art, science, technology, philosophy—surface with great promise but lock us always only into infinitesimally little hopes that by all

rights should be registered as despair.

Our species will by means of architectural procedures release itself from the stranglehold that its own culture has on it.

Worldwide Suicide Rates by Country and Year
(as of May 2003)
TOTAL DEATHS PER 100,000: 2,193.5

Country	Last Year For Which Figures Are Available	Number per 100,000
Albania	00	3.6
Antigua And Barbuda	95	0
Argentina	96	12.9
Armenia	00	3.2
Australia	99	26.3
Austria	01	37.1
Azerbaijan	00	1.6
Bahamas	95	2.2
Bahrain	88	5.4
Barbados	95	13.3
Belarus	00	73.1
Belgium	96	40.1
Belize	95	13
Bosnia And Herzegovina	91	23.6
Brazil	95	8.4
Bulgaria	00	34.3
Canada	98	24.6
Chile	94	11.6
China (Selected Areas)	99	27.8
China (Hong Kong Sar)	99	26.5
Colombia	94	7
Costa Rica	95	11.8
Croatia	00	43.2
Cuba	96	36.5
Czech Republic	00	32.7
Denmark	98	29
Dominican Republic	94	0
Ecuador	95	9.6
Egypt	87	0.1
El Salvador	93	15.9
Estonia	00	57.7
Finland	00	45.5
France	99	35.5
Georgia	00	6
Germany	99	27.5
Greece	99	7.3
Guatemala	84	1
Guyana	94	21.1
Honduras	78	0
Hungary	01	60.1
Iceland	97	24.3
India	98	21.3
Iran	91	0.4
Ireland	99	22.7
Israel	97	13.1
Italy	99	14.5
Jamaica	85	0.7
Japan	99	50.6
Jordan	79	0

Only biotopologists live as groups of processes and procedures on many scales of action at once and as organisms that person who know they are organisms that person and as thoroughgoing architectural bodies. Do not override the complexity of an organism that persons. The "I" has to open up fully and become this.

Country	Last Year For Which Figures Are Available	Number per 100,000
Kuwait	00	3.2
Kyrgyzstan	99	23.3
Latvia	00	68.5
Lithuania	00	91.7
Luxembourg	01	34.6
Malta	99	14.3
Mauritius	99	30.6
Mexico	95	6.4
Netherlands	99	19.3
New Zealand	98	30.6
Nicaragua	94	6.9
Norway	99	26.3
Panama	87	7.5
Paraguay	94	4.6
Peru	89	1
Philippines	93	4.2
Poland	00	30.8
Portugal	00	10.5
Puerto Rico	92	17.9
Republic Of Korea	00	27.1
Republic Of Moldova	00	30.8
Romania	01	24.7
Russian Federation	00	82.5
Saint Kitts And Nevis	95	0
Saint Lucia	88	15.1
Saint Vincent & Grenadines	86	0
Sao Tome And Principe	87	1.8
Seychelles	87	9.1
Singapore	00	18.9
Slovakia	00	27.5
Slovenia	99	60.7
Spain	99	16.4
Sri Lanka	91	61.4
Suriname	92	23.8
Sweden	99	27.7
Switzerland	99	36.5
Syrian Arab Republic	85	0.2
Tajikistan	99	5.8
Thailand	94	8
Tfyr Macedonia	00	14.8
Trinidad And Tobago	94	22.4
Turkmenistan	98	17.3
Ukraine	00	62.1
United Kingdom	99	15.1
United States Of America	99	21.7
Uruguay	90	20.8
Uzbekistan	98	13.6
Venezuela	94	10.2
Yugoslavia	90	30.8
Zimbabwe	90	15.8

Because we as a species do not even know yet what the body (the organism that persons) is, it is definitely too soon to think of throwing it away. The above segments of biocleave, organisms that person adrift, would not have even thought of doing away with themselves had they been able to live as biotopologists within tactically posed surrounds/tutelary abodes.

Die at your own risk mayor proposes

Proposal: Residents should mind 'health in order not to die'

From our Correspondent

BIRITIBA MIRIM, Brazil Jan 12. - There's no more room to bury the dead, they can't be cremated and laws forbid a new cemetery. So the mayor of this Brazilian farm town has proposed a solution: outlaw death.

Mayor Roberto Pereira da Silva's proposal to the Town Council asks residents to "take good care of your health in order not to die" and warns that "infractors will be held responsible for their acts." The bill, which sets no penalty for passing away, is meant to protest a federal law that has barred a new or expanded cemetery in Biritiba Mirim, a town of 28,000 people 45 miles east of Sao Paulo. "Of course the bill is laughable, unconstitutional, and will never be approved," said Gilson Soares de Campos, an aide to the mayor. "But can you think of a better marketing strategy?"

A 2003 decree by Brazil's National Environment Council bars new or expanded cemeteries in so-called permanent preservation areas or in areas with high water tables. Environmental protection measures rule out cremation.

That left no option for Biritiba Mirim, a town on the so-called "green belt" of rich farmland that supplies fruits and vegetables for Sao Paulo, Brazil's biggest city. The town produces 90 percent of the watercress consumed in Brazil.

Most of Biritiba Mirim sits above the underground water source for about 2 million people in Sao Paulo, de Campos said. The rest is covered by Mirim's municipal cemetery, which was inaugurated in 1910.

More than 50,000 people already are buried in the 3,500 crypts and tombs in Biritiba Mirim's municipal cemetery which was inaugurated in 1910.

The cemetery ran out of space last month, and 20 residents who have died since November were forced to share a crypt. But even that solution has limits.

"We have even buried people under the walkways," de Campos said, predicting that crypts will reach capacity in six months. "Look, people are going to die. A solution has to be found, or we'll have to break the law."

At least 20 towns within 60 miles of Biritiba Mirim have a similar dilemma, de Campos said, though none has ordered its citizens not to die.

Biritiba Marim isn't the first Brazilian town to draw attention with an unusual law. A few years ago, a mayor in Parana state banned the sale of condoms, arguing that his town needed to increase its population to keep qualifying for federal aid. Drugstores ignored the ban.

De Campos said his town wants the Environment Council to change the wording of the cemetery decree to allow exceptions approved by environmentalists.

Biritiba Mirim has set aside public land - five times the size of the current graveyard - for a cemetery that environmental experts from the University of Sao Paulo say "will not affect the region's water tables or surrounding environment," de Campos said.

The Environment Council declined to comment before a meeting to discuss the matter with local officials Thursday.

Meanwhile, town officials say they are hoping no one else dies.

(AP PHOTO)

ounds and Peril

dly replacing traditional foods in the lo-

a all over the world are walking the same cle course as obesity and Type 2 diabetes strike the young.

pend time with May Chen and the other mmigrants in Flushing — at home in TV, in the places where they eat and buy schools — is to appreciate the everyday nting a particularly vulnerable group: ericans who make up half the communi-

ut the future of New York, a city of immi-e Asians are the fastest-growing racial

especially those from Far Eastern na-na, Korea and Japan, are acutely sus-

Local Insurgents Tell of Clashes With Al Qaeda's Forces in Iraq

DEMOCRATS TA
AGGRESSIVE TA
ALITO IS UNFA

MORE DOCUMENTS SO

Questions on Consist of the Judge's Reco and Earlier Answe

By RICHARD W. STEVENS and NEIL A. LEWIS

WASHINGTON, Jan. 11 — crats tried with increasing f tion on Wednesday to elicit mo cific views from Judge Sam Alito Jr. about abortion and topics and sought to build against his nomination to ti preme Court by raising que about his character and consist

From the opening moments third day of hearings by the Judiciary Committee, Dem aware that Judge Alito had m through the first two days w significant damage to his pro of confirmation, struck an a sive tone. [Excerpts, Page A26

They challenged him on ele of his record and statements questioning on Tuesday. An successfully pressed the pane! man, Senator Arlen Specter, lican of Pennsylvania, to records that they said migh light on the judge's members Princeton alumni group tha been characterized as opposi education and affirmative acti

Senator Patrick J. Leahy mont, the ranking Democrat committee, started the proce by stating that members of his "have been troubled by what as inconsistencies in some of swers" on subjects including rights, presidential power, Jud to's failure to recuse himself f case involving a potential con interest and his involvement w Princeton alumni group.

Rebutting Judge Alito's stat on Tuesday that he would take court an "open mind" on ab rights, Senator Richard J. D Democrat of Illinois, said the

But does not the whole planet exist to be turned into a graveyard.

REVERSIBLE DESTINY

To be more sure of the body and thereby less sure of it
To be more sure of the *organism that persons* and thereby less sure of it
To be less sure of the body and thereby more sure of it
To be less sure of *the organism that persons* and thereby more sure of it

February 10, 2002

Dear Arakawa, Dear Madeline,

Would you be so kind as to describe to me how you found your way to the concept of reversible destiny? How on earth did you get that idea? I think every living being who is aware of your work wants to ask you this question. In which circumstances did it germinate? And did it come to you in a flash? An inspired moment? Many inspired moments? Did a particular experience bring it forth? Were you perhaps spurred on by Marx's thought and action?

I have read that the two of you have devoted many hours to the study of the lives and works of Da Vinci and Rimbaud. Did they point the way to reversible destiny? Both those artists radically abandoned that at which they were most skillful. Each did so because more than anything else he desired to invent life on a new basis.

It is my belief that you found this crazy concept lying in wait for you. I am considering making it my life's work to prove that such was the case or to prove that this finally crazy-enough concept has been lying in wait for our species ever since . . .

yours sincerely,
Leslie Fukuzawa-Emerson

February 15, 2002

Dear Professor Leslie Fukuzawa-Emerson,

We knew it was only a matter of time before we would be asked the question you pose.

Not having enough hours available these days to put together an account of how we came to escape from planetary despair, we urge you not to let us off the hook about this, provoking us over time as you see fit to draw out a complete-enough response.

The impetus toward reversible destiny grew out of the total disgust we felt for the human condition—disgust and abhorrence—and out of endless despairing over the seeming impossibility of its ever being able to be made into a truly humane condition, but then, too, and particularly, out of a tremendous desire not to live as defeatists. Just because 10 billion organisms that person have made a certain mistake need not necessarily point to our having to go ahead and make it as well. One day we wrote this and meant it: WE HAVE DECIDED NOT TO DIE. We might mention that some years before this we had written *To Not To Die*, in which we tried to breathe open ethics. Reversible destiny, the will toward reversible destiny, commences with the decision not to let the organism that persons (oneself after all) be locked into existing words or narratives, which is to say, with the refusal to let open-ended events be reduced back into limited and mortal ways to live as a person.

Reversible destiny—we have witnessed several world-renowned philosophers and artists fail to get it at all, remaining, to our amazement, impervious to what it has to offer, that is, oblivious to its implications. You have to be sufficiently devastatedly wounded at the pith or discriminated against in the society within which you operate, a continual wounding at the pith , and able or willing to recognize that such is the case, to get to reversible destiny. The child's mind and the adult's mind alike tend to close over this subject matter right away, it being so akin to, although the opposite of, the dreaded happenstance and term, death. Reversible destiny—it has to be thought, felt through, and held to, so that in its name non-cloying juxtapositions get buoyed up to form the will to resist the thus far inevitable onslaught of negativity. Within it lies the reworking of all terms and conditions. Prior to the existence of the concept of reversible destiny, only those grounded in and receptive to the fact of having been wounded had it in them to

ram open the so-called given; reversible destiny once entertained and embraced at once never lets wounds of every variety close even as it blows them away.

Whoever does not struggle directly against the human condition: a defeatist. Basically, anyone not willing to subscribe to the possibility of a reversible destiny: a defeatist.

Yes, those two artists knew they had to discard everything except the bloody body. No music, no art, no philosophy, no science—at least none of those disciplines on its own.

stay tuned,
within the reversible destiny mode,

Arakawa Madeline

February 21, 2002

Dear Madeline, Dear Arakawa,

Perhaps your term *reversible destiny* originated as a poetic fragment or a poetic jump? Then again, every new term originates as such. Most hard-won concerted efforts happen as or lead to poetic jumps.

You found yourselves involved, did you not, in having to name a different and, I am sorely tempted to say, new type of willing? All poetic jumps seem to those doing the jumping to come to some degree from out of the blue even as, growing as they do out of a great deal of thought and action, they can easily be proven to be far from out of the blue. The poetic jump that I am guessing you took, did that repeat this pattern, coming from out of nowhere but grounded in a sure progression toward something?

When did you realize that it would not be possible for you even to begin to convey to others the tenor and scope of the anti-nihilistic stance you had succeeded in constructing for yourselves? How long and hard did you search for a name that could signal the total unacceptability of life lived on the basis on which it has had to be lived so far?

Your anti-nihilistic stance had you willing along a very particular line, in a unique direction. Looking around you, did you fail to find—you must certainly

175

have failed to find—contemporaries who were willing along the same line, in a similar direction? Am I right to think that you suspected that others actually did will in the direction that you were willing, but that theirs was a muted willing? A necessarily muted willing in face of the big no recourse sign that has been hung up on the universe?

In any event, poetic jumps are multiply motivated. I wonder whether you agree with me that your decades-long research project *The Mechanism of Meaning* motivated, to be sure, by your anti-nihilistic stance, further advanced or motivated in its turn that stance it owed its existence to, taking this stance along with it far into the future, and bringing it to culminate in that full-blown anti-nihilism that you have come to speak of as reversible destiny?

yours sincerely,

Leslie Fukuzawa-Emerson

February 28, 2002

Dear Leslie Fukuzawa-Emerson,

Outcomes of poetic jumps depend on who does the jumping and why. Different types of coordinating skills combine to spring different types of willing into life and action. Only those who have engaged this or that type of coordinating skill or combination of them can produce this or that type of will. In other words, willing is a function of coordinating skills in place.

Those who discover or come up with actions that give promise of not being futile lessen, in as much as they have succeeded in devising a counter-move to you name it, the degree to which they move about the planet as defeatists. Those who desire to resuscitate ethics, by having it never stray from a non-defeatism, should attend vigorously to all possible contributory factors to the condition that rings out as all that is the case. What does not get approached radically enough gets covered over then subsides. To be radical, do not miss a beat or an about-to-happen beat that could reconfigure dire circumstances for the better. The degree to which a person can take radical action in the world is directly linked to the degree to which that person is a non-defeatist. Only non-defeatists have the degree of radicality

necessary to face up to or face down an aggressively engulfing abyss.

How do we know what dies if we don't even know what lives or wills to live? We took several jumps, breaking one metaphysical ankle after another, or spraining them, or disintegrating them. But then we hit upon a term that started talking, and talking big. Now we have given you life, term. What will you give us?

I, *reversible destiny*, will be for you and all others of your species an ethical rallying call. Let me be a means for rerouting the religious urge. Let me signal respect for all scales of action simultaneously in effect.

until ever,

Arakawa Madeline

March 10, 2002

Dear Madeline, Dear Arakawa,

You write: Within cleaving areas dedicated to sensation, thinking about and feeling, the assuming of the body to be one's own takes hold. This identity-conveying assumption proceeds as directly as does any other coming to think about or feel something, or as might any arriving at noting there to be a thinking about and feeling along, but also far more circuitously. Stirred into the received mix, these words, whose intoning accumulated across time, becoming enunciable within the briefest of moments, forming a hardly distinct then, during and throughout an ample selection of then-and-there's in place before or under or provisionally to one side of saying: Here, this is yours to go on with. If anything of the sort gets pronounced or as-if pronounced, we have the *washed-ashore effect.* Something that is the body gets to have this effect on itself.

Even as you give us the washed-ashore effect, you make haste to whisk it away. It is the washed-ashore effect that stands in the way of reversible destiny, is it not? Am I correct in surmising that you wish to indicate that the taking of oneself up as a very appendaged chunk, amnesic operative that happened to hit shore, brings with it a certain will toward destinal thinking? Suddenly there you are, as if washed-ashore—out of the sea of anything and everything hurled onto the shore. Having as far as can be recollected not participated at all in the assembling

177

of the body you move as, you surface as and to yourself as washed-ashore jetsam on the move.

yours sincerely,

Leslie Fukuzawa-Emerson

March 25, 2002

Dear Professor Leslie Fukuzawa-Emerson,

It gets given to each of us to know—how this happens needs more looking into—that it is the destiny of the body each of us has to be exactly that body. The washed-ashore effect produces the real-as-day illusion that having gotten here as me equals being destined to be here in this form.

An *I* turns up to claim what's here. How could it not have been inevitable for this *I* to have been *me*? This is not just any *I*, it is *me*, *mine*. I was destined to be *this*. If another *I* had been destined to be *this*, *it* would have turned up instead of me. This *I* with which this body has become associated—*why, it's mine*. If I had not become this body, it would simply not have been my destiny to be *it*.

"To be washed ashore" is the coming to be aware of having a body; this has been delivered by some "surf," a momentum that can refer to itself, an expressive momentum. Because the expressive momentum has no final resting state, *it* ought to be thought of as a continual washing ashore. If there is a continual washing ashore, then the washed-ashore effect, which signals a cutoff point for action, does not accurately represent what occurs and is, we say it again, illusionistic.

I suddenly turned up as *this*. How suddenly did my turning up as *this* come about? Did I not perhaps gradually accrue to *this*? Did I gradually accrue to some stabilizing? Several instances of body formed *I*, an *I*. In breaking this *I* in, I made it into *my me*. This *I* which this body has become associated with turns out to be *mine*, my *I*. This *I* which this organism that persons has generated turns out to be *mine, my I*. Whatever *I*'s this organism that persons has generated turn out to be mine, but not mine alone. There is no *mine* such that it is on its own.

There is no *this* alone, not one *this* by itself, that can elicit an *I*. Every world consists of many *thises*. Instead of giving an abrupt and drastically narrowed-

178

down, severely truncated report—*I suddenly turned up as this*—of having been startled to discover the organism that persons who one is, instead of, that is, the washed-ashore effect, by virtue of which one stumbles upon having been brought up short on terra firma, give a more faithful report of what is occurring—*I suddenly turned up as this and this and this and some of that near this, this, this, that and that, and this other, and this plus this*—and thereby unloosen the illusionistic effect's hold on you. Countless events anchor me here.

<div align="center">in the reversible destiny mode,</div>

<div align="center">Madeline and Arakawa</div>

<div align="center">April 3, 2002</div>

Dear Madeline, Dear Arakawa,

I am not at all sure about what to say at this moment except that I am at the point of deciding to live as an architectural body . . .

Bodies can speak (can say, emote, consider). What happens when a body—an architectural body—says it has decided not to die?

<div align="center">Yours washing ashore,</div>

<div align="center">Leslie Fukuzawa-Emerson</div>

<div align="center">April 19, 2002</div>

Dear Leslie Fukuzawa-Emerson,

Those who decide not to die not only opt for but actually begin to define (a) reversible destiny for themselves.

It is our position, as you know, that an organism that persons cannot carry out this declared intention apart from the support and guidance of a tactically

<div align="center">*179*</div>

posed architectural surround. Prior to that, even in its greatest freedom, an organism that persons is in a terribly tight spot. Even so, it manages to bring itself and gets itself brought from one day to the next. Some well-dispersed set of events thinks to behave as the body ongoingly.

An architectural body decides not to die—a momentous occasion.

hey,

Madeline and Arakawa

May 7, 2002

Dear Madeline, Dear Arakawa,

If everyone is a cipher unto herself why are most people so sure of themselves? Why do the majority of folks have such a difficult time thinking of still other ways to live as an organism that persons? Why is it so difficult for people to get the logic of the following argument? Using the body in radically different ways from how it has been used can lead to radically different ends or, even better, non-ends. Why do people as unknowns insist on perpetuating the circumstances that keep them in the dark about themselves? The self-love of an unknown? For the most part, people would rather die than reassemble. The art of prolonging one's life or inventing life on a new basis—that is the science of the future which, to my joy, is now.

yours sincerely,

Leslie Fukuzawa-Emerson

180

May 21, 2002

Dear Professor Leslie Fukuzawa-Emerson,

Reversible destiny signals an escaping from a certain organismic enslavement.

Can we not alter the form of our own organicity?

It is not the organismic *per se* that should be despised, but a meek engaging of the organismic.

as ever,

Madeline Arakawa

June 16, 2002

Dear Madeline, Dear Arakawa,

As long as the organism that persons remains a cipher to itself, logic must be judged to contain a fundamental inconsistency. To arrive at a concept requires some foreclosing on an issue. Logic stakes out realms and then reveals logical and illogical paths within them. Expanding or stretching logic has been the task of the poet or artist to one side of the world as usual. Unfortunately, logic can be constrained by rationality, and reason can be applied illogically. Not taking enough into consideration, reason holds sway over what it can, but in a conceptual morass. Narratives distort the unknown into the known. Blake railed against Newton's remarkable equations because he sensed how much had been left out of them.

yours sincerely,

Leslie Fukuzawa-Emerson

July 1, 2002

Dear Professor Leslie Fukuzawa-Emerson,

As sure as cartilage scaffolds your nose and gives it form, concepts scaffold events and form them. Even so, *destiny* is far less a sure bet than the nose on your face. Inasmuch as the term *destiny* has everywhere left its clumsy mark, the term *reversible destiny,* its newly nominated opposite and antidote, will need to operate as a salutary dynamism (a salutary dynamism?!) for many years or many millennia to come. Had the term *destiny* never held sway, it is hard to say what term we might have come up with to do the work of the term *reversible destiny.*

ever and again,

Madeline and Arakawa

July 18, 2002

Dear Madeline, Dear Arakawa,

The concept of destiny gets handed down through generations, but also slightly altered with each new generation. A way to say it was not my doing, it has been used to cover over what remains inexplicable. It happened as if by destiny. It was destined to happen, therefore I didn't have much to do with it. In this we have the tyrant's path. Bierce tells us it is a tyrant's authority for crime and a fool's excuse for failure.

yours sincerely,

Leslie Fukuzawa-Emerson

August 4, 2002

Dear Professor Leslie Fukuzawa-Emerson,

It was destined to happen therefore I didn't have much to do with it —the cop-out *par excellence*. In the following tale, Stephen's seemingly straightforward report of his flesh-tearing bullying action can be taken as showing in wonderfully slow-motion the arrival on the scene of the concept of destiny as a replacement for free will: Stephen bites Mark's ear. "You bad boy, why did you do that?" "I didn't," replied Stephen, "I simply closed my eyes and opened my mouth, then closed my mouth and opened my eyes, and when I did, I saw to my great surprise, that ear was in that mouth, I mean this mouth." It would seem to be the case that *that* ear was *destined* to be in *that* mouth. But who or what was Stephen in all of that? And for that matter, what was Mark up to?

Stephen's account of events can be taken as either an amazingly well hid-den-in-plain-sight *lie* or—it is the interpretation that we next put forward that we favor—as an organism's report of what has happened to it apart from any person-ning, a report delivered nonetheless in the words of that person this organism persons as on those occasions when this becomes possible for him. If someone says something to the effect that what has occurred simply had to happen or that it just happened without there having been an I there who made it happen, we have in our midst a "victim of circumstances." Where agency is up for grabs, destiny or fate rush in or can be poured on heavily.

your organisms that person,

Arakawa Madeline

August 8, 2002

Dear the two of you,

And what others speak of as destiny: only what happened to happen?

There is that which is in the realm of narration and explanation, however forced, and then there is . . . the actuality of it!! It as it!!

A group of elementary school children were walking along the seashore with their professor. Suddenly a distant roar was heard growing closer. Everyone in the group started running inland, and as they did this, the sea started coming at them, and a giant tidal wave reared up. One fourth of the class was never seen again.

On one hand, a clear distinction can be made between the *destiny*—a word that for the three of us, at least, is full of not wanting to be said—of Group A (the vanished ones) and that of group B (the undrowned). On the other hand, as things stand, it is only a matter of time before group B disappears, before the undrowned themselves vanish. Prior to reversible destiny, this vanishing suggested itself to be destined to occur.

How pitiful that we are obliged to distinguish between the dark and the darker, between the never as of now and the never sooner or later.

yours sincerely,

Leslie Fukuzawa-Emerson

September 1, 2002

Dear Professor Leslie Fukuzawa-Emerson,

On the day that Joe, a returning veteran from Iraq who had become entranced beyond belief by the great beauty of Baghdad, took the still visible once oft-trod path to the side door of his neighbor's house, an ant colony had started-up and gotten well into a new anthill just adjacent to that no longer distinct path. Joe was so thrilled with the news he had to tell his neighbor Alice that he wove in and out of the path between their houses and ended up wiping out the neighboring

184

ant colony's new initiative.

Were there an historian with a sufficiently encompassing point of view to factor into her account of the Iraqi war the battlefield seen from the perspective of the trampled-on ant colony, would she write that destiny had foreordained that Joe would live to see another day so as to be able to inadvertently utterly destroy their venture, their troops near his house. This little tale does show us one thing: how linked to scales of operation and action this after-the-fact and before-the-fact concept or dictator of narratives is.

yours in the reversible destiny mode,

Arakawa Madeline

September 16, 2002

Dear Madeline, Dear Arakawa,

Life—Is it or is it not as terrifying as we think it is in our worst moments?

An historian doesn't know *this*, cannot know *that*, fails to know something else, can find no way of knowing a great deal about a different something else, and so she is moved to suppose some of this and a bit of that and quite a quantity or a lot of this, and not long after supposing begins, suppositions get crafted. Yes, it's futile to try to say what's going on, but there is surely something within the organism-person that loves futility. Because so far everything has been couched in terms of either say it or leave it unsaid, know what's going on or admit you don't know, concepts such as destiny get started up, get a lot of mileage then wither, fade away, become insidious.

Recently I came upon Hobbes' definition of *cause*, which would seem to have more than a little to do with what we have been going back and forth about in our letters and which I have a hunch the two of you will be able to put to good use:

"A cause simply, or an entire cause, is the aggregate of all the accidents both of the agents how many so ever they be, and of the patient, put together; which when they are all supposed to be present, it cannot be understood but that the effect is produced at the same instant" (1656).

Once engaged the verbal module never shuts off. Any referential path

185

opened has a wending existence for the life of the pathmaker. Where do referential paths wend? They wend, as constraining sequences, through and around the nonverbal. Who will not answer *yes* when asked whether we ask more of language than it can deliver?

yours sincerely,

Leslie Fukuzawa-Emerson

Editor's note: Although Arakawa and Gins suspect they did reply to Fukuzawa-Emerson's letter of September 16, 2002, they can neither recall its substance nor find it on their computer within the folder marked Letters to F-E. For his part, Fukuzawa-Emerson has no recollection of having received a reply and still has hopes of one eventually reaching him. If it is the case that this letter was indeed written and then lost in the mail, it may, he surmises, still be on its snail mail way to him.

October 4, 2002

Dear Madeline, Dear Arakawa,

From the array of citations brought forth to exemplify the definitions of the words *destiny* and *reversibility* proffered by the OED, it has come to be apparent to me that for centuries the concepts have been heading toward one other as if to achieve an irrevocable union such as the one you write of in the introduction to *Architectural Body*, that is a veritable wedding of one to the other.

Once that which is organismic complicates and coordinates its own wherewithal to the degree that it knows of itself and has feelings and beliefs, it becomes unbearable for that evolving entity (all entities are evolving) to entertain its own end as a looming void:

[DESTINE]
1440 Dede be my destenyng. [Gaw. & Gol. 270]
The bold statement. A clear and definite link. One's own end as a looming void—anything but that. Solace? Speculative balm. Speculative solace. Shoddy recompense. Over and done with.

[DESTINE]
1616 Statue of Adonis, She sighed, and said: 'What power breaks Destine's law?' [Drummond of Hawthronden Song Poems 14]

The downhill course of all things living does smack of *destiny*. Smack of it it might, but if at this juncture language is to have the first and last say, why not permit ourselves to insist into juncture-space, the more inclusive, the more expansive *reversible destiny*? This provides a non-fated fate, a fully fateless one.

yours sincerely,

Leslie Fukuzawa-Emerson

October 25, 2002

Dear Leslie Fukuzawa Emerson,

We applaud your surmise that within the language that you (and I and I) speak, and that speaks us, reversible destiny has for many centuries been getting prepared for and stirring to life. Will you be able—you will!!—to show us this?!

The 1440 citation weighs in particularly powerfully, quickly and definitively managing to make the necessary link with inexorability.

Had the speaker thought to put the phrase in the negative, reversible destiny would have then and there been born:

Dede **not** be my destenyng.

The tight early spelling of the dreaded word keeps it vividly dire. The end gets stated, over and done with, through a simple repetition of a phoneme that is more than a little morphemic: de + de.

We can hardly wait to read what next you send our way.

in the reversible destiny mode,

Arakawa Madeline

187

November 15, 2002

Dear Madeline, DearArakawa,

Lying in stirring wait for hundreds of years within recorded history, a strong incli-
nation toward *reversible destiny*?! The desire to secure it and to see it named. I say
that there was such a need for it to exist that it was at times starting to see the light
of day even before the two of you brought it forth.

Simply, not surprisingly, and yet astoundingly, the term had many times
before in its language of origin, the English language, been nearly formulated. In
1796 the clear opposite of the term—with great explosive force, clear opposites
motivate poetic jumps (reversible destiny = poetic jump)—got itself said:

[REVERSELESS]
The urn, whence Fate Throws her pale edicts in *reverseless doom*! (my ital-
ics) [A. Seward To Thomas Erskine xi]
But wait, my entire body insists that I present you with this far earlier adum-
bration:

[REVERSIBLE]
If it was not Fate, and so might be reversible, then there was nothing certain
in his Art. [J. Dunton Lett. fr. New-Eng. 18]
How now, the two words (*reversible* and *destiny*) that together yield the rev-
olutionary new term, *reversible destiny*, the pulling-at-each-other motivators of its
releasing meaning, have been attracting or calling out to each other for centuries.
In 1500 the word *reverse* is used to evoke *destiny*, and for that matter, *reversible
destiny*—albeit the negative case of it:

[REVERSE]
Oure solace, playsire & joye ben reuersed in byttir teerys & contynuel
wepynges. [Melusine 316]
If it cannot be reversed then it must be destined, and when it's destined, is
that God's, or gods' and goddesses' doing?:

[REVERSIBLE]
1420 For a goddes wrytyng may nat reuersyd be. [Lydg. Assembly of Gods
492]

188

[REVERSER]
1868 *Reverser of misfortunes*, . . . listen to my prayers. (my italics) [Coffin tr. Ligouri's Glories of Mary 87]
1883 Manu, 'the great, the *reverser of fate*' . . . (my italics) [Schaff Encycl. Relig. Knowl. 1470]

All life is a contingent condition. Life has always been contingent on not going on. Everyone knows this, only the youngest children don't, and even some of them do.

yours sincerely,

Leslie Fukuzawa-Emerson

Editor's note: Although Arakawa and Gins suspect they did reply to Fukuzawa-Emerson's letter of November 15, 2002, they can neither recall its substance nor find it on their computer within the folder marked Letters to F-E. For his part, Fukuzawa-Emerson has no recollection of having received a reply and still has hopes of one eventually reaching him. If it is the case that this letter was indeed written and then lost in the mail, it may, he surmises, still be on its snail mail way to him.

November 30, 2002

Dear Madeline, Dear Arakawa,

We have had this drummed into us: Death is the price you pay for having had life, one learns. That which lives must die. That which must happen may be said to have been destined to happen. It will not not happen. One's number is up; it's only a matter of time. The die has been cast, rather pre-cast.

I find a notable willing toward reversible destiny in these words written in 1712:

[DESTINIES]
I shall not allow the Destinies to have had a hand in the deaths of the several thousands who have been slain in the late war. [Addison Spect. No. 523 _7,]
And in these words written in 1777:

[FATE]

Fate was something that even the gods often endeavoured . . . to resist. [Priestley. Philos. Necess. Pref. 25]

At the beginning of the 18th century, we find this soaring willing toward a reversal of the suppositions underpinning ethics:

[FATE]

The Bird of Night With Fate-denouncing Outcries takes his Flight. [Ozell tr. Boileau's Lutrin 48]

Then comes evidence down across the centuries of an agonizing need and demand for reversibility in life matters coupled with a wondering as to which among the living might be in any way deserving of this and despair as to whether something of this order could even ever be achieved:

[DESTINE]

1616 This hold to brave the skies the Destines framed. [Drummond of Hawthornden Song Poems 14]

[DESTINED]

1703 The infernal judge's dreadful pow'r, From the dark urn shall throw thy destin'd hour. [Prior Ode Col. G. Villiers 92]

[DESTINY]

1814 We, poor slaves . . . must drag The Car of Destiny, where'er she drives Inexorable and blind. [Southey Roderick xxi. 345]

Offering up a new level of possibility, the term *reversible destiny* makes a completely new type of human luxury or human ordinariness available.

yours sincerely,

Leslie Fukuzawa-Emerson

December 5, 2002

Dear Professor Leslie Fukuzawa-Emerson,

Your tracking of the gradual and, by your lights, the inevitable blending of the spheres of influence of the two concepts *reversible* and *destiny* makes us weep with joy or at least smile and smile, devastatingly smile into the ages.

The other day on the phone you worried about what a field day critics would have with you about this discovery of yours; how easy it would be for them to throw it in doubt because depends for its proof on a single source, and a dictionary at that, and deals only with the current lingua franca. You will certainly be broadening your search for these conceptual trajectories to include all their calling-to-each-other appearance in all languages and cultures. Until then, we will, with your permission, let others take a peek at what you have been up to by publishing our correspondence within *Making Dying Illegal*.

One by one, and as a group, all the citations you have amassed show how by taking those two terms together the human condition can be stripped of its dread and terror. Before you went in search of citations, admittedly to only a single source, hereafter the needed citations will come to you from far and wide.

until soon,

Madeline and Arakawa

January 1, 2003

Dear Madeline, Dear Arakawa,

It had been thought that the grin-and-bear-it approach would supply maximal fortitude and thus be for all intents and purposes unsurpassable. Die with your dying. All goes down hill, you included, get ready to roll off the planet or be placed within it.
In the air:
Even so, if most people did not have an appetite for non-dying, it would be hard to keep the planet populated.
I definitely don't know what I am, but I don't want to go on like this, or to go under like that.

There are reversibles; things, and substances, and conditions revert some-
times for the best, but not always.
Reversible destiny in the air:

[REVERSE]
 1400 He lay in swone longe, or he spak ought,..But whan he reuerted and
 ros a_eyn, 'Alas,' he seyde. [Laud Troy Bk. 3077]

[REVERT]
 1432-50 The sawles begynne ageyne after dethe to wylle to be reuertede
 in to theire bodies. [tr. Higden (Rolls) III. 197]
 1485 A! no lengar now I reverte! I yeld vp ?_e gost! [Digby Myst. (1882)
 iii. 782]
 1500-20 Now spring vp flouris fra the rute, Reuert _ow vpwart naturaly.
 [Dunbar Poems x. 42]
 1509 Come vnto my Joye and agayne reuerte Frome the deuylles Snare.
 [Hawes Conv. Swearers xviii,]
 1513 Throu kynd ilk thyng springis and revertis. [Douglas ÆÆneis xii.
 Prol. 230]
 1560 _it for faintnes..The quhile befoir fra time he did reuert [etc.].
 [Rolland Crt. Venus i. 686]
 1632 I..strain'd to assume..A dying life, reuert in liuing death. [Lithgow
 Trav. i. 5,]
 1639 My name preserve By force of Numbers, which *revert the Lawes Of
 Destinie*. [G. Daniel Vervic. 67] (my italics)

[REVERSIBLE]
 1648 The *fate* and *state* of this Kingdom might be a *reversible mutable
 state*. [Hammond Wks. (1683) I. 81] (my italics)

[REVERT]
 1649 Firme-written *destinie Reverts* the Breath of Kings; and playes with
 it. [G. Daniel Trinarch., Hen. V, ccxv] (my italics)

[REVERSION]
 1680 A Cat, you know, is said to have *nine Lives, that is eight in Reversion*
 and one in Possession. [Butler Rem. (1759) I. 408] (my italics)

[REVERSIONABLE]
1681 For it was proposed, that whatsoever Security we were to receive should be both Conditional and Reversionable. [H. Nevile Plato Rediv. 191]

[REVERSION]
1717
Is there no bright reversion in the sky,
For those who greatly think, or bravely die?
[Pope *Elegy to the Memory of an Unfortunate Lady*, 9]

Needless to say, the destiny to be reversed is that which has also been spoken of as the way of all flesh.

yours sincerely,

Leslie Fukuzawa-Emerson

p.s. To revert or not to revert, that is the question.

APPENDIX A

THE THREE HYPOTHESES OF
PROCEDURAL ARCHITECTURE

Architectural Body Hypothesis or Sited Awareness Hypothesis

What stems from the body, by way of awareness, should be held to be of it. Any site at which a person deems an X to exist should be considered a contributing segment of her awareness.

Insufficiently Procedural Bioscleave Hypothesis

It is because we are creatures of an insufficiently procedural bioscleave that the human lot remains untenable.

Closely Argued Built-Discourse Hypothesis

Adding carefully sequenced sets of architectural procedures (closely argued ones) to bioscleave will, by making it more procedurally sufficient, reconfigure supposed inevitability.

APPENDIX B

ARCHITECTURAL PROCEDURES IN THE WORKS

- *Ambient Kinesthesia* **Procedure**
- *Bioscleave Fructifying* **Procedure**
- *Biotopological Open Code* **Procedure**
- *Biotopological Scale Juggling* **Procedure**
- *Borrowed Proprioception* **Procedure**
- *Boundary Swaying* **Procedure**
- *Cleaving Loosening* **Procedure**
- *Discontinuity Exaggerating* **Procedure**
- *Disparateness Emphasizing* **Procedure**
- *Disperse to Contrast* **Procedure**
- *Feeling Sculpting* **Procedure**
- *Identity Loosening* **Procedure**
- *Indirect Refusal* **Procedure**
- *Landing Site Palpating* **Procedure**
- *Mistake on Purpose* **Procedure**
- *Multiplying the Experiencer* **Procedure**
- *Organism That Persons Biotopologizing* **Procedure**
- *Pacing* **Procedure**
- *Re-assembling* **Procedure**
- *Re-visiting* **Procedure**
- *Risis Purus* **Procedure**
- *Tentativeness Cradling* **Procedure**
- *X for Y Substitution* **Procedure**
 [*Say X Think Y* **Procedure**]

APPENDIX C

CONCISE VERSION OF DECLARATION
OF THE RIGHTS OF PERSONS AND
THEIR ARCHITECTURAL BODIES

17. Every person must be given the means (a tactically posed surround/tutelary abode) to live as an architectural body so as thereby to be able to construct and invent herself to be free and equal in rights.

16. When achieving of a reversible destiny hangs in the balance, what needs to be firmly guaranteed above all else is the right of a person to self-create and to blossom forth as an architectural body.

15. No person or architectural body may exercise any authority that does not proceed directly from the desire to make reversible destiny a reality for the greater organism (the species *homo sapiens sapiens)*.

14. Liberty **B** (the new liberty that comes from living as an architectural body) consists in the freedom to augment one's own existence to determine contributory factors to liberty **A** so as to be less slavish when it comes to the exercising of this right.

13. Insofar as the death of even one citizen is hurtful to the greater organism, the greater organism is duty-bound to issue a law that prohibits dying.

12. Every citizen has the right to participate in the formation of laws through her coordinating skills alone or in combination with and primarily through those of her representative.

11. No person shall be accused, arrested, or imprisoned except in the cases and according to the forms prescribed by law.

10. No one shall suffer radical reorganization unless it is legally inflicted in virtue of a reversible-destiny law passed and promulgated *before* the commission of the offending error.

9. All persons should be considered blameless or innocent until they shall have been found to have in some way harmed the reversible destiny of the greater organism. All harshness not essential to the securing of the prisoner's person shall be severely repressed by law.

8. Provided the manifestation of opinions, including religious views, autopoietic or self-organizing acts do not disturb the public order established by law, no one shall be disquieted on account of them.

7. Every citizen may, accordingly, with freedom, speak, write, and print; and furthermore, invent and assemble architectural procedures for tactically posed surrounds/tutelary abodes; participate in the design of closely argued built-discourses both on this planet and, if possible, intergalactically. But every citizen shall be responsible for such abuses of this freedom as shall be defined by law.

6. The security of the rights of persons and their architectural bodies requires the existence of a public immune system (public military force in the 1789 document), a welcome result of a well-functioning closely argued built-discourse.

5. All citizens must contribute in proportion to their means to the maintenance of the public immune system and for the cost of its administration.

4. All citizens have the right to decide, either personally or by their representatives, as to the necessity of the public contribution; to grant this contribution freely; to know to what uses it is put; and to fix the proportion, the mode of assessment and collection, and the duration of the contribution.

3. Society has the right to require of every public agent, and indeed of every forming agent, an account of how extensive her coordinating skills are for the administration of her own life and for the lives of others.

2. A society in which the observance of the law is not assured, nor the separation of powers defined, has no constitution at all.

1. Only property **B**— namely, all that the architectural body subtends and lives as —can and should be deemed an inviolable and sacred right that no one shall be deprived of except where public necessity, legally determined, shall clearly demand it, and then only on condition that the owner shall have been previously and equitably indemnified.

APPENDIX D

DIRECTIONS FOR USE
REVERSIBLE DESTINY LOFTS—MITAKA

The discussion of crisis ethics in the text Architectural Body *is required reading for* reversible destiny *loft dwellers.*

Not only does a resident of a Mitaka reversible destiny *loft live as an architectural body, she also lives as a biotopologist. She becomes an architectural body by fully associating herself with what surrounds her. She lives and works as a biotopologist by taking cognizance of and tracking far more scales of action than are usually taken account of.*

- Once at your front door, listen in every direction, knock at your own front door, and after doing so, listen again in every direction.

- When stepping through the doorway do all you can to slow yourself down.

- Do not forget that not only is the doorway a medium-scale, sucking breathing passageway but so too is the actual door itself. All that manages to come in through these passageways that differs so greatly in density becomes part of this unit's circulating atmosphere. Say farewell to all that does not get sucked into your loft together with you, to a great deal of what previously surrounded you out in the hallway or swirled around you as you moved through the city.

- As you come in the door, before taking a single step, close your eyes. Make careful note of temperature variances throughout your body and attend as well to temperatures across your loft. Once in awhile after having performed this settling-in routine, do an about-face so as to make a quick exit; once out of your loft do another about-face and immediately re-enter.

- Go into this unit as someone who is at the same time both two or three years old and one hundred years old.

- As you step into this unit fully believe you are walking into your own immune system.

- Have each floor element be as if a piano key, an organ key, a xylophone key or a small drum.

- The floor is a keyboard that is in the process of being invented. Try to help figure out what type of keyboard this is. Once in a while use the keyboard with your hands as well as your feet or even go so far as to play upon it with the full length of the body.

- At least once a day amble through the apartment in total darkness.

- In addition to treating your floor as a keyboard, from time to time, enter into conversation with it (For example: "Hello"; "What is going on with you?" "I wonder what you are like over there in that remote corner." "What would be another way for you to be a floor?").

- Use the floor to chart the intricate set of actions by which you succeed time and again in regaining your balance.

- Interact with the floor so as to produce sunlight.

- Immediately upon moving into your loft, give a name or title to the central area's ceiling. Once having lived in your loft for a month or so, and after having inserted belongings into the soft sculpted portable closets grouping them as best suits you, find a more fitting name or title for this ceiling together with all that hangs off of it (For example: Museum of Infrastructure; Overhanging Garden of Continuity; Kehai Monitor)

- Attempt to account for every single centimeter of your loft simultaneously. Do this as frequently as possible.

- Cluster all your loft's rooms into a tight-knit group then forget all rooms except the one you are in.

- Treat each room as if it were you yourself, as if it were a direct extension of you.

- Treat each room as if it were a close relative or friend.

- Treat each room as if it were a close relative or friend who wishes to learn how not to die.

- Every month move through your loft as a different animal (snake, deer, tortoise, elephant, giraffe, penguin, etc.).

- Here is an initial list of the roles you can and should assume within this theater of action: nurse; rock climber; ballerina; immunologist; boxer; pickpocket; wait-person).

- Use your loft's brightly colored shaped volumes to structure and compose your own vitality.

- Compare the hills and vales, the swirling contours, of those streams of lighted air you find in your vicinity upon awakening with those that surround you at bedtime.

- Use the brightly colored shaped volumes to increase your ability to remember things and events.

- Encourage large and small expanses of color to extend far out beyond the surfaces they cover.

- Have one self that keeps the many hues distinctly apart and another that lets them freely mix.

- Compare words and musings evoked in you by one brightly colored shaped volume with those evoked by the other volumes.

- Produce movements and gestures through which to impart to a deafblind person, to Helen Keller, an over-all sense of the set of brightly colored shaped volumes within which you live.

- Invent at least ten ways to use the shaped volumes whose colors suffuse the atmosphere to heal whatever you need to have be healed in you.

- Your loft comes with a set of sculpted, pliable closets that can, in conjunction with the poles found in each of its rooms, be used to form a forest.

- Treat each sculpted, pliable closet as if it were a direct extension of you.

- For a couple of hours every month, so completely give yourself over to your loft that it turns you into someone else.

- For a couple of hours every month, have the person your loft re-configures you as be Helen Keller.

- To be continued……

APPENDIX E—FROM *THE MECHANISM OF MEANING* (1963–1971) (right): The Mechanism of Meaning/5. Degrees of Meaning, panel 6, acrylic, carpenter's level, metal chain, newspaper, packaged outdoor thermometer, paintbrush, sponge and wristwatch on canvas (1964).

APPENDIX E

A B C D E F G H I J K L M Z

1234 5 6 78 9

CAT RAN MAT DOG HAT COW GOT BOY

WHISPER WHISTLE COVER PAIR WOOL SHEEP

NEVER MIND WHAT HE SAYS

HOPE TO SEE YOU SOON AGAIN

Attempt to pronounce each of these with mouth closed (with or without tape).

KINAESTHETIC SCULPTURE

zhit

VARY THE RATE OF PRONUNCIATION ACCORDING TO THE
LENGTH OF TIME SPENT TOUCHING THE OBJECT

T H A S

GLOSSARY

APPROXIMATIVE-RIGOROUS ABSTRACTION

- Predominant within biotopology's lexicon, approximative-rigorous abstractions basically run the show. They can with a considerable amount of accuracy mark and hold places for indeterminate things and events. The best way to give a sense of what is indeterminate or not fully ascertainable is to make an approximative-rigorous statement about it, approximately taking its measure while rigorously allowing it its proportionate due.

- Approximative-rigorous abstractions: cleaving; bioscleave; landing site; architectural body.
- Approximative-rigorous abstractions can, for interactive diagramming purposes, be used to schematize elements singled out for emphasis as well as component factors needing to be brought out in the open.

- The best approximative-rigorous abstractions have it in them to stand out strikingly as, but of course, mere abstractions, even while they sit or splash conspicuously, and weightily enough, in gravitational amplitude, on the cusp of materiality.

- Central to biotopology's diagrammatic method, approximative-rigorous abstractions are the means of putting in place and maintaining appropriate level of abstraction.

ARCHITECTURAL BODY

- The architectural body is a body that can and cannot be found. Boundaries for an architectural body can only be suggested, never determined.

- An architectural body only more or less takes shape and only more or less presses forward and manifests as that which it is purported to be.

- Architectural bodies have everything to do with what a person makes of the fact, the soft but sure-enough fact, that she perceptually subtends, and as-if palpates, architectural surrounds as wholes.

- There is that which prompts (architectural surround/tactically posed surround/

tutelary abode) and that which gets prompted (*organism that persons*). Features of architectural surrounds/tactically posed surrounds/tutelary abodes prompt the body to act. Actions and maneuvers secure a general taking shape for an *organism that persons* of the characteristic features of a(n) architectural surround/tactically posed surround/tutelary abode. In responding to the ubiquitous call that comes from nooks, crannies, and non-nooks and crannies of a(n) architectural surround/tactically posed surround/tutelary abode—most observers feel that they ought eventually to get around to noting everything around them—a person assembles and takes on an architectural body, half-knowingly piecing it together into a flowing whole. The harkening to any feature or element of the architectural surround/tactically posed surround/tutelary abode, bodily stirrings and promptings included: an articulation of the architectural body.

- An architectural body exists paradoxically enough as that which is most probably specifically dispersed and even so only roughly present.

- The gist of biotopological thinking: No less attention should be paid to the atmospheric component of the architectural body (the bioscleavic atmospheric surround) than to the body proper.

- The dispersing and juxtaposing and culling of landing sites in respect to an architectural surround; a super-convening of many convenings; messenger-like —in rapport with all there is; that which revs as momentum—revved and revving; an amassing of the provisional; a ubiquitous piecing together. All that emanates from a person as she projects and reads an architectural surround forms an architectural body that moves with her, changing form depending on the position she assumes.

- The architectural body consists of two *tentative constructings towards a holding in place:* body-proper and architectural surround.

- Covering a large area indeterminately, an architectural body, exists, when you come right down to it, as a statistical entity, with now these proportions, now those. An architectural body has theoretical and actual existence, but as an entity of this kind, it has such a remarkable degree of instability that it is fair to say it is as elusive as anything can be. This huge and difficult-to-track entity of sorts does have a highly visible generating source, and that is the human body, which

itself has a statistical existence as a composite of actions and events in addition to its every man, woman, and child appearance as articulated corporeality.

- Take it as the near-animate group of loci its definition demands for it and accept that out it extends into an architectural surround, enormously expanding the body-proper; do not trouble yourself as to where in relation to a surround it begins or ends or fret over what its full extent might be.

- A perfectly proportionate something or other that cannot even be determined as present and accounted for apart from what its definition specifies for it.

- An architectural body critically—ever examining and always assessing— holds possibilities in place.

- A person's capacity to perform actions is keyed to layout and composition of her architectural body.

- What stems from the body, by way of awareness, should be held to be of it. Any site at which a person deems an X to exist should be considered a contributing segment of her awareness. Architectural Body Hypothesis or Sited Awareness Hypothesis

ARCHITECTURAL PROCEDURE
- An architectural procedure is a complex something or other. Perhaps no concept is clumsier. We urge you not to let its overarching clumsiness scare you off. It works as both a this and a that. Tactically posed surrounds/tutelary abodes remain what they are, but architectural procedures have two distinct stages of existence or levels of implementation. An architectural procedure definitionally unfurls as one segment or many or as one set-up or many of a tactically posed surround/tutelary abode—level one of its first implementation. The level two implementation of an architectural procedure is the sequence of actions that the level one implementation constrains.

- A person moving through a tactically posed surround/tutelary abode will be led to perform procedures that may or may not be recognizable to her as architectural procedures.

- All of a sudden, what seemed a group of disparate actions, the doing of this and that, may strike her as the steps of a procedure. If these procedures, which have a lot in common with medical procedures, elude their performers, they do so openly, or are constitutionally elusive. Always invented/reinvented on the spot, they exist in the tense of the supremely iffy. Not a fixed set of called-for actions, an architectural procedure is a spatiotemporal collaboration between a moving body and a tactically posed surround/tutelary abode.

- An architectural procedure resembles its predecessor, a word, in two respects for a start: first, it is a repeatable item that readily lends itself to discursive use; second, charged with conveying a specific experience or range of experiences, it can be evaluated as to how well it serves its purpose or how effectively it has been put to use.

- Architectural procedures used only for studying interactions between body and bioscleave have an observational-heuristic purpose, while those devised for transforming body and bioscleave have a reconfigurative one.

- Movements and the sited awareness they modulate and that enfolds them mediate architecture; responding to tactically posed surrounds/tutelary abodes, joining forces with them, actions complete the architectural procedures that put (the) procedural into procedural architecture.

- Adding carefully sequenced sets of architectural procedures (closely argued ones) to bioscleave will, by making it more procedurally sufficient, reconfigure supposed inevitability.　　　　　Closely Argued
　　　　　　　　　　　　　　　　　　　　Built-Discourse Hypothesis

ARCHITECTURAL SURROUNDS
- To counter the deer-in-the-headlights effect, turn from speaking of architecture, vast architecture, to speaking of what of vast architecture a person can encompass in any given moment, naming this the architectural surround.

- An architectural surround's features: its boundaries and all objects and persons within it.

- Architectural surrounds exist only in relation to those moving within them.

- Architectural surrounds stand as shaping molds for the *What happens next?* of life.

- Isolating persons from their architectural surrounds leads to a dualism no less pernicious than that of mind and body.

TACTICALLY POSED SURROUND
- A tactically posed surround consists of architectural procedures.

- An architectural surround that has architectural procedures embedded in it shall be known as a *tactically posed surround/tutelary abode.*

- Each tactically posed surround generally has embedded in it two or more distinctly different architectural procedures. Within a tactically posed surround, both the architectural body and its constituent factors become more apparent.

- Architectural procedures hardly exist or begin to be what they can be until they have been incorporated into a tactically posed surround.

- Choosing to live within a tactically posed surround/tutelary abode will be counted as an all-out effort to go on living.

TUTELARY ABODE
- Tutelary abodes (aka tactically posed surrounds) augment existing coordinating skills and scare up new ones.

- Home sweet home as a work of procedural architecture.

- A dwelling replete with architectural procedures.

BIOSCLEAVE
- Bioscleave—There is no part of bioscleave that is not cleaving.

- Without exception, all that can be and does get detailed as bioscleave consists,

by definition, of cleaving. We have an entire field alive with cleaving: bioscleave. From cleaving, by means and in terms of it, bioscleave, an event-fabric capable of giving and holding and functioning as life, forms. Although it can be put to a purpose, cleaving on its own happens aimlessly, in both its modes, in its coming together mode and in its pulling apart one.

- Bioscleave denotes life in all its multiplicity as communally lived and all regions that can or could encompass the whole of this vivid crew in the fullness of their interaction on all possible scales of action at once.

BIOTOPOLOGY
- Biotopology is the art-science of emphasis, studying closely related but notably different degrees of emphasis.

- Biotopology: the art-science that seeks to be as inclusive as possible.

- Think of elementary biotopology as being as much a meadow of knowing as a field of study and a meadow as broad as the day and a knowing that has within it plenty of room for not knowing. Its subject matter wraps around you or around the referent of any member of your ever-available suite of pronouns and would-be pronouns and counts as you or one or another of these referents and follows you or such referents wherever you or they go.

- Biotopology introduces a world of approximative measurement whose basic measure is the architectural body, which, by definition, and in actuality, is approximative.

- Biotopology, together with procedural architecture, the field it was invented to serve, holds that because living as an architectural body involves a roundabout way of pinning down but not exactly pinning down that which is in play, an *organism that persons* who lives as one stands a fair chance of escaping many of the conceptual pitfalls, particularly those born of an unconscious move toward reductionism, that commonly plague theorists and researchers.

- At the heart of biotopology's methodology lie approximative-rigorous abstractions, and underlying all biotopological description are the pair of terms *cleav-*

ing and *bioscleave*, which rigorously and approximately hold the places, respectively, for the firm attaching of one segment of massenergy to another and the equally firm separating of such segments from each other, and the biosphere in the dynamic throes of omnipresent cleaving.

• Within biotopology's lexicon, approximative-rigorous abstractions predomominate and basically run the show. These terms can with a considerable amount of accuracy mark and hold places for vague things or events.

• Whereas regular topology looks at similarities between boundary conditions, biotopology does away with the discrete object, and thus with boundary conditions altogether. Although biotopology refuses to accept the traditional view that the epidermis of an organism that persons constitutes its boundary with the world, it does recognize that there are crossover zones and differences between organizational levels of the event-fabric on one side of the epidermis (within the body proper) and on the other (the atmospheric component of the architectural body).

LANDING SITE
• Landing site: the "coming alive" for sentience—as sentience?! of anything whatsoever, even the most fleeting sensation.

• Landing site: a neutral marker, a simple taking note of, nothing more.

• Landing sites exist on many different scales of action at once and abound within one another.

LANDING-SITE CONFIGURATION
• A landing-site configuration: the full set of landing sites an *organism that persons* disperses at any given moment.

• Every landing-site configuration—every instance of the world involves all three ways of landing as a site (perceptual landing site, imaging landing site, and dimensionalizing landing site).

PERCEPTUAL LANDING SITE
• A perceptual landing site lands narrowly as an immediate and direct response to a probable existent, a bit of reporting on what presents itself.

- With every move she makes, a person disperses her perceptual landing sites differently.

- Perceptual landing sites pop up on demand, converging upon whatever is around to be landed on. They occur always in sets—a flock of birds flying in formation.

- All singled-out elements of surrounding surfaces: perceptual landing sites.

- Were there no perceptual landing sites, there could be no organism-person that is a body. Perceptual landing sites serve up the initiating site of all sites, the basically fixed but constantly changing kinesthetic-proprioceptive schema of body that keeps a person always kinesthetically grounded and figured and configured.

- Regardless of the softness of numbers assigned, despite the inevitable imprecision, perceptual landing sites, whatever their number, always, by definition, register accurately enough features and elements of the circumstances they have been dispersed to record.

IMAGING LANDING SITE
- An imaging landing site lands widely and in an un-pinpointing way, dancing attendance on the perceptual landing site, responding indirectly and diffusely to whatever the latter leaves unprocessed.

 - An amorphous according of more information than is directly supplied, an imaging landing site exists as an even less discrete patch of world than a perceptual landing site. Blending the surroundings and blending into the surroundings, it has hardly any shape at all and perhaps had best be spoken of as shapeless; even so, it helps define the shape of this or that part of the world.

- Absent perceptual landing sites, when a sensory modality has closed down, an imaging landing site can also suggest itself to be a direct response that initiates a report, thus turning itself for all intents and purposes into a perceptual landing site.

DIMENSIONALIZING LANDING SITE
- A dimensionalizing landing site registers location and position relative to the body. Building, assessing, and reading volume and dimension, dimensionalizing

landing sites "engineer" depth and effect the siting of sites. These sites register and determine the bounds and shapes of the environment.

• A dimensionalizing landing site lands simultaneously narrowly and tightly and widely and diffusely, combining the qualities of a perceptual landing site with those of an imaging one, coupling and coordinating direct responses with indirect ones, the formed with the formless.

• Attaching a grappling hook of a perceptual landing site to a vaguely sketched-in rope of an imaging landing site, a dimensionalizing landing site, in landing, hooks onto the environment to gain traction on it. With the hook-and-rope ensemble flung out and an availing surface caught hold of, there comes to be an as-if-tugging-back-to-the-body that conveys a sense of (kinesthetic) depth.

ORGANISM THAT PERSONS
• An organism that persons is a highly organized segment of bioscleave.

• It may seem that an organism has a person with which it is associated, but rather than actually having a person, an organism has a long-term association only with behaving as a person. Who has been accepted as a person by other persons is really nothing more than the set of ways an organism that person behaves.

• A dynamic composite of organizing principles, an organism that persons is an organization that can recognize or express to itself (by means of coordinated landing sites) how it (as organized entity or massenergy cluster) is positioned.

• Each organism that persons finds new territory that is itself, and having found it, adjusts it. This is so only if systematically organized events, fields in which relations among events have some degree of order, can count as territories.

• An organism-person-environment gives birth to an organism-person-environment.

• *Organisms that person* become persons through social embedding.

• Distinctions among members of society may only be founded upon the commu-

nal studying of architectural bodies, which are the extended domains of *organisms that person*.

- Not all *organisms that person* succeed in forming themselves into persons.

EVENT-FABRIC
- Everything is tentative, but some things or events have a tentativeness with a faster-running clock than others. So that there can at least be a keeping pace with bioscleave's tentativeness, it becomes necessary to divine how best to join events into an event-fabric, which surely involves learning to vary the speed at which one fabricates *tentative constructings toward holding in place*.

- Staying current with bioscleave, remaining alive as part of it, involves keeping pace with the tentativeness it brings to bear, staying focused on the elusiveness of this tenuous event-fabric or event-matrix.

- For the organism that persons, the sequences of landing-site configurations that form its architectural body add up to the event-fabric.

TERMINOLOGICAL JUNCTION
- Biotopologists name any set of terms that they see fit to group together: *terminological junction*. A terminological junction is a collecting area for multiple terms that either have synonymous import for one another (organizing principle/allowing tendency/axis of possibility) or that provide good contrastive support for one another (event-fabric/landing-site configuration).

- Biotopologists alternate freely among the following ways of constructing a terminological junction: _ _ _and _ _ _ and _ _ _ ; _ _ _ or _ _ _ or _ _ _ ; _ _ _ / _ _ _ / _ _ _ .

BLURB NEST FOR NONDYING

Take a deep breath and read, "A herd of bison watch helplessly, with eyes and *miens* that call out to be read as suffused with fellow-feeling, as one of their number falls through the ice." Let it out slowly. Now read the rest of *Making Dying Illegal*. You're ready.
 —STAN SHOSTAK, evolutionary biologist and author of
 The Evolution of Death

A great book can expand your powers of being, but only Arakawa and Gins, to my knowledge, have found, and continue to discover, ways to do so literally as well as metaphorically. When I think of the entire long history of the avant-garde, they are the standard of sincerity and commitment—and when I think of the future, I see them already there, kindly waiting for the rest of us.
 —SUSAN STEWART, Professor of English, Princeton University
 and a MacArthur Fellow

Arakawa and Gins' *Making Dying Illegal* is, like all great satire, a serious contribution to a serious problem—a problem that so far each of us has had to face for him- or herself, namely that of stopping being. Who but this singular collaborative pair has risen to the occasion of addressing death as a misdemeanor, if not a felony, on the part of the one who has died? For the first time death is treated not as a certainty or a necessity, but as an option it should be illegal to exercise. The book joins, if it does not constitute, the exiguous library of thanatosophical masterpieces. Its aim, of course, is not literary. It is corollary to the authors' audacious imperative to take destiny in hand and reverse it.

 —ARTHUR DANTO, philosopher, former President of the American Philosophical Association, Emeritus Johnsonian Professor of Philosophy, Columbia

Not since John Donne has anyone so humbled death as do Madeline Gins and Arakawa in *Making Dying Illegal*, a volume as pioneering as it is generous. Equal parts poetry, philosophy, legislation, blueprint, remedy, and demand, this book throws down the gauntlet and calls Dying what it really is—treason against the body.
 —JOSHUA EDWARDS, publisher and co-editor of *The Canary*

A survival manual for the post-utopian age, *Making Dying Illegal* suggests that 21st century poetics will have to field some of the toughest questions raised by cognitive psychology, linguistics, radical philosophy and experimental architecture.
—MICHEL DELVILLE, Professor, Université de Liège and Director of the
Interdisciplinary Center for Applied Poetics and
STÉPHANE DEWANS, architect

Death is an absurd mistake, an inconvenience to the spirit, and it is required that we outlaw it NOW!
—CATHERINE FITZMAURICE, Professor, University of Delaware
and founder of Fitzmaurice Voicework

Arakawa and Gins have once again escalated the struggle to reverse destiny, this time taking on the legal and governmental structures that would be needed for *Making Dying Illegal.* What if death were to be made illegal? For one, it would make those already tragic deaths in a terrorized world even more tragic. One of the secrets to Arakawa and Gins' trajectory is that they engage our actions, particularly our embodied actions, to radically change our ethical perspectives. Beginning with the disorienting way of looking at paintings with eyes closed, standing on a ramp, on through the highly interactive housing architecture that engages and changes perspectives, now into the wider social world, they produce the procedures that radically reverse our ordinary embodiment, and it's taken for granted we are led farther and farther into a different destiny.

—DON IHDE, philosopher, Distinguished Professor of Philosophy,
Stony Brook University

Reading *Making Dying Illegal* took my breath away. This struck me as odd, when I realised what was happening: isn't death the moment at which our breath is finally taken away? But it's OK, I reassured myself, because bridging the momentary absence of breathing was a quickened pulse. This was not a step toward death, but intensified living: swept into intensity.
—PIA EDNIE-BROWN, co-director of *Liveness Manifold,*
a research collective

Arakawa and Gins reverse destiny by affirming life's possibilities indefinitely. In light of aging populations, their architectural procedures warrant, indeed demand, attention from policy-makers and practitioners throughout the globe. In an originary moment in the history of philosophy, the female and male voices come together in shared and mutually enlightening expression. This opening is a landing site in which gender can be engaged super-constructively for the first time.

—TRISH GLAZEBROOK, eco-feminist and philosopher of science,
 Associate Professor of Philosophy, Dalhousie University

Grandma Marilyn and I have spent time looking at Arakawa and Gins' architecture. When she told me that the houses they build will help people not die, I looked up at her and asked, "Why doesn't everyone build like that?" Yesterday she read to me from *Making Dying Illegal*. When I told her that I thought dying had always been illegal, she began to cry.

—JOSEPH FALCEY, age 9

Early in the 20th century, thinkers such as Bergson and Heidegger fundamentally questioned the assumption that time and its experience should be thought of in spatial terms, and especially in terms of Newtonian spatiality. But what of space itself? Is space correctly thought of in temporal terms? Bachelard suggests not, and the work of Arakawa and Gins presents this rejection in its most rigorous form. What would be the *ne plus ultra* of the experience of non-temporalized space? Thinking of space as a vessel of pure immortality. This is the core of Arakawa and Gins' challenge to us—one that is well worth taking up.

—FRED RUSH, Associate Professor Department of Philosophy,
 University of Notre Dame

The grand synthesis presented here—theoretical physics, molecular biology, philosophy, political science, medicine and architecture combined—presents a person with the means finally to accept the true and full enormity of all that she can be. *Making Dying Illegal* supplies readers/patients with a whole array of new concepts (architectural body, organism that persons, landing site, biscleave and biotopology) through which to counter commonly accepted reductionist conceptions of bodily orientation that may lead to dysfunction and disease. As quoted from their book, "a unified field theory that does not account for the body, bodily actions, and the history of individual bodies or organisms could never represent the universe." I believe the architectural body to be the long-awaited next step in

healing and health. The body, as architectural body, does not have separate cause-and-effect linear mechanisms; it lives instead as a dynamic interactive totality, not only within itself but also within the environment, from this point on to be counted an essential part of bodily integration.

　　—FRANIA ZINS, physical therapist and Feldenkrais practitioner/
　　MSPT, CFP

Making Dying Illegal is a provocative treatise for the 21st century that firmly places the subject in the present, obliging it to account for its surroundings. Gins and Arakawa deliver a usable meaning dependent on the body's interaction with the world; employing a set of evolving procedures, which they name *architectural procedures*, they accomplish through their radical interdisciplinarity what poets, artists, and philosophers have attempted for decades—a retooling of phenomenology. *Making Dying Illegal* forces Cartesian dualism to recede and diminish—taking with it into oblivion its metaphysical and teleological ramifications—the Grand Narrative; the subject-object divide; logical, objective signification; even Death itself.

　　—CHRISTINA MAKRIS, Doctoral Candidate, University of Sussex

Antonin Artaud once wrote, in a 1947 letter to André Breton: "We shall die only because we were once made to believe so." More than half a century later, the strange, new, single yet collective voice of Arakawa and Gins emerges, loud, unmistakable, buoyant and large, to fight the persistently ingrained, species-unfriendly belief. Biotopology tells the story of bodies responsive to the philosophy of TNT—three explosive letters that should no longer stand for trinitrotoluene, but for the only explosive worth writing about: To Not To, the life elixir and electuary of *To Not To Die*. Some books are for reading. Others are palpable flesh made word.

　　—MARIE-DOMINIQUE GARNIER, Professor of English Literature,
　　University of Paris

With baby boomers sobered by the prospect of now entering the bow-out final phase of their lives, we need more and better perspectives on our mortality. This demanding, eclectic, challenging and exotic book helps, as it offers a fresh angle on life, death, and all that goes in -between. Admirers of the Built World, in particular, will find much to ponder, and as will everyone who has ever looked with awe at timeless structures. No easy read (the language is arcane), and no fast

read (nearly every page gives one pause), the book is well worth the candle—and then some!

—ART SHOSTAK, Emeritus Professor of Sociology,
 Drexel University and editor of *Viable Utopian Ideas*

Arakawa and Gins are the uttermost modern of fleet honey-hunters who postulate, then materialize vastly original pith-points which in turn move to trump Time as we know it, to near Time as applied Love, nakedly passing through our pervasive dysbiosis. *Making Dying Illegal* is an extraordinary invitation to witness and coact in this sinewy transfiguration; the lofty map that meets the mystery.

LISSA WOLSAK, poet

1. The most self-serving bit of legislation ever proposed. If this goes through, we'll be forced to pour tons of money into reversible destiny construction contracts, just to stay in compliance, i.e. alive. These guys are like Halliburton, only the other way around.

2. Poet/painters turned anti-death architects, now they're messing with the legal system. The parapoetic drift continues, boldly doubting where no doubt has gone before.

3. An anti-dying statute, the first-ever treatise on biotopology, intimate correspondence with the artists, cameo appearances by Chief Seattle, young Werther and Frankenstein, and, finally, detailed do-it-yourself instructions for creating your very own reversible destiny architecture. This book is the bonus disc with *all* the special features.

—ALAN PROHM, Ph.D., University of Art and Design, Helsinki
 and poetic research artist

Shoplifting and double-parking are illegal but dying is not?! Gins and Arakawa address the greatest affront to human life—dying. Moving readers away from death-accepting literature—"stages of grieving," "coping with death," and the whole host of cultural rituals associated with dying and death—they posit spatial poetic calibrations of body capable of drawing members of our species away from Thanatos Boulevard.

—MARILYN SLUTZKY ZUCKER, Ph.D., Lecturer in Writing
 and Rhetoric, Stony Brook University

It is normal to decry excess deaths as untimely and unnecessary. But what, this book asks, if all deaths were excess and unnecessary? What if the familiar "human condition" could be changed? Could it become normal to have no deaths?
—DAVID KOLB, Emeritus Charles A. Dana Professor of Philosophy, Bates College

In making the body the center of an analysis of what architecture can do, Arakawa and Gins lend new meaning to our dislocated posthuman lives. *Making Dying Illegal* is not merely an important step in the direction of what appears to be the primary purpose of art/architecture in our time—it marks a radical new turn for life to take in the 21st century.
—KLAUS BENESCH, Professor, University of Bayreuth

Are we ready for Arakawa and Gins? And the impact of *Making Dying Illegal*? To be given a choice—to construct and invent ourselves to be free and equal—to-to go on living. NEVER have we allowed this.

For at long last having it within our power to choose never to die? What a long-standing crime it has been on the part of our society against its elders that a choice of this nature could never be offered to them before!
—MARTA M. KEANE, rehabilitation consultant, founder and president of The Strategies Group

I would make this visionary book mandatory reading for all those worldly, all-too-worldly philosophers, corrupted poets and lazy minds who lead their lives as if dreaming were not far more important than living. *Making Dying Illegal* compels us to see life in a different light. That dying should be outlawed, that death should be subjected to nothing less than the capital punishment—this should scare to death our garden-variety teachers of intellectual conformism and apostles of academic commonsense.

—COSTICA BRADATAN, Assistant Professor of Humanities, Texas Tech University

"Certainly allowing oneself to be legislated towards ongoingness looks forward to a future in which jokes are finally really, really funny because the so-called last laugh will be stretched out. That's all such legalities will ever be: an ultra-long, ecstatic elasticity. Even the cynics, even those citizens who hurt others, will submit to the wondrous, jumbo-hearted edicts of ha and ha and

haaaaaaaaaaaaaaa. A super-radical statute for all those fed -up with bucket-kicking and farm-buying.
—JAKE KENNEDY, poet

We know that Socrates welcomed death as a release from the limitations of embodied life, and this thought, from the beginning of philosophy, through almost all religious traditions, and right through to Heidegger's thought that our existence just is a being-unto-death, has shaped the way we think of our finitude. What if we could think differently? What if we could think against the presumption and the entire history of that presumption? What if we could shape our world so that death was something less than our destiny? It's a thought worth thinking.
—SHAUN GALLAGHER, philosopher and experimental psychologist,
 Chair and Professor of Philosophy, University of Central Florida

Feeling domesticated, sublimated, ontologically inert? Tired of the same old habitual, pre-determined, teleological fixations that ground us (quite literally) six feet under?

For God's sake, organisms that person, what (in the hell) are we doing here?

Architectural anarchists Arakawa and Gins are here to assist, but don't expect a helping hand, more a kick in the backside!

Through *Making Dying Illegal* the pale imitation of life as the "self" is issued an ultimatum . . . To deliver up to life all that it deserves.

As self-appointed spokesperson for the species, let me say, "We are eternally grateful."
—RUSSELL HUGHES, Doctoral Candidate/Lecturer, RMIT

With awareness becoming aware of its awaring, the possibilities are unending.
—STACY DORIS, poet

EARTHLINGS: RED ALERT. A new constitution has arrived. You hold in this book a Declaration of Rights for the newly determined life of our species. Building upon their stunning *Architectural Body*, Arakawa and Gins project and construct a world and a life where the defeatist presumption of mortality no longer rules.
—HANK LAZER, poet/administrator

Inductive reasoning points to the supposed truth of deductive reasoning's syllogistic super-star major premise: All men are mortal. Oh yes, billions have died. Even so, this fact does not imply the future demise of all the living. It only indicates that we all face a strong probability of dying—if the laws governing mortality remain constant. Fortunately, Arakawa and Gins are masters at exposing inconsistencies of the allegedly constant. This book demonstrates that the logic behind universal mortality is growing weaker by the minute; we simply do not know enough about our bodies to foredoom them. The existence of this possibility obviates death as a destiny and transforms it into a problem to be solved—a serious ethical issue. We need to refigure everything. Mortality might not be necessary. Clearly, this work marks a major step in our collective evolution.

—ALEX DUENSING, poet laureate of Braddock, PA

In *Making Dying Illegal* humans confront their commitment to closure, and "subjectivity" meets its maker in the very operations of organism-person-surround. Such a book should make it impossible to go back to the tin cans and string of our historically determined bodies. Could there be a more subversive, dangerous, or important book?

—JONDI KEANE, Ph.D., Lecturer in Cross-Arts Practice,
Griffith University

I delight in contemplating the opposition that *Making Dying Illegal* will occasion. For example, those who advocate a "right to life" will, no doubt, find fault with any attempt by humankind to disturb the divine scheme (intelligently designed?) that includes death. Thus, we may anticipate advocacy of a right to die (free of criminal sanctions) by the right-to-lifers. A perfect circle for the reactionaries! A perfect irony for the rest of us!

—HOWARD J. FREEDMAN, attorney

Making Dying Illegal X-rays the niche of the final cultural blindspot and opens the way for a democratization of the architect's impulse.

—BOB NEVERITT, paramedia ecologist

Arakawa and Gins seem to know that where and what we are give rise to where and what we are—but the question is how to get this where and what going. "Take a turn for the less unknown" and find out how you wind up. *Making Dying*

Illegal keeps pointing up *what means*, so I'd say read this book and let your "approximative views blossom forth."
 —CHET WIENER, poet

 The Marxian motto aptly applies: "Philosophers have only interpreted the world; the point, however, is to change it." While trans-humanists -- despite all their seeming radicality and the changes they are about to bring to human beings and the world -- remain firmly grounded in Cartesianism: splitting mind from body, body from environment, Arakawa and Gins go all the way: in order to reverse destiny, science and philosophy have to find their own footing again. To cut off organisms from their surroundings for the sake of philosophical or scientific reduction should be unthinkable, yet it has been thought -- almost exclusively. Those who want to change their fate have to start where they start. This is what Arakawa and Gins are about to achieve.

 —DAGMAR BUCHWALD, independent scholar

 Think of this book—this assemblage of words, concepts, correspondences that is a new science of indirection—as a veil that allows travel outside of that plane of existence about which industrialized being has thus far been too convinced. "A knowing that has plenty of room within it for non-knowing," explodes the circuitry of presumptions that cover over or erase the extended sensorium.
 —LEO EDELSTEIN, editor of *Pataphysics*

 Arakawa and Gins are surely right to see architecture (conceived in its fullest sense) as fundamental to changing our destiny or even—who can tell?—*reversing* it forever, so that death shall have no dominion. Do not go into that good night *at all.*
 —RONALD SHUSTERMAN, Professor of English, Literary Theory and
 Aesthetics, University of Bordeaux 3

 Gins and Arakawa have rethought what constitutes a person. They propose an extraordinary approach to living that, with sustained inquiry, praxis, and adherence, translates into perennial nondying. Consider this book, then, as—at the very least—a philosophical invitation; or as—at its most revealing—the essential handbook for transcending mortality.
 —PATRICK PARDO, poet

Feeling the urgency of our planetary situation, Arakawa and Gins have thrown themselves wholeheartedly into the process of inventing a response that measures up. Some may feel Arakawa and Gins overshoot the mark, but those people should be the first to question their own ethical response to this world.

—DANIEL ROSS, philosopher and filmmaker

A witty mesh of gates that opens up our daily awareness that comes with "death."

—FLORENTINE SACK, architect and architectural theorist

If all this seems absurd to you, I suggest you more closely consider the status quo. The challenges posed by Arakawa and Gins pry at the gaps of what we take for granted and at the foundations of many issues considered insoluable. If you let yourself be productively provoked into articulating your discomfort with their texts, you might notice that things aren't the way you thought they were. You'll be one step further.

—JOST MUXFELDT, philosopher

uncompromising transwayfulformations cradle and field an offer of whole body capabilities, eventing, evidencing, assembling procedures, compassioning "many scales of action at once"—this radical, visionary, interrogatory project outsentiencing its multidimensionality, unsettling, reAnewing my heart, calling open to how much has been left out/into being/FEARLESS, courageous, "which to my joy, is now"

—MAGGIE O'SULLIVAN, poet

It is hard to suspend our assumptions, but that is the way into the unknown. I, who was at first skeptical, found myself, upon reading further, won-over by these theories, by this radically gently post-heroic way of thinking, with its visionary openness so fully a foil for reductive thinking. I embrace biotopology, a challenging new daughter science, an example of shenius manifesting in our newly unknown bioscleave. If an "architectural body" can intend differently within the fabric/cleave of bioscleave, beginning an altered sentience, anything could happen.

—JUDITH ELLISTON, editor of *Pataphysics*

Impossible, you say? Well, then sit back in your movie theater and watch yourself propelled toward doom: Enraptured or skeptical; it's all the same. Or act.

Can't decide? Well, then read Arakawa and Gins' new volume *Making Dying Illegal* and learn that until, like a free radical, you drift *against* the major flow, beyond Duchampian skepticism and Deleuze's vitalist rapture, and you feel your way through a "biotopology" of an enacted life lived in an architectural surround. Whatever is forbidden *is* mandatory.

 —MARTIN ROSENBERG, independent scholar

They say that death is inevitable and "natural," and that it is a "law of nature," and that's that, but—DID I EVER GIVE IT MY VOTE?

 —JEAN-MICHEL RABATÉ, Edward S. Sanford Professor
 of Comparative Literature, Princeton University

Fined for dying . . . What if reversing destiny were a legal issue? Arakawa and Gins' latest book is not just a utopian statement but a ground-breaking quest for new radical thinking which revives the optimistic stance of modernism.

 —FRANÇOISE KRAL, Associate Professor,
 University of Paris

Thanks to their unwavering faith in the force of language, Arakawa and Gins have reinvented the genre of the groundbreaking manifesto for the 21st century. *Architectural bodies of all countries, unite!*

 —SIMONE RINZLER, Associate Professor of Linguistics,
 University of Paris

SUBMIT RADICAL BLURBS FOR THE NEXT EDITION OF *MAKING DYING ILLEGAL* TO: WWW.REVERSIBLEDESTINY.ORG